How to

How to use gra
to sell things, ex
make things loo
make people la
people cry, and
in a while) chan
Michael Bierut

phic design
plain things,
k better,
ugh, make
(every once
ge the world

How to
Copyright © Michael Bierut 2015
Typeset in NeueHelvetica DOT
Used by special arrangement with Monotype and
the New York City Department of Transportation

Written and designed by Michael Bierut
Production management by Sonsoles Alvarez
with Chloe Scheffe
Production supervision by Julia Lindpaintner
Design supervision by Hamish Smyth
Editorial consulting by Andrea Monfried
Copy editing by Rebecca McNamara

Published by arrangement with
Thames & Hudson Ltd., London

HarperCollins books may be purchased for
educational, business, or sales promotional use.
For information please e-mail the Special Markets
Department at SPsales@harpercollins.com.

First published in North America in 2015 by
Harper Design
An Imprint of HarperCollins*Publishers*
195 Broadway
New York, NY 10007
Tel: (212) 207-7000
Fax: (855) 746-6023
www.hc.com
harperdesign@harpercollins.com

Distributed in North America by
HarperCollins*Publishers*
195 Broadway
New York, NY 10007

ISBN 978-0-06-241390-1

Library of Congress Control Number: 2015930130

Printed in China

First Printing, 2015

Contents

10
**How to be a graphic designer
in the middle of nowhere**
An introduction

16
How to think with your hands
Four decades of notebooks

36
How to destroy the world with graphic design
American Institute of Graphic Arts

40
How to have an idea
The International Design Center, New York

42
How to transcend style
American Center for Design

44
How to create identity without a logo
Brooklyn Academy of Music

52
How to invent a town that was always there
Celebration, Florida

60
How to work for free
Parallax Theater

66
How to raise a billion dollars
Princeton University

70
How to win a close game
New York Jets

80
How to be good
The Good Diner

86
How to run a marathon
The Architectural League of New York

100
How to avoid the obvious
Minnesota Children's Museum

106
How to avoid doomsday
Bulletin of the Atomic Scientists

112
How to be fashionably timeless
Saks Fifth Avenue

124
How to cross cultures
New York University Abu Dhabi

130
How to behave in church
The Cathedral Church of St. John the Divine

138
How to disorient an architect
Yale University School of Architecture

154
How to put a big sign on a glass building without blocking the view
The New York Times Building

164
How to make a museum mad
Museum of Arts and Design

172
How to judge a book
Covers and jackets

178
How to make a mark
Logotypes and symbols

190
How to squash a vote
The Voting Booth Project

192
How to travel through time
Lever House

196
How to pack for a long flight
United Airlines

204
How to have fun with a brown cardboard box
Nuts.com

210
How to shut up and listen
New World Symphony

216
How to top the charts
Billboard

224
How to convince people
Ted

234
How to get where you want to be
New York City Department of Transportation

246
How to investigate a murder
A Wilderness of Error

252
How to be who you are
Mohawk Fine Papers

258
How to get the passion back
American Institute of Architects

266
How to make news
Charlie Rose

274
How to set a table
The restaurants of Bobby Flay

282
How to survive on an island
Governors Island

292
How to design two dozen logos at once
MIT Media Lab

306
How to save the world with graphic design
The Robin Hood Foundation's Library Initiative

318
Acknowledgments

320
Image credits

"**Inspiration is for amateurs.
The rest of us just show up and get to work.**"
Chuck Close

NORMANDY HIGH SCHOOL WAIT UNTIL DARK

FRI. & SAT: NOV. 17 & 18, 1972

$1.00 8:00PM

How to be a graphic designer
in the middle of nowhere
An introduction

As far back as I can remember, I always wanted to be a graphic designer.

I must have been no more than five or six years old. I was in the car with my father on a Saturday on my way to get a haircut. We were stopped at a light, and my dad pointed at a forklift truck parked in a nearby lot. "Isn't that neat?" he asked. What, I said. "Look at the way they wrote 'Clark.'" Clark was the logo on the side of the truck. I didn't get it. "See how the letter L is lifting up the letter A?" explained my father. "It's doing what the truck does."

It was as if an amazing secret had been revealed, right there in plain sight. I was dumbfounded and thrilled. How long had this been going on? Were these small miracles hidden all over the place? And who was responsible for creating them?

I was in the first grade at St. Theresa's School in Garfield Heights, Ohio, when my teachers first noticed that I was good at drawing. This was no small thing. I was a good student, but among my peers in 1960s suburban Cleveland, academic diligence was viewed with suspicion, if not outright contempt. Artistic ability, on the other hand, was like a kind of magic. Inept at sports and generally withdrawn, I suddenly had a way to distinguish myself in the schoolyard. The nuns called it a "God-given talent," and I milked it for all it was worth. Luckily, I received nothing but encouragement from my parents. They bought me a succession of ever-more esoteric implements (charcoal sticks! pastels! kneaded erasers!) and signed me up for Saturday morning art classes at one of the world's great cultural institutions, the Cleveland Museum of Art. By the time I reached junior high school, I could render anything realistically. Everyone assumed I would be an artist when I grew up.

Art was something I used to make friends (and, occasionally, to keep from getting beaten up). At the request of one of the school's more frightening bullies, I painstakingly replicated the Budweiser logo on the cover of his civics notebook. Having acquired a Speedball pen set and having mastered a convincing Fraktur, I generated heavy metal insignia upon request.

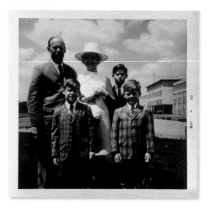

Above
Easter Sunday, 1969, in Parma, Ohio. I'm standing with my parents, Leonard and Anne Marie, and behind my twin brothers, Ronald and Donald.

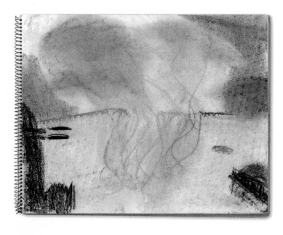

Above
My parents enrolled me in Saturday morning art classes at the Cleveland Museum of Art. Here is my rendition of a masterpiece in their collection, J. M. W. Turner's *The Burning of the Houses of Lords and Commons*. I was seven years old.

A turning point came in the ninth grade when I was asked to do a poster for the school play. I handed in the artwork on a Friday morning, it was printed that afternoon, and by Monday morning my poster was hanging all over the school. This was my first experience with the miracle of mass production. More people would see my poster than would see the play. I realized then I didn't want to settle for just doing a single painting to be stuck on the wall at someplace like the Cleveland Museum of Art. I wanted to create things with a purpose, things that people would see all over the place, things that were about something other than themselves. It was hard to explain.

I had no idea how posters and logos came into the world. I didn't know any working artists, and didn't know anyone else to ask. If pressed, I would have guessed that things like album covers were designed by real artists like Franz Kline and Robert Rauschenberg who had decided to take a day off and make some extra money. One day, I was in our school library, idly browsing the Career Resource Center. This was a grandiose name for what was no more than a shelf bearing a matched set of books called the Aim High Vocational Series. The titles included *Aim for a Job in Baking*, *Aim for a Job in the Dry Cleaning Industry*, and *Aim for a Job in Domestic Help Occupations*. One caught my eye: *Aim for a Job in Graphic Design/Art* by someone named S. Neil Fujita. I opened it and realized with a start that I was staring at my future.

Here were page after page of men and women who were doing what I wanted to do, with examples of work from ad man George Lois, magazine designer Ruth Ansel, and television art director Lou Dorfsman. I now realized this activity that fascinated me had a name: graphic design. Newly armed and wanting more, I went to my local public library and looked up those two words in the card catalog. There was exactly one book listed. It was *Graphic Design Manual: Principles and Practice* by Armin Hofmann.

An introduction

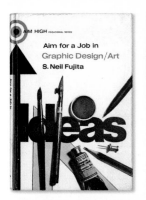
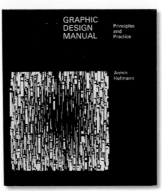
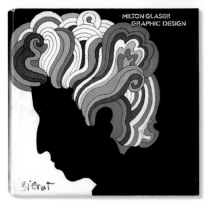

Looking back, I am utterly mystified that this obscure book, a dry account of the coursework at the Kunstgewerbeschule in Basel, Switzerland, ended up on the shelves of a small suburban library in Parma, Ohio. At the time, I was electrified. From the black-and-white studies of dots and squares to the exercises involving the redesign of European lightbulb packages, I devoured it all. After checking it out repeatedly—as far as I knew, I was the only one who ever did—I told my parents that the only thing I wanted for Christmas was my very own copy.

My mother, God bless her, called every store in town, miraculously finding someone who had just gotten it in stock. I opened it on Christmas morning to discover my poor mother's mistake. She had accidentally bought me *Graphic Design* by Milton Glaser, 240 glorious pages of unfettered eclecticism from the cofounder of Push Pin Studios, without a trace of dogma in sight.

My career was set in motion by these three books: a pragmatic guide by an East Coast journeyman, a rigorous manifesto by a Swiss theoretician, and a dazzling tour de force by a brilliant virtuoso. I was barely 18 years old, and without ever having met a graphic designer in person, I knew what I wanted to do for the rest of my life.

Somehow, my high school guidance counselor found just the right college for me at the opposite end of the state, where the University of Cincinnati's College of Design, Architecture, and Art offered a five-year program in graphic design. There I was plunged into a milieu that owed more to the minimalism of the Swiss Kunstgewerbeschule and less to the vibrant worldview of Push Pin Studios. Submitting myself to a boot camp's worth of punishing visual exercises, I unlearned my bad habits and replaced them with the basics of design, typography, color, and layout. Imagination and energy may be innate traits, but precision and craftsmanship are skills that can only be mastered through hard practice. Our professors were determined that no one graduate without them. It was telling that the degree I received was a bachelor of science, for in Cincinnati I mastered a kind of design that was as logical, self-contained, and elegant as the laws of physics. It was later in New York that I would discover the power of passion.

In retrospect, it wasn't a surprise that Massimo Vignelli loved my portfolio: sans serif typefaces on every page, modular grids underpinning every layout. After all, this was the acclaimed designer who had introduced Helvetica to the United States, created a relentlessly geometric map for the New York subway system, and devised a system to ensure that every national park from Acadia to Yosemite would have a matching brochure. With his wife, Lella, Massimo ran a Manhattan office from which issued a mind-boggling stream of logos, posters, books, interiors, and products. In the summer of 1980, I married my high school sweetheart, Dorothy, and moved to New York to become Vignelli Associates' newest and most junior employee. I was in awe of Massimo and couldn't believe my luck. But I also knew that my new boss had a strong point of view, and that his designers worked within clearly prescribed aesthetic limits. My plan was to spend 18 months there and move on.

I ended up staying ten years. Despite the firm's reputation for modernist austerity, Lella and Massimo presided over a workplace of extraordinary warmth, filled with noise and laughter and varied, exciting projects. Design there was a sacred calling, and in joining the profession you were committing to a fight against stupidity and ugliness. The clients who came to us were enlisting in the same battle. It helped that I was a good, even compulsive, mimic. Having learned my earliest lessons about graphic design by copying from library books, I found it impossible not to imitate Massimo's unmistakable style. He came to trust me, and continued to encourage me even when my ideas began to diverge from his. After ten years, I was managing the firm's graphic design operations. But more and more I wondered: what kind of work would I do if I were on my own?

The answer came in the form of a dinner invitation from a colleague, Woody Pirtle. Woody was a partner in the New York office of a firm called Pentagram, legendary for its unique structure. Its partners worked in a hierarchy-free collective, each managing a small design team, each sharing the resources of an international organization.

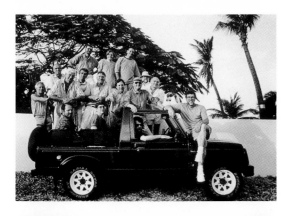

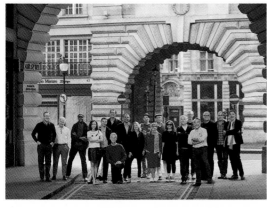

Top
A new family: my first international meeting in Antigua, 1990, as the newest partner in the firm's New York office. I'm seated in the back of the truck, surrounded by Mervyn Kurlansky, Colin Forbes, Theo Crosby, David Hillman, Neil Shakery, John Rushworth, Kenneth Grange, Linda Hinrichs, Etan Manasse, Woody Pirtle, John McConnell, Kit Hinrichs, Alan Fletcher, and Peter Harrison. Peter Saville is at the wheel.

Bottom
A more recent partners' meeting in London, 2014. From left to right: Abbott Miller, John Rushworth, Eddie Opara, Natasha Jen, Luke Hayman, Harry Pearce, Michael Gericke, Lorenzo Apicella, Paula Scher, Angus Hyland, Marina Willer, me, Emily Oberman, Domenic Lippa, William Russell, Daniel Weil, DJ Stout, Naresh Ramchandani, and Justus Oehler.

A casual conversation about my future turned into something else. Over coffee, he asked if I might be interested in becoming Pentagram's newest partner. His timing was perfect. I loved the bustle of a big office. The loneliness of a sole proprietorship held little appeal. Combining autonomy and community, Pentagram offered the best of both worlds. I thought about it overnight, talked it over with Dorothy, and said yes. In the fall of 1990, I started my second job.

My second job may be my last job. I've been at Pentagram for nearly 25 years. And, to a remarkable extent, I am doing exactly what I always wanted to do. I still recall the seismic jolt of seeing that forklift truck logo, or opening that book in my school library. What I couldn't figure out then was how people came to make these kinds of things. Where did the ideas come from? What happened between an idea and its realization? How could you tell if the ideas worked? How were people talked into accepting them? Was it magic? Or was there a limit to what graphic design could do? And, finally, how could I get to do it, too?

Since my first poster in the ninth grade, I've discovered that my questions have many possible answers. Although none of them are final, all of them are interesting. No one can tell you what to do. But once you decide, the real fun is figuring out how to do it.

How to think with your hands
Four decades of notebooks

**Opposite
and above**
For more
than 30 years,
I've seldom
gone
anywhere
without a
composition
book.
As a result,
they take
a beating.

On August 12, 1982, I opened up a standard 7½" by 9¾" composition book and began taking notes on a phone conversation. I forget where the book came from. I may have found it in the supply cabinet of Vignelli Associates, where I had been working for a little over two years.

This was the beginning of a habit—or a compulsion—that has continued to this day. I cannot walk into a meeting or start a phone call without my notebook. Other designers have amazing sketchbooks. Not me. A few pages look like they belong to a real designer: drawings, type studies, visual ideas being worked out. But most are filled with to-do lists, phone calls to be returned, budget calculations, meeting notes. In college, I discovered that writing down something helped me remember it later. Paradoxically, that means that a lot of these notes, taken once, are never referred to again.

Although I am (or I used to be) a good draughtsman, drawing may no longer be a relevant skill in the digital world. (Knowing how to read is more important than knowing how to draw.) But looking back through the years, I'm surprised by the occasional visual notes in these books, and how often they anticipated the design work to come. Often, in the midst of a dense list of bullet points, there will sit a quick diagram, an embryonic sketch that represented the first step of what would be months of work.

When the idea of a personal digital assistant was first described to me, I thought, oh, sort of like my notebook, except a computer. (It's no accident that the iPad is nearly the same size.) Like most designers, I'm dependent on my digital devices. But my notebook is still with me: diary, sketchbook, security blanket, friend. On August 26, 2013, 31 years after the first, I started notebook number 100. How I would love to fill 100 more.

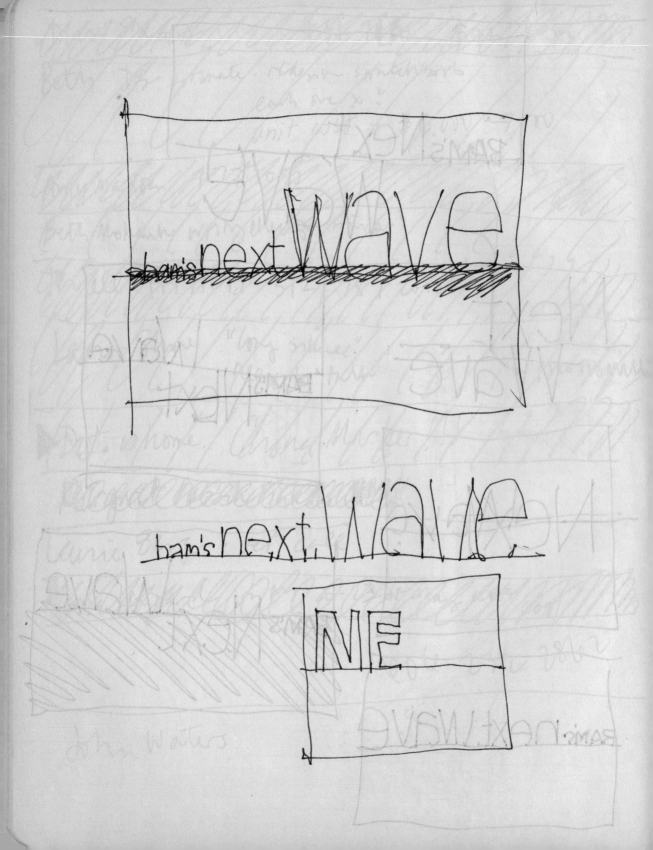

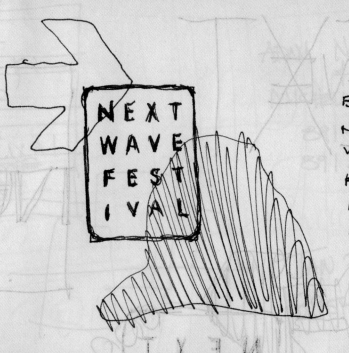

NEXT
WAVE
FEST
IVAL

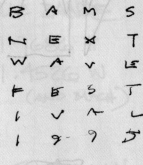

B A M S
N E X T
W A V E
F E S T L
I V A L
I 9 9 5

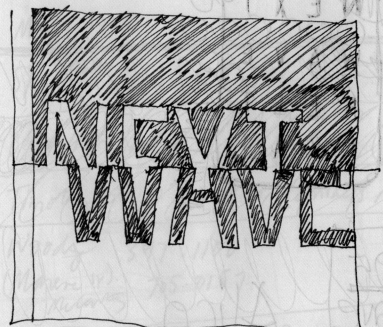

NEXT
WAVE

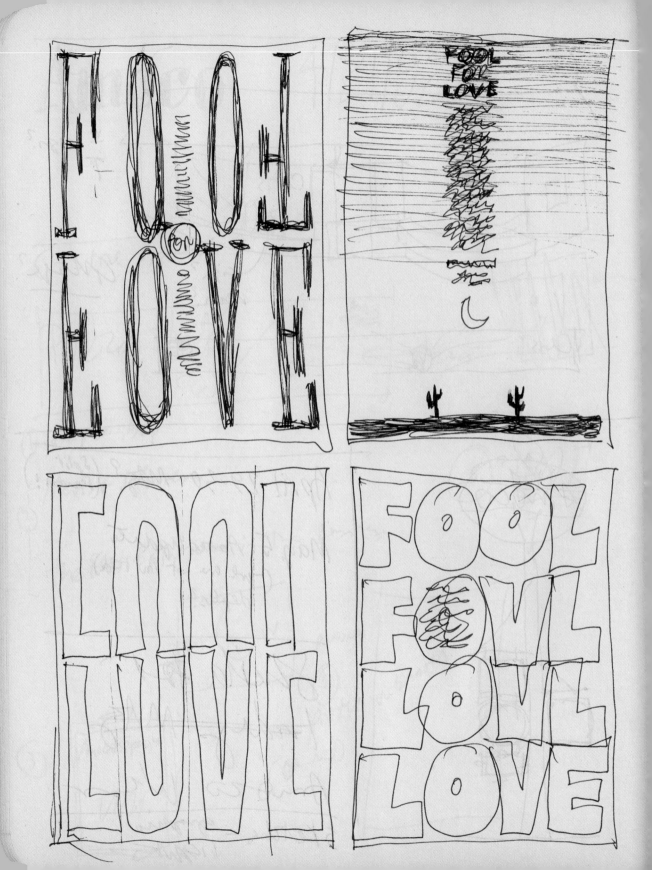

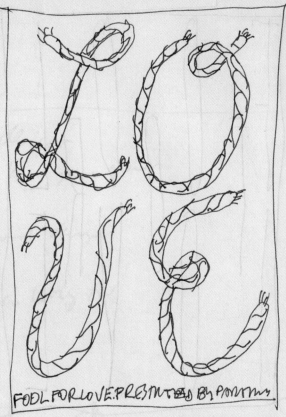

FOOL FOR LOVE. PRESENTED BY PARTM...

David McNulty }

Lexy - Tony

Paris star

1:

~~Susan Sheerd~~

917 493

~~Suzy Miller~~

~~Shannon 10'c~~

~~Babe~~

Right
Sometimes
a detailed
sketch is
enough to get
an idea out
of my system.
For this poster
for a Yale
symposium
on the architect
Charles Moore,
we went with
the simpler
approach
(see page 144,
bottom left).

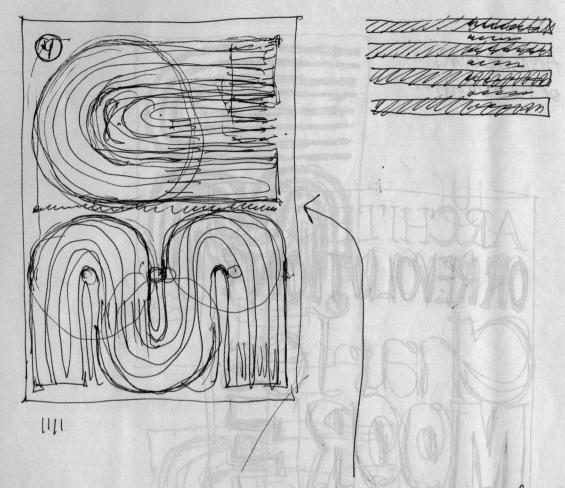

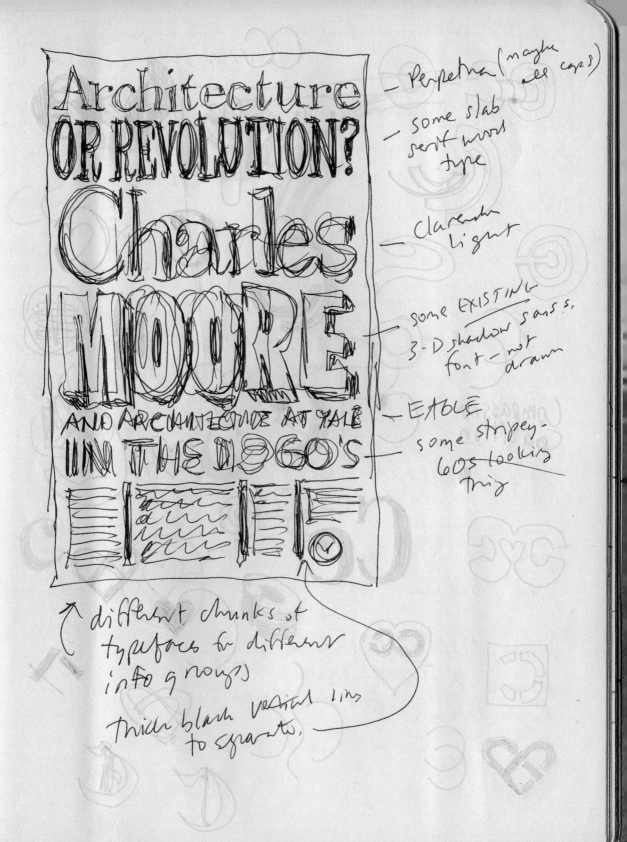

Architecture
OR REVOLUTION?
Charles
MOORE
AND ARCHITECTURE AT YALE
IN THE 1960'S

— Perpetua (maybe all caps)

— some slab serif wood type

— Clarendon Light

— some EXISTING 3-D shadow sans s. font — not drawn

— EAGLE some stripey-60s looking thing

↑ different chunks of typefaces for different info groups

Thick black vertical lines to separate.

Right

Sketches
for a *New
York Times*
assignment
(see page 156)
commingled
with a list of
unreturned
phone calls.
It seems to
have taken me
four tries to
solve this one.

Rethinking Design #4) — Sked
Deliver Oct 4th

Jackie to → at work till 2/14
 vacation 2/15 - 2/23
 starts 2/26

United mtg w/ 2/4/97
 John Rubaak

Li Kris Cargo - Scott to send
 cargo = $15

Shuttle 737/300 + 500's

Richmond Childrens
Museum.

MAD MAD

process, materials pr ansfrmenta

original
differentiated
Creative

Alex Knoll
S + G writer
Sven, Creative Director

MAD

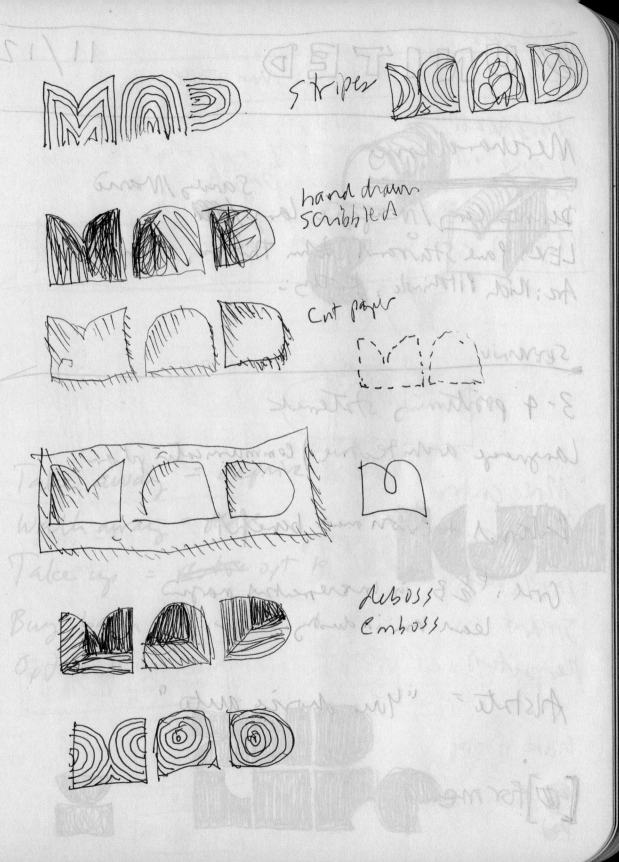

stripes

hand drawn
scribbled

cut paper

Emboss
Embossed

There is nothing glamorous about working out a layout grid, as I am reminded by my sketches for *Billboard*'s chart pages (see page 216).

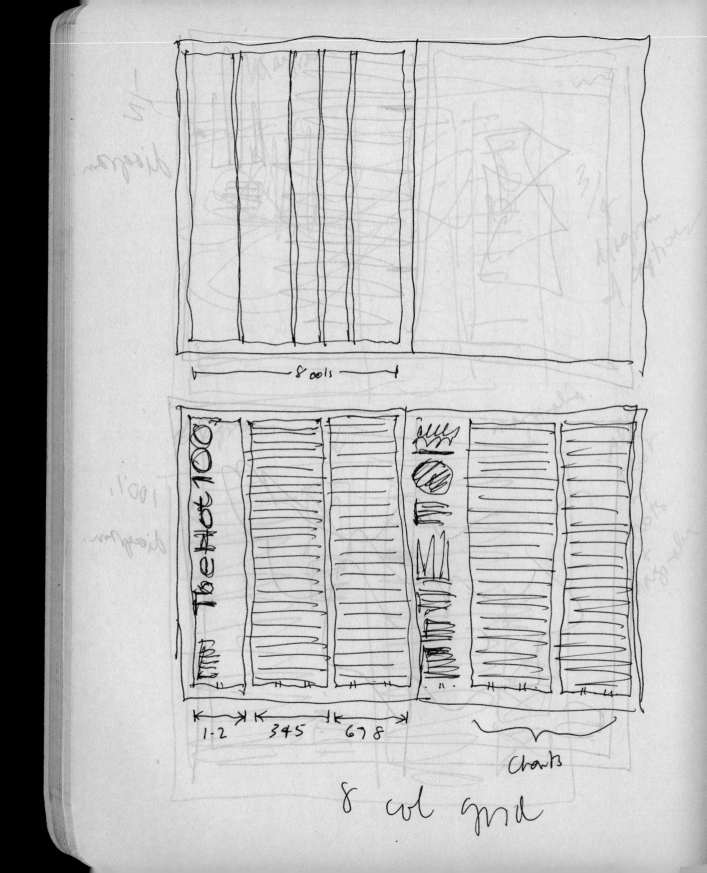

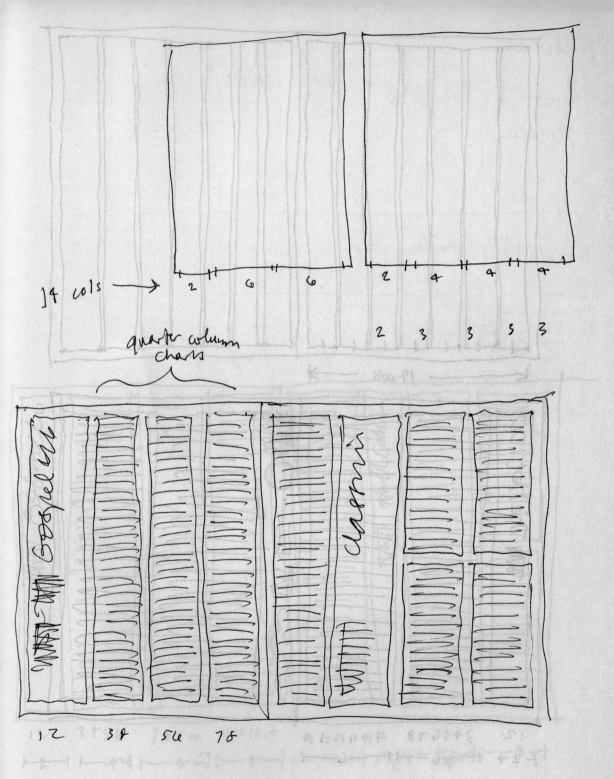

]4 cols → 2 6 6 2 4 4 4

2 3 3 3 3

quarter column
charts

Gospel Us Chopin

112 3 34 5u 75

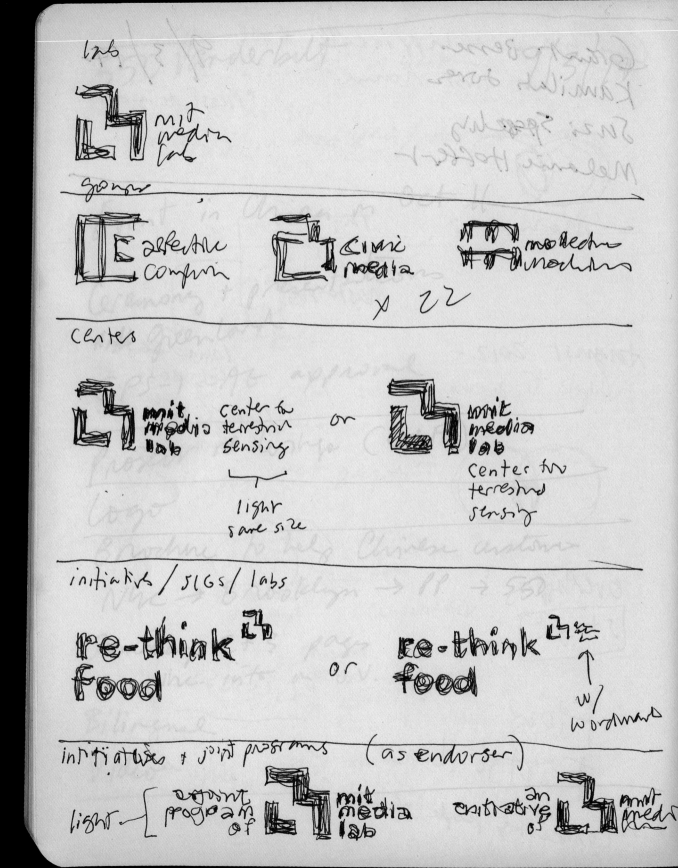

32

fellows

director program

omit
introduction
tab
director
fellows
program

UR

omit
introduction
tab

director
fellows
program

red

bold + red (or other color)
grey?

Right
After a number
of false starts,
I hit on a simple
concept for
a logo for
the Robin Hood
Foundation's
Library Initiative
(see page 306)
Generating
more ideas
than we would
ever actually
need reassured
me that we
were on the
right track

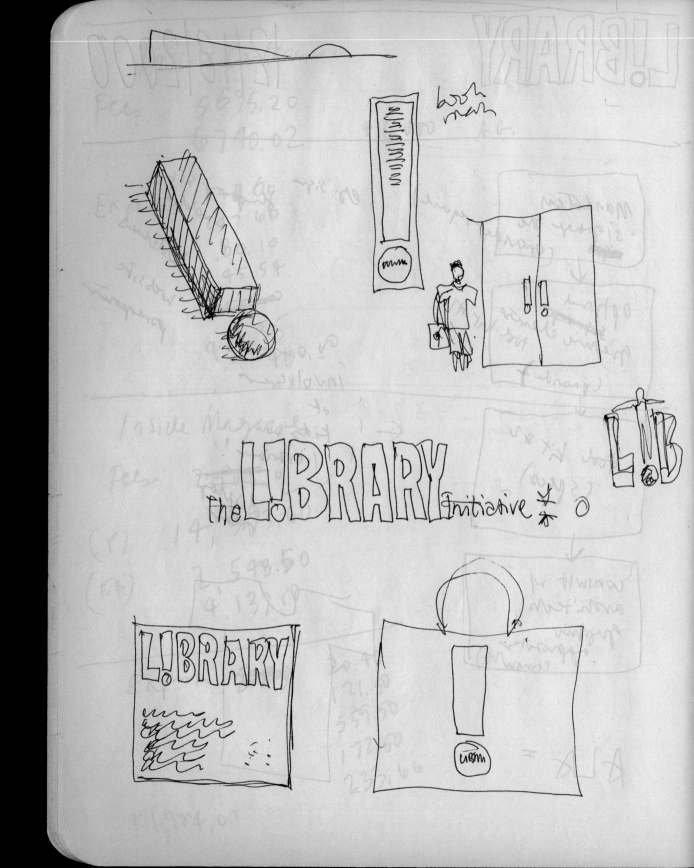

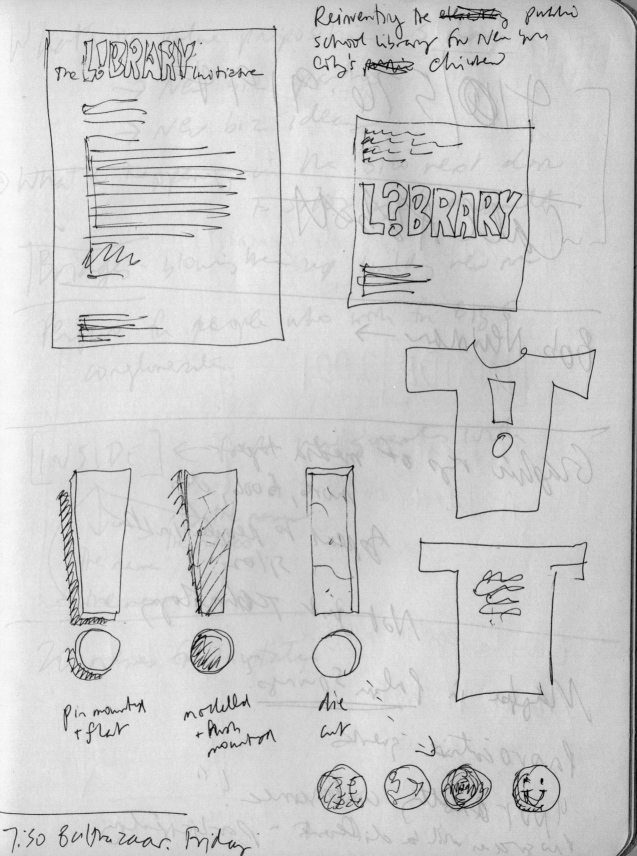

Reinventing the ~~elderly~~ public
school library for New York
City's ~~poorest~~ children

The LIBRARY initiative

L?BRARY

[INSIDE]

pin mounted
+ flat

modelled
+ flush
mounted

die
cut

7:50 Balthazaar. Friday

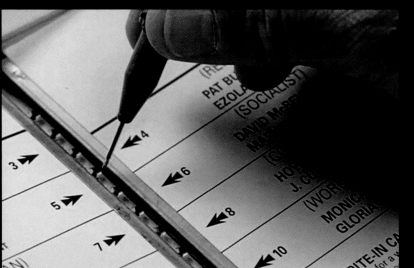

Left
The butterfly
ballot was
not a new
invention,
but its flaws
threw the
2000 election
into chaos.

Above
Theresa
LePore, the
21st century's
most influential
graphic
designer.

Below
It took more
than a month
to determine
the election's
outcome, still
disputed 15
years later.

How to destroy the world with graphic design
American Institute of Graphic Arts

It was the fall of the year 2000, and Theresa LePore had a problem. As supervisor of elections in Palm Beach County, Florida, she was not a trained graphic designer, but her challenge was one that every graphic designer in the world has faced: too much text, not enough space. In this case, the text couldn't be edited. It was the list of candidates for president and vice president in the upcoming national election. The format couldn't be changed. It was the ballot for the Palm Beach County voting machines, on which voters would register their choice by punching out a hole adjacent to the name of their preferred candidate.

But this year, there were too many candidates to fit in a single column. So LePore came up with a new layout. She alternated the names on either side of the holes, first on the left, second on the right, third on the left, and so on. This turned out to be a problem on election day. The first name on the left side of the ballot was George W. Bush. If you wanted to vote for him, you punched the first hole. Right under Bush's name was Al Gore's. But if you punched the second hole, you wouldn't be voting for Gore, but for archconservative Pat Buchanan, the first name on the right side of the holes.

Confused? You aren't alone. The *Palm Beach Post* later estimated that over 2,800 Gore voters accidentally voted for Buchanan. As it turned out, Florida's votes, counted and recounted over a month, decided the election's outcome. And Palm Beach County decided Florida's. Bush won the state by a margin of 537 votes. By this count, Theresa LePore's design gave the presidency to George W. Bush.

Compared with architecture and product design, graphic design seems ephemeral and harmless. Bad typesetting, as they say, never killed anybody. But in this case, the execution of a trivial, aggravating job—laying out a humble government form—ended up affecting the fate of millions around the world. It was such a dramatic demonstration that I made it into a poster for the American Institute of Graphic Arts.

Human beings communicate with words and images. Good graphic designers know how to make those elements effective. And every once in a while that really matters.

Palm Beach County, Florida		Official Ballot	November 7, 2000	General Election
Electors for President and Vice President Choose one group.			A vote for the candidates will actually be a vote for their electors.	
President	Vice President		**Political Affiliation**	
George W. Bush	Dick Cheney	▶	**1** Republican	
Al Gore	Joe Lieberman	▶	**2** Democrat	
Pat Buchanan	Ezola Foster	▶	**3** Reform	
Ralph Nader	Winona LaDuke	▶	**4** Green	
James Harris	Margaret Trowe	▶	**5** Socialist Workers	
John Hagelin	Nat Goldhaber	▶	**6** Natural Law	
Harry Browne	Art Olivier	▶	**7** Libertarian	
David McReynolds	Mary Cal Hollis	▶	**8** Socialist	
Howard Phillips	J. Curtis Frazier	▶	**9** Constitution	
Monica Moorehead	Gloria La Riva	▶	**10** Workers World	

Above
An alternate design, using the same format, demonstrates how confusion could have been avoided.

(REPUBLICAN)

ORGE W. BUSH - PRESIDENT

CK CHENEY - VICE PRESIDENT

(DEMOCRATIC)

GORE - PRESIDENT

E **EBERMAN** - VICE PRESIDENT

ARRY BROWNE - PRESIDENT

T OLIVIER - VICE PRESIDENT

(GREEN)

LPH NADER - PRESIDENT

NONA LaDUKE - VICE PRESIDENT

(SOCIALIST WORKE

MES HARRIS - PRESIDENT

ARGARET TROWE - VICE PRESIDENT

(NATURAL LAW)

Desig

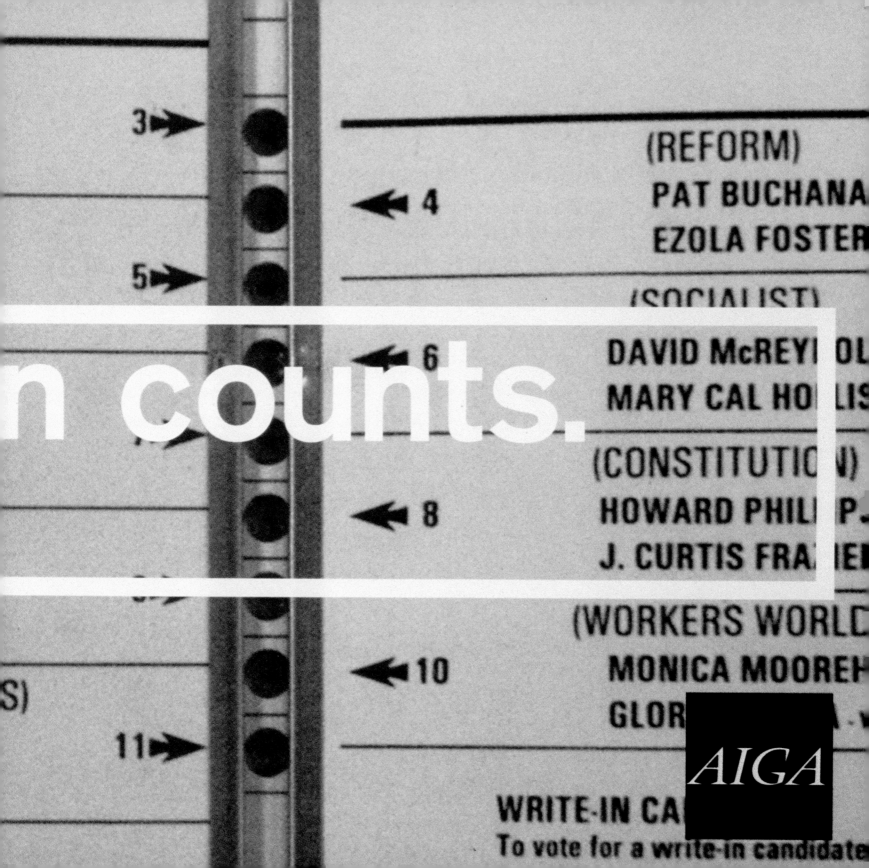

Progressive Architecture
International
Furniture Awards
May 14

NASA News for Now:
Space Planning
in Outer Space
June 4

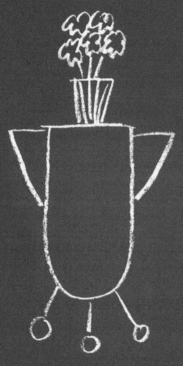

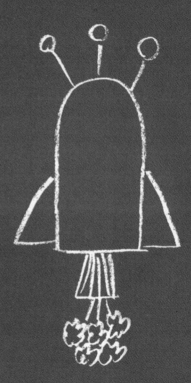

NASA News for Now:
Space Planning
in Outer Space
June 4

Progressive Architecture
International
Furniture Awards
May 14

How to have an idea
The International Design Center, New York

I had been working for Massimo Vignelli for four years, devoting my days to mastering what I thought of as "the Vignelli style": a few preapproved typefaces, two or three bright colors, and structural elements like lines and stripes, all deployed on a modular grid. I enjoyed mimicry and flattered myself with the delusion that Massimo couldn't tell the difference between my designs and his. Now he had entrusted me with a big client, a complex of furniture showrooms called the International Design Center, New York. We set the ground rules at the outset: the typeface, Bodoni; the color, PMS Warm Red. As long as I stuck to those ingredients, I was on my own.

I worked with the brilliant young marketing manager Fern Mallis, a quick-talking New Yorker who was my favorite client. She asked me to design invitations for two upcoming events: an exhibition of experimental furniture and a lecture by NASA scientists on designing spacecraft interiors. I was excitedly completing designs for both invitations (Bodoni, PMS Warm Red) when my phone rang.

It was Fern. "I'm afraid we just got our budget cut, and we can only afford one invitation. Can you combine them?" "No, of course not," I sputtered. The two subjects were completely different: end tables and outer space. No one will come to either event. Plus, I liked the designs I had already done.

Fern didn't budge. I hung up the phone in frustration. Clients! Would it never get easier? How was one supposed to work under these conditions? What were they expecting, something like this? Almost without thinking, intending to do nothing more than demonstrate the impossibility of the problem, I did a drawing. Viewed one way, it was a table and a vase of flowers. Upside down, a rocket ship. I was smart enough to realize this drawing was the answer.

Like everything else I did for this client, it was in Bodoni and PMS Warm Red. But people don't care about typefaces and colors. They are merely the delivery mechanisms for something else: ideas. And my drawing, crude as it was, was an idea, something with the capacity to surprise, engage, and amuse people. It was at that moment of scribbling I realized content is more important than form.

What is GOOD DESIGN.

IS it PROBLEM SOLVING?
Or is it the cooLEST Thing
You can make The client Buy??
IS IT TYPE ReveRseD out
of an oval?
Little books BOUND WiTh TWigs?
OLD clip ART xeroxed
up go peRcent?
FRANKLIN Gothic iN A LoT
of DiffereNT SiZeS ALL
Jammed ToGether.
What if oNE LeTTer is a
diFFereNT coLor?
Or maybe some EMiGRE
TyPe aBove a picture
of A chair?
ShouLD We LAyeR IN a
Quote from FoucauLt.
OR maybe GRoucho MaRX?

Is this Good DesigN?

or is it SomethiNG MoRE

CALL FOR ENTRIES
THE FIFTEENTH ANNUAL AMERICAN CENTER FOR DESIGN
ONE HUNDRED SHOW

ALEXANDER ISLEY, JILLY SIMONS, ERIK SPIEKERMANN, JUDGES
MICHAEL BIERUT, CHAIR

ENTRY DEADLINE: MAY 1, 1992

DESIGN: MICHAEL BIERUT / PENTAGRAM
LETTERING: ELIZABETH ANN KRESZ BIERUT / TRANSFIGURATION SCHOOL

How to transcend style
American Center for Design

When style is referred to in design circles, it's usually disparagingly. Most designers claim to "have no style," inventing new approaches for each assignment. Original design work is said to be reduced to "mere style" by those who imitate it. Shallow cosmeticians are dismissed by their critics as trafficking in "nothing but style."

Yet in any artistic activity style is inescapable. This is particularly true in graphic design, where the functional requirements of most projects are minimal. A business card has to bear legible type and fit in a wallet. After that, all the decisions—typeface, color, layout, material, production technique—are bafflingly arbitrary, what regular people call "a matter of taste." But ask a designer about the last time a meeting degenerated into a taste discussion. It was probably yesterday, and the memory will not be pleasant.

In the early 1990s, still fresh from my ten years at Vignelli Associates, I was desperate to find my own voice, and at a total loss as to how to do it. With the design world roiled by change, from the typographic daring of *Emigre* to the experimental invention of Cranbrook and CalArts, I brooded about the seeming impossibility of moving beyond style. Consumed as I was with soul searching, it was ironic to be asked to chair the world's most progressive (and stylish) design competition, the American Center for Design's 100 Show, and create the poster that would invite my fellow designers to participate. Predictably, weeks of paralysis followed. An increasingly panicked ACD staff wondered if I was up to the task. Finally, I was asked to at least write the statement that would appear on the announcement's reverse side. I responded with a stream of consciousness that would have been better suited to an analyst's couch. They liked it, and suggested I simply run the text on the front of the poster. Ah, an all-type solution.

But what typeface? The decision was now reduced to its toughest core. Should I pander to the trendsetters with a newly designed grunge font? Hold strong with the modernists with Helvetica? Or play it safe with Garamond No. 3? At the last possible moment, the solution hit me. I dictated the text, letter by letter, to my four-year-old daughter Elizabeth. The innocence of the form vanquished the weary cynicism of the content, and I was free at last.

Kronos Quartet
Chinoiserie
The Whispers of Angels
The Duchess of Malfi
Mark Morris Dance Group

How to create identity without a logo
Brooklyn Academy of Music

When the Brooklyn Academy of Music, the oldest continuously operating performing arts center in the United States, fell on hard times in the 1960s, it was saved by a young visionary, Harvey Lichtenstein, who remade it as a destination for the global avant-garde. Lichtenstein's Next Wave Festival stole the standard of progressive performance from Manhattan, and launched an unstoppable revival of Brooklyn that continues to this day.

In 1995, after years of experimenting with different graphic approaches for the Next Wave, BAM asked us to create something permanent. ("You don't keep changing the Marlboro Man," said board member Bill Campbell, longtime head of marketing for Philip Morris.) From now on, they wanted everything—from a poster to a 36-page subscription mailer to a small-space ad—to simply look like BAM. What they didn't want was a logo.

I was inspired by the legendary midcentury advertising art director Helmut Krone. "I've spent my whole life fighting logos," he once said. "A logo says, 'I am an ad. Turn the page.'" Instead, he created indelible identities for his clients by making distinctive choices and deploying them relentlessly, most famously on behalf of Volkswagen, still using the combination of Futura and white space that he introduced in his "Think small" ad in 1959.

So I hit on the idea of using one typeface, workhorse News Gothic, but with a twist: we would cut the type off, as if it couldn't fit in the frame. As I explained to Harvey and his colleagues Karen Brooks Hopkins and Joe Melillo, this suggested that BAM crossed borders and couldn't be contained on a single stage. But it was economical, too, allowing us to use four-inch-tall letters in two inches' worth of space. It was like seeing King Kong's eye in your bedroom window, I explained. Even if you couldn't see the whole beast, you knew it was big.

The new look for the Next Wave launched in 1995. The idiosyncratic headline treatment (dubbed "Cuisinart typography" by BAM's longtime architectural consultant Hugh Hardy) was disorienting at first. Twenty years later, it is inextricably linked to BAM.

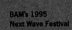

BAMbill

The Brooklyn Academy
of Music

Brooklyn Academy of Music

BAM

Brooklyn
Academy
of
Music

BAM

30 La...
Brook...
Teleph...
Fax: 7...

**BAM's 1995
Next Wave Festival**

Robert Wilson
Tom Waits
Vito Acconci
Kristin Jones & Andrew Ginzel
Ilya Kabakov
Don Byron
Bill Frisell
Vernon Reid
Steven Berkoff
Cloud Gate Dance Theatre
Carl Dreyer
Richard Einhorn
The Camerata Chorale
Brooklyn Philharmonic
Kronos Quartet
Ping Chong
David Rousseve / REALITY
Cheek by Jowl
Mark Morris Dance Group

ee
tickets
to the **15th**
Anniversary of
the BAM Next
Wave Festival

New Wave

Light

95

guid

Music

Brooklyn
Academy
of
Music

30 Lafayette Avenue
Brooklyn NY 11217
Telephone: 718.636.4122
Fax: 718.857.2021

Stephen P. Millikin
Audience Development Manager

BAM

**Mark Morris
Dance Group**

**Brooklyn Academy of Music
1995 Next Wave Festival
Is sponsored by
Philip Morris Companies Inc.**

For tickets call TicketMaster
212.307.4100
For information call BAM
718.636.4100 .
BAM Prefers VISA

Brooklyn
Academy
of
Music

30 Lafayette Avenue
Brooklyn NY 11217
Telephone: 718.636.4100
Fax: 718.857.2021

BAM

er while the famous gas lamps are burning

s–Sat, 5–7pm, $19.96

Live Piano Music
(718) 875-5181
ds accepted

Based on Alice's
Adventures in Wonderland
and Through the Looking-Glass
by Charles Dodgson
(a.k.a. Lewis Carroll)

Brooklyn Academy
of Music
October 6 at Tom
October 7,
10–14 at Bonz
October 8 at 3pm

The late design genius Tibor Kalman was once asked to design a brand identity for a museum. Rather than designing a logo, he handed the client a book of typefaces and said to simply pick one and use it over and over again: if they did that long enough, they'd have an identity. He was right. I'm convinced the most important characteristic for a great brand is consistency. This is different from sameness. Sameness is static and lifeless. Consistency is responsive and vibrant. Working with, yes, just one typeface, BAM is a model of consistency.

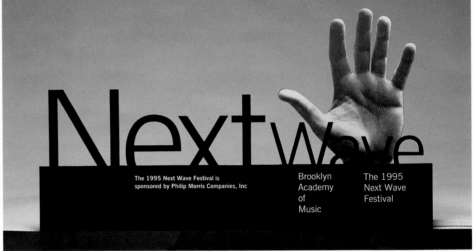

The 1995 Next Wave Festival is
sponsored by Philip Morris Companies, Inc

Brooklyn
Academy
of
Music

The 1995
Next Wave
Festival

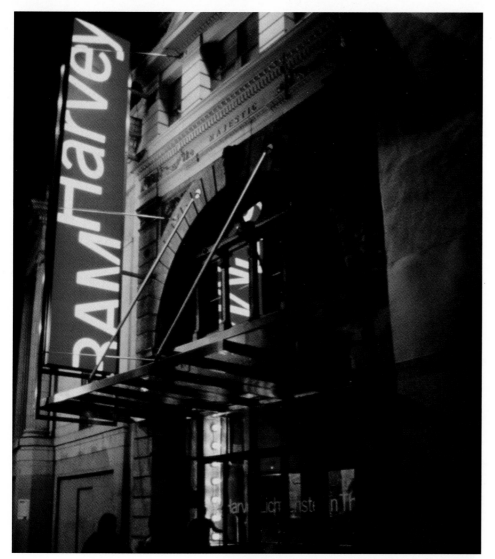

Left top
The Majestic Theatre was renamed the BAM Harvey Theater when Lichtenstein retired in 1999.

Left bottom
Even the BAM bathroom icons are subject to chopping.

Below
After resisting creating a logo for several years, we finally made one using BAM's signature typography. The guidelines for use, created by designer Emily Hayes Campbell and only six pages long, are still faithfully followed.

Next spread
Contemporary lettering collides with the BAM Opera House's century-old Beaux-Arts details.

Brooklyn Academy of Music

30 Lafayette Avenue
Brooklyn NY 11217
Telephone: 718.636.4131
Fax: 718.636.4171

M. Lourdes Marquez
Associate Director of Sponsorship

BAM

Men's Room

49

opera

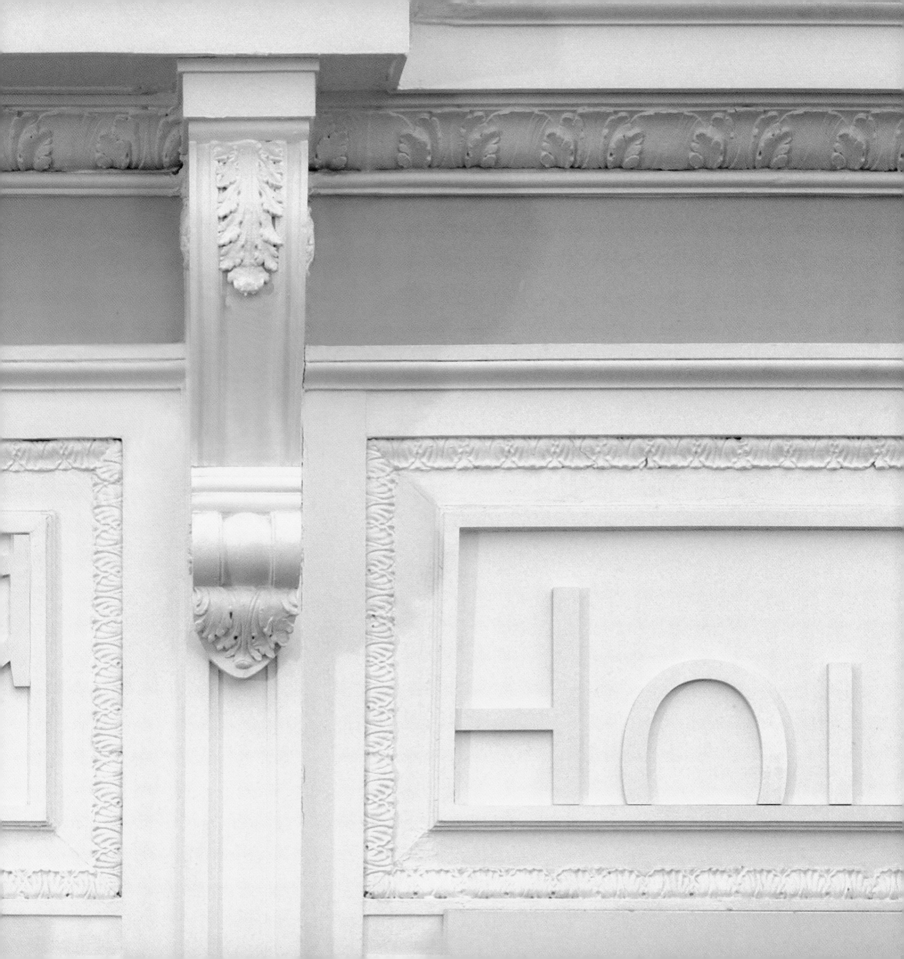

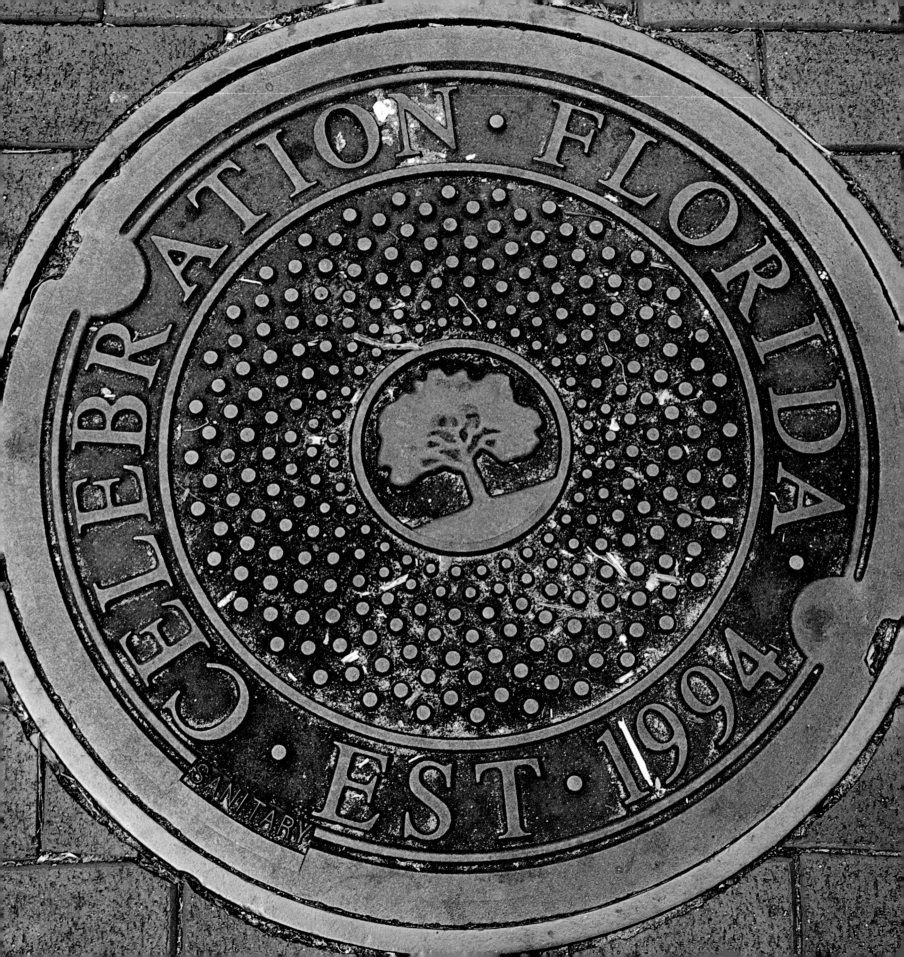

How to invent a town that was always there
Celebration, Florida

Opposite
Our designs
in Celebration,
Florida, are
ubiquitous,
including
places that
usually escape
notice,
like manhole
covers.

Above
Walt Disney's
original dream
to create
a futuristic
utopia in
central Florida
morphed
into a theme
park, the
Experimental
Prototype
Community
of Tomorrow
(EPCOT), which
opened in
1982. A dozen
years later,
Celebration,
built on
considerably
different
theories,
broke ground.

If you drive down Interstate 4 in central Florida, exit on Route 192, and make a right turn at a long white fence, you will enter another world. Traditional houses with front porches on small lots set close to the street. A town center with the scale of a classic Main Street, small shops lining the sidewalks. Parks and schools within an easy walk. It is utterly unlike the world of parking lots and warehouse stores that surrounds it, and it is all about twenty years old. This is Celebration, Florida.

In the early 1990s, the Walt Disney Company decided to take 5,000 acres of land it had acquired around its theme park properties and try something new: residential development. CEO Michael Eisner was passionate about design, and he enlisted architects Robert A. M. Stern and Jaquelin Robertson to plan the project. They proposed a large-scale experiment in New Urbanism, design principles that call for planning small-scale, mixed-use communities similar to towns familiar from a century ago. Among the traditional homes are public buildings by some of the most famous architects in the world: a town hall by Philip Johnson, a post office by Michael Graves, and a bank by Robert Venturi and Denise Scott Brown.

It was our job to create all the graphics: the street signs, the names over the shops, the markings at the holes at the public golf course, even the manhole covers. Authenticity is a tricky thing, especially for a graphic designer. We are not just creators of form but communicators of ideas. This requires fluency in a common language, an ability to manipulate elements that are widely, if subconsciously, understood—typefaces, colors, images. There is a reason a sign in an airport looks different from a sign on a small town street corner. To create graphics that 7,500 people would have to live with, day in and day out, was a challenge. Our goal in Celebration was to become part of the scenery.

I have worked with many idealistic clients, but none more so than the team that created Celebration. We were inventing a new world, and it was thrilling. Today the town is not so new anymore. And the older it gets, the more I like it.

Below
Towns don't have logos, but they do have seals. The Celebration seal created by Pentagram Associate Tracey Cameron was meant to invoke the quintessential American small town. It was also made into a wristwatch on which, once a minute, the dog overtakes the girl cyclist (see opposite, bottom right).

Right and opposite
Our graphics were designed to be approved by some of the world's best architects, including Robert A. M. Stern, Robert Venturi and Denise Scott Brown, Cesar Pelli, Michael Graves, and Philip Johnson. It was a bit of luck that our recommendation for the town's official typeface was created by an architect:

Cheltenham, designed by Bertram Goodhue in 1896. Classic without being fussy, available in multiple weights and versions, it was used on everything from painted signs to cut metal details to a fence that enclosed a 40-foot live oak at the community's entrance.

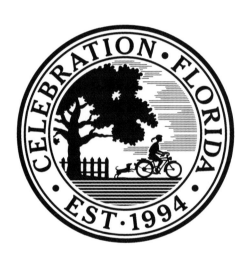

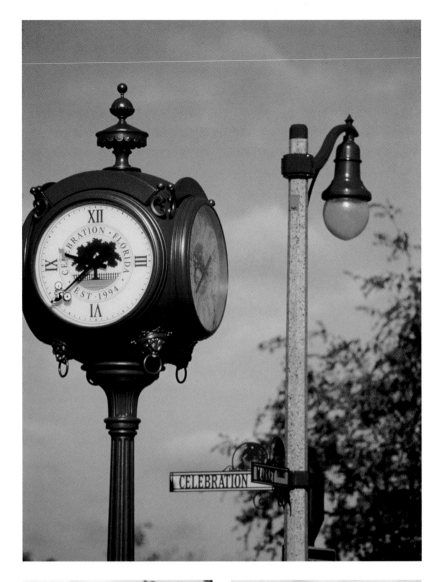

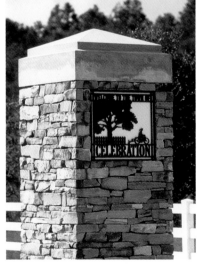

Celebration, Florida

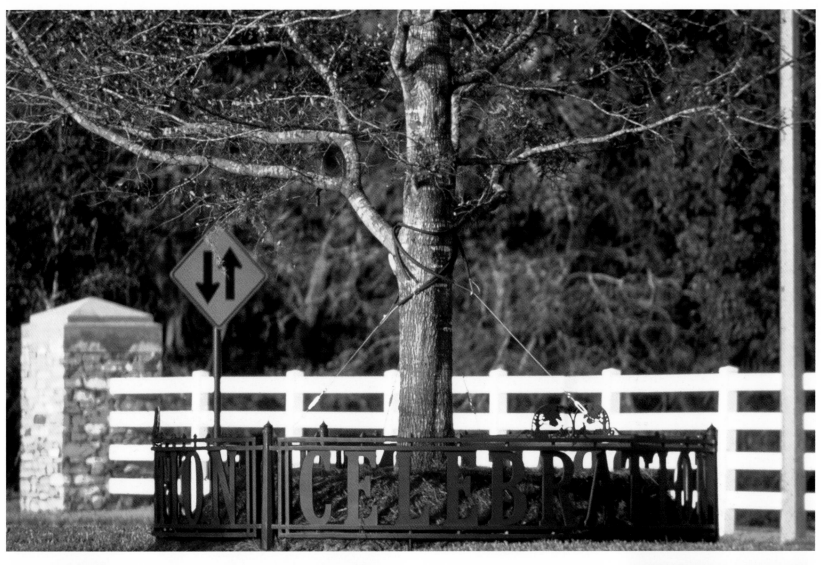

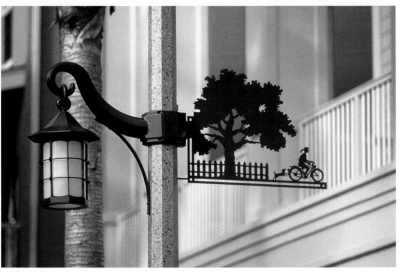

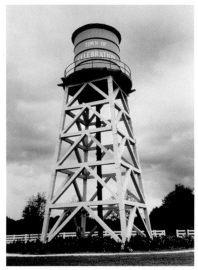

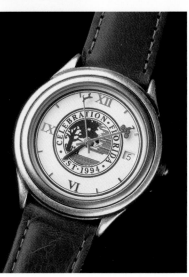

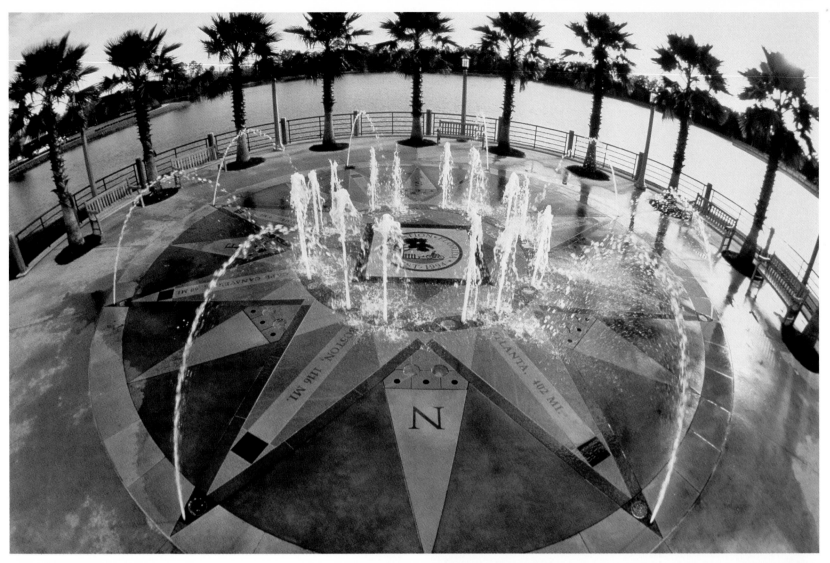

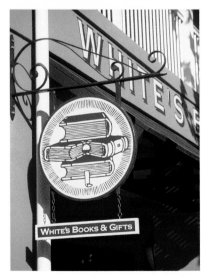

Celebration, Florida

Opposite top
Our graphics included the design of a fountain in the heart of Celebration's shopping district, with compass points connecting the community to the rest of the world.

Opposite bottom
Overlaying the consistency of the town's infrastructure were the signs for the town's retailers. Whereas street signs and manhole covers used a consistent visual language, store signs explored the history of American vernacular signage, from neon to woodcarving to mosaic tile.

Right top
The town's movie theater, a stylish contemporary take on American Moderne by Cesar Pelli, is a landmark that bears the town's name on its twin masts.

Right bottom
Designing the graphics for Celebration's public golf club was much harder than designing the town seal. It took me some time to realize why: none of our clients were Schwinn-riding, ponytailed girls, but most of them were enthusiastic golfers. The silhouette on the golf club sign was refined endlessly as various executives demonstrated their swings in client meetings.

Next spread
Ironically, the town that celebrates Main Street values has no Main Street itself. (There was already another street with that name in Osceola County.) Instead, the central thoroughfare is called Celebration Avenue.

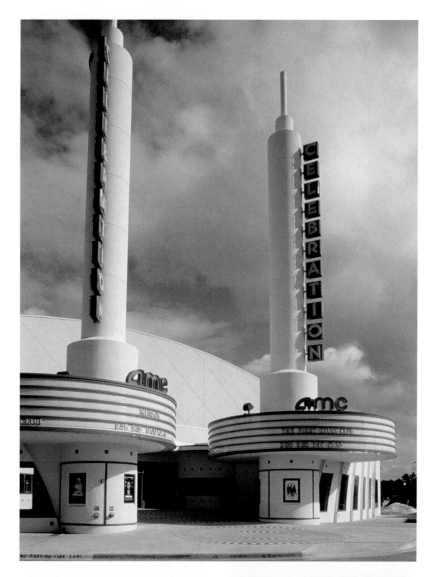

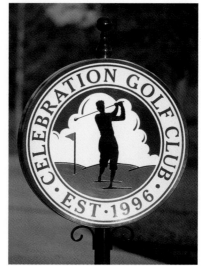

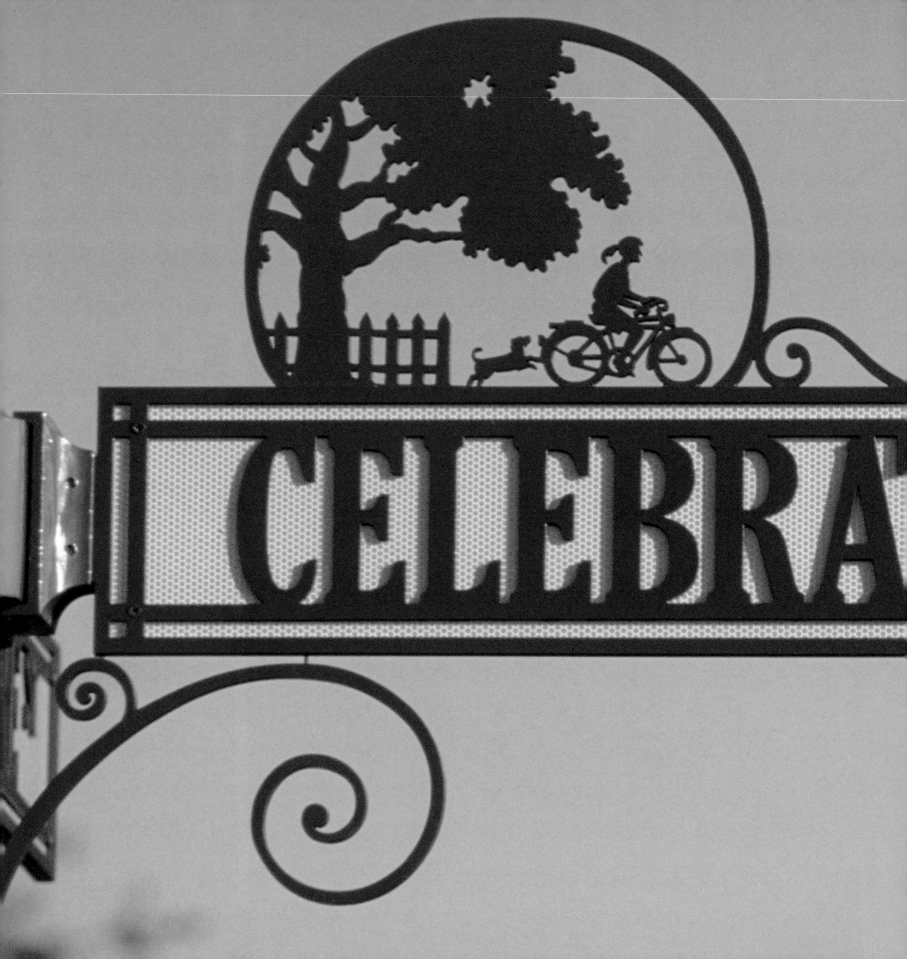

How to work for free
Parallax Theater

Victor D'Altorio was the best actor in my high school. He was in every play our school mounted, and if not in the starring role, at least in the hammiest one: Captain Hook in *Peter Pan*, Boris Kolenkhov in *You Can't Take It with You*, Malvolio in *Twelfth Night*. I did the posters.

After college, he arrived in New York to look for work as an actor as I was just starting out as a designer. Before long, I got a call. "Hey, Mike?" he asked. (Only my family and oldest friends still call me Mike.) "We're putting on a show. Could you do the poster?" I said, sure. He told me they didn't have much money. I said, don't worry about that.

Victor would never hit the big time as an actor. But he became a beloved teacher and a sometime director, first in New York, then Chicago, and ultimately Los Angeles. And I designed every one of his posters for free. The Internet is filled with designer rants about the corrosive evils of free work. I love working for free, especially under the unspoken terms that governed the relationship I had with Victor.

First, the work was fun. Victor would explain what the play was about in two sentences, and would send me the text that had to go on the poster. The explanation was always vivid and inspiring, and the text was always complete and free of typographical errors. Second, after receiving my design, Victor would permit himself a single question: "How can I thank you?" Finally, he never promised me exposure to movie stars on opening night or high-paying jobs down the road. I think as an actor, he understood what so many clients don't: that for a creative person, the real reward is to simply do the work. Getting a "Hey, Mike?" call from Victor meant I'd have one more chance to do my best.

Sadly, I won't get that call again. Victor died, too young, in 2009.

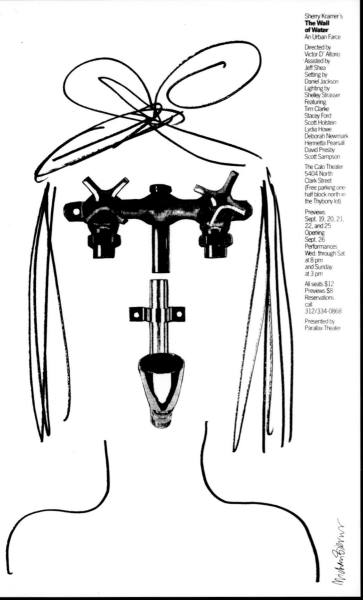

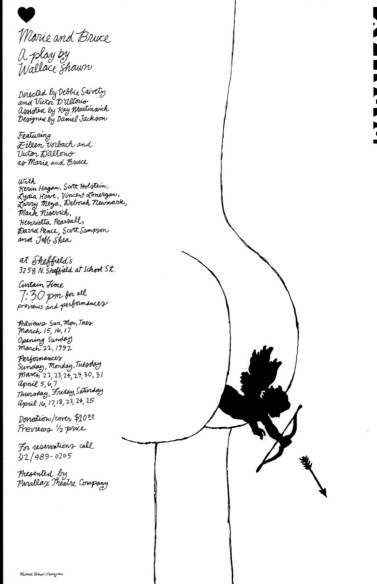

Above

The Wall of Water is a farce about four female roommates living in a small apartment with a single bathroom who gradually drive each other crazy. The challenge was to make the visual connection between neurosis and indoor plumbing.

Above

Wallace Shawn's play *Marie and Bruce* is one of the funniest, darkest, and most scatological portraits of a dysfunctional relationship ever put on stage. For many years, this poster hung in one of Pentagram's bathrooms.

FOOL *for* LOVE.

A PLAY *by* SAM SHEPARD.

Directed *by* Victor D'Altorio.
Setting *by* Daniel Jackson. Lighting *by* Lee Kennedy.
Costumes *by* Amy Carlson. Sound *by* Chris Olson.
With Neil Flynn, Henrietta Pearsall, Thom Vernon & Tom Webb.

Chicago Actors Ensemble (*in the* Preston Bradley Center).
941 West Lawrence, Fifth Floor. (Free parking in lot east of building.)
First preview, Thursday, June 4. Opening night, Sunday June 7, 1992.
Performances, Thursday, Friday, Saturday, Sunday *at* 8 pm through July 12.
Tickets $10.00. Previews $7.00. Senior and student discount $8.00.

Presented *by* PARALLAX THEATER COMPANY.
For reservations, *call* (312) 509-8172.

PARALLAX

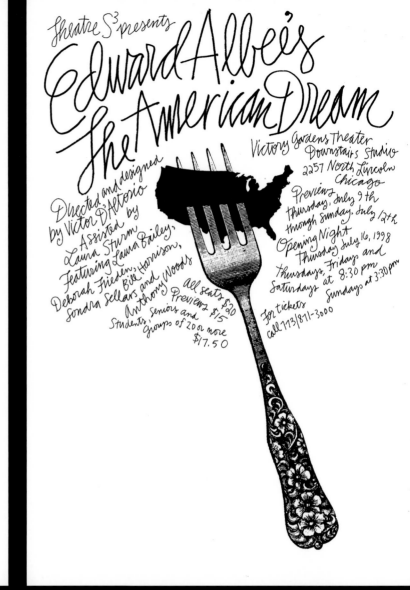

Design: Fons Hickmann

Above
For some reason, many of Victor's productions seemed to revolve around broken or mutually abusive relationships, including Sam Shepard's *Fool for Love.*

As with most Parallax productions, I took pleasure in contrasting the name of the play with the grim brutality suggested by the illustrations.

Above
America's obsession with consumption meets a delicate whisper of mutilation in Edward Albee's classic, and ironically titled, play *The American Dream*.

Parallax Theater presents

TheBabysitter

A short story by Robert Coover.
Designed and directed by Victor D'Altorio.
Adapted by Victor D'Altorio and Henrietta Pearsall. Lighting by Rand Ryan.
Performed by Keith Bogart, T. L. Brooke, Winifred Freedman, James C. Leary, John Eric Montana, Rhonda Patterson, Henrietta Pearsall & Darin Toonder.
McCadden Place Theater at 1157 North McCadden Place, one block east of Highland between Santa Monica and Fountain.
Thursdays, Fridays & Saturdays at 8pm. Previews Thursday, January 6,7,8,13. Opening night Friday, January 14, 2000.
All seats $20, previews $14. For tickets 323/960-7896.

PARALLAX

How to raise a billion dollars
Princeton University

Opposite
For the theme of its biggest fundraising effort to date, Princeton looked to the words of its alma mater. "With One Accord" was the result.

Above
At the campaign launch, giant banners in the school colors of orange and black flanked the doors to Nassau Hall, the oldest building on campus and the song's subject.

One day, after I had been at Pentagram a few years, I got a call from a former client, Jody Friedman. She had just gotten a new job doing something called "development communications" at her alma mater, Princeton. She said they were about to launch a capital campaign and asked if I could help.

I didn't know what development communications were, I didn't know what a capital campaign was, and I had never set foot on the campus of Princeton University. Jody patiently explained to me that this was all basically about fundraising. I got uneasier. As someone who had spent his career working like a plumber (my customer needed something done, I figured out how much it would cost, the customer agreed, I did the work, the customer paid), the idea of making money by simply asking for it was absolutely foreign.

Secretly, I was scared of venturing into unknown territory, and preemptively intimidated by the very smart, very well-educated people I was sure to encounter. I tried to back out, but Jody was persistent. I agreed, and learned an obvious lesson: your best chance to grow is to do something you don't know how to do. My clients at Princeton were wonderful guides, and initiated me in the mysterious world of university fundraising. We devised a theme and a graphic treatment. I created some innovative pieces of communication not because I was daring or imaginative, but simply because I didn't actually know how such things were usually done. Not being familiar with the ritualized ways of asking for money, I simply portrayed the university in a way that its alumni would recognize as authentic, and asked for their support. They responded. It helped that the economy was booming. The campaign's goal was $750,000; it raised $1.2 billion.

Graphic design, where form is so dependent on content, is a perfect way to learn about the world. My projects have put me at laboratory benches with microbiologists and in locker rooms with professional football players. I design best when I'm interested in the subject matter. As a result, I've learned to be as interested in as many things as possible.

WITH ONE DIRECTION

WITH ONE GOAL

WITH ONE FOUNDATION

Above
A small book
designed by
Pentagram's
Lisa Cerveny
hinted at the
campaign to
come by finding
number ones
on and around
campus, from
cornerstones to
street signs.

Above
A graphic
program
devised by
Princeton-
educated
designer Bill
Drenttel with
his partner
Stephen Doyle
had designated
Baskerville
as the school's
typeface.

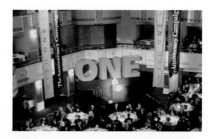

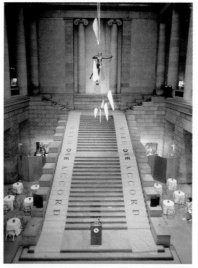

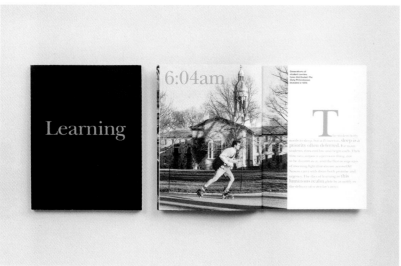

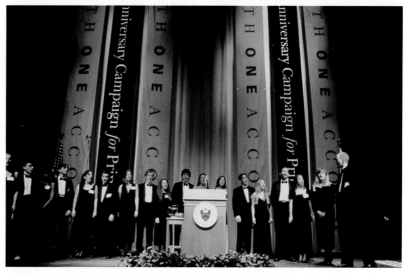

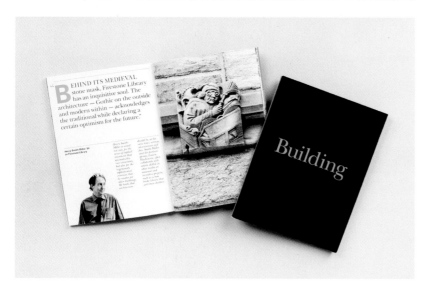

Left top, middle, and bottom
Three small paperbacks, modestly printed in black and white, replaced the ponderous tomes that were then the default way to raise money for schools in the early 1990s. *Teaching* focused on beloved professors on campus and raised money to support the faculty. *Learning* traced a day in the life of five students and made the case for scholarships. *Building* interviewed the distinguished architects who were working on campus and built support for new facilities.

Above
Launch events for the campaign around the country turned the graphic identity into celebratory pageantry. A huge, three-dimensional "ONE" traveled with the school's vocal groups and served as instant photo opportunities for proud alumni.

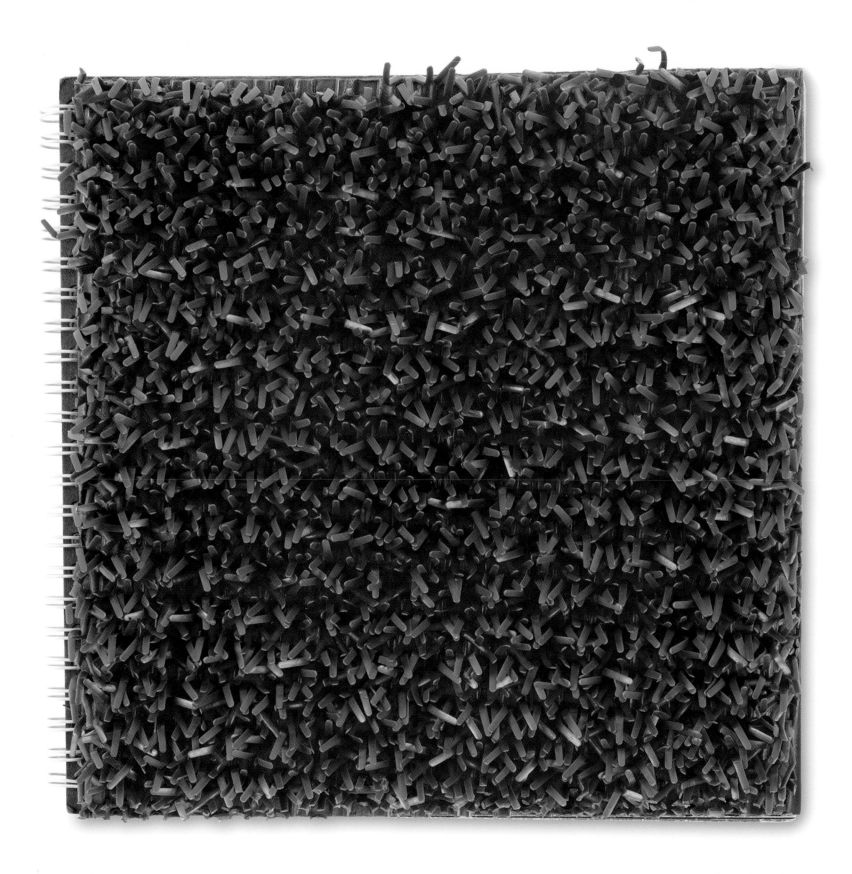

How to win a close game
New York Jets

In 2001, we got a call from Jay Cross, then president of the New York Jets. Probably the only person in sports management with degrees in both architecture and nuclear engineering, Cross had an assignment with a catch. The assignment was to rebrand the team. The catch? We couldn't touch the logo.

The New York Jets are a media-age invention. Founded in 1959 as the New York Titans, the team changed its name and logo in 1963. The Jets had one indelible moment of glory six years later when the glamorous quarterback Joe Namath led them to an upset victory in Super Bowl III. Since then, the team has been a reliable source of heartbreak to its loyal fans, with a rotating cast of colorful players and outspoken coaches who could never quite regain the heights attained in 1969.

Probably no genre of graphic design is more fraught with emotion than the design of identities for sports teams. If you change a logo for a bank, no one will notice. If you change a logo for a football team, you will get hate mail. The logo that Namath and his teammates wore to the Super Bowl was thought to have totemic power. (Identity design is one of the few professions in which magical thinking qualifies as a business strategy.) As we undertook our work, it was this original logo, now sacrosanct, drawn by an anonymous artist four decades ago, that we were stuck with. This is what designers call a "cat's breakfast": the name of the team in one typeface, superimposed upon the initials NY in another typeface, a tiny football underneath, all placed on another football shape. We made it our starting point.

It turned out that for all its messiness, the logo was a source of endless inspiration. The four letters in the team name could be extrapolated into a proprietary alphabet. The letters NY, superimposed on the football shape, became an immediately identifiable alternate logo. Even the tiny football turned out to be a character we could bring to life. Combined with an expanded color range and a few other graphic devices, the logo provided the Jets with a whole new identity, one that is still in use more than a dozen years later.

Printed standards manuals, once ubiquitous, have been largely replaced by online tools. Yet a physical document can convey a level of authority that a website cannot, particularly if it's made simple and memorable. The book that introduced the new graphic identity for the Jets, bound with hard-to-ignore artificial turf, was meant to provide both instruction and inspiration.

Below
The Jets had already updated their logo once before, introducing an aerodynamic version, not shown here, in 1978. The fans viewed it with suspicion if not outright distaste.

Twenty years later, in an attempt to evoke the glory of the Namath years, coach Bill Parcells reinstated the original logo. It was the unlikely source of the whole brand system.

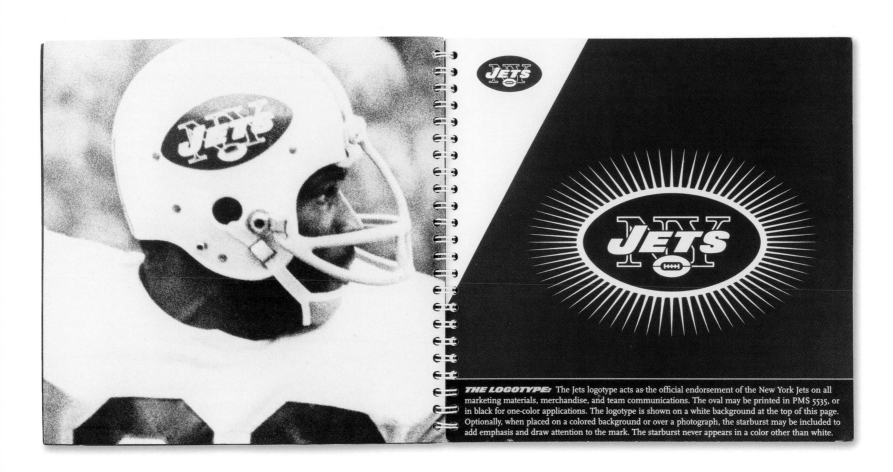

THE LOGOTYPE: The Jets logotype acts as the official endorsement of the New York Jets on all marketing materials, merchandise, and team communications. The oval may be printed in PMS 5535, or in black for one-color applications. The logotype is shown on a white background at the top of this page. Optionally, when placed on a colored background or over a photograph, the starburst may be included to add emphasis and draw attention to the mark. The starburst never appears in a color other than white.

New York Jets

Below
Working with
the letters
J, E, T, and S,
type designers
Jonathan
Hoefler
and Tobias
Frere-Jones
created a
complete
typeface. It
exists in
only one form:
extra heavy
super italic.

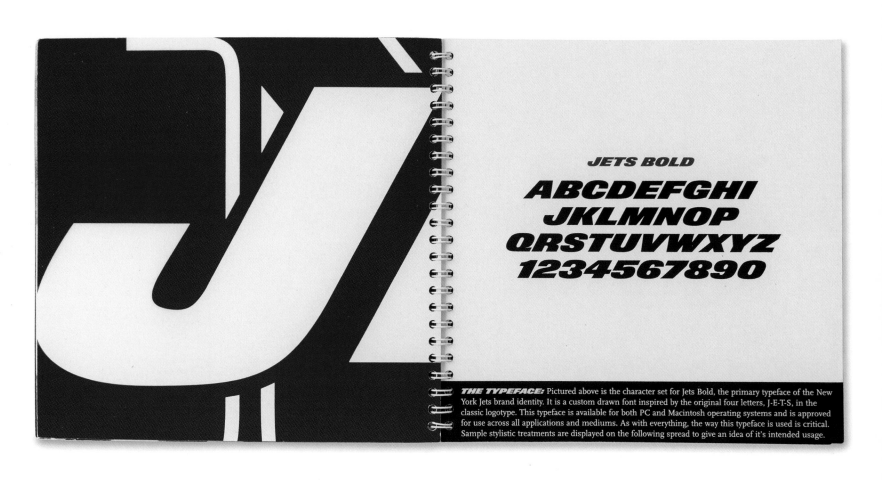

JETS BOLD

**ABCDEFGHI
JKLMNOP
QRSTUVWXYZ
1234567890**

THE TYPEFACE: Pictured above is the character set for Jets Bold, the primary typeface of the New York Jets brand identity. It is a custom drawn font inspired by the original four letters, J-E-T-S, in the classic logotype. This typeface is available for both PC and Macintosh operating systems and is approved for use across all applications and mediums. As with everything, the way this typeface is used is critical. Sample stylistic treatments are displayed on the following spread to give an idea of it's intended usage.

Right
The new typeface, Jets Bold, made any word look intimidating. Jonathan and Tobias used to joke that it would be perfect for Michael Bay movie posters.

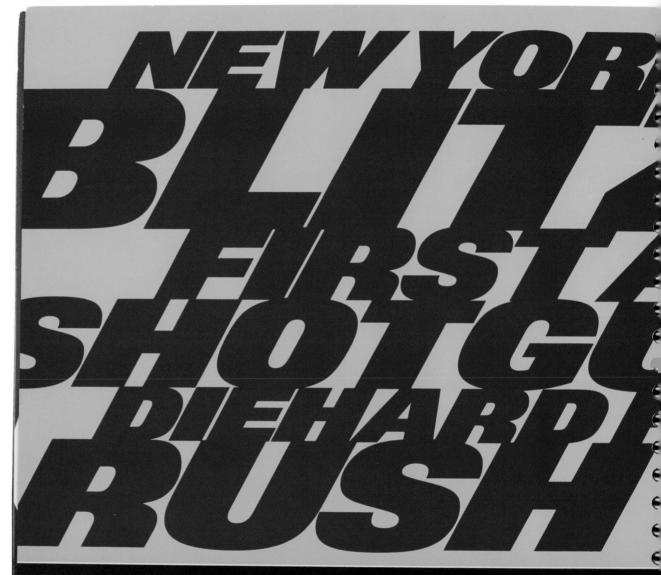

TYPOGRAPHIC STYLE: The vocabulary of football is rich with hard-hitting, descriptive terms such as those displayed above. Whether it be for a promotional flyer for a Jr. Jets event, or the design of stadium graphics, it's use instantly adds an unmistakable New York Jets flavor. It is intended primarily as a display typeface for headlines and titles, but works well at both small and large sizes. It is also extremely legible for a typeface of such angle and weight. Do not stretch, or otherwise manipulate the letterforms.

New York Jets

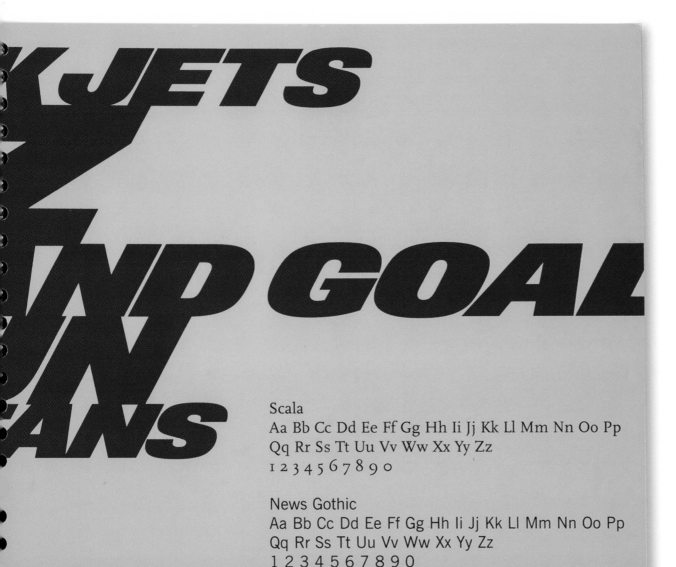

K JETS

ND GOAL

N

ANS

Scala
Aa Bb Cc Dd Ee Ff Gg Hh Ii Jj Kk Ll Mm Nn Oo Pp
Qq Rr Ss Tt Uu Vv Ww Xx Yy Zz
1 2 3 4 5 6 7 8 9 0

News Gothic
Aa Bb Cc Dd Ee Ff Gg Hh Ii Jj Kk Ll Mm Nn Oo Pp
Qq Rr Ss Tt Uu Vv Ww Xx Yy Zz
1 2 3 4 5 6 7 8 9 0

SUPPORTING TYPEFACES: As a complement and support to the primary typeface, two additional fonts have been specified. These supporting typefaces increase functionality and are intended for use at smaller point sizes. Do not use them in large headlines or titles. Scala is a good choice for body copy and longer narratives, such as in Jetstream, or the Yearbook. News Gothic works well for charts, statistics, and other technical applications. Bold and italic weights are also available within these font families.

Next spread, top left
Fans are as obsessed with color as they are with logos. We very carefully introduced several complementary colors to the green-and-white Jets palette.

Next spread, top right
Designer Brett Traylor discovered a fierce linesman hidden in the tiny football within the logo, and a new mascot, "Gameface," was born.

Next spread, bottom left
Unlike that of their crosstown rivals, the New York Giants, the Jets logo failed to highlight the team's highly marketable hometown. We remedied this with an alternate logo that put the initials NY, set in Jets Bold, inside the football shape created by the logo.

Next spread, bottom right
The brand system, derived as it is from a common source, is designed to permit maximum variety while remaining close to the team.

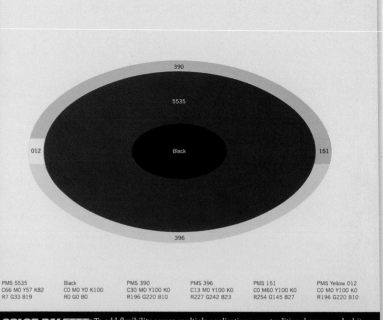

PMS 5535
C66 M0 Y57 K82
R7 G33 B19

Black
C0 M0 Y0 K100
R0 G0 B0

PMS 390
C30 M0 Y100 K0
R196 G220 B10

PMS 396
C13 M0 Y100 K0
R227 G242 B23

PMS 151
C0 M60 Y100 K0
R254 G145 B27

PMS Yellow 012
C0 M0 Y100 K0
R196 G220 B10

COLOR PALETTE: To add flexibility across multiple applications, our traditional green and white palette has been expanded to include other colors as well. Consistent color usage across the brand is maintained by following these rules: PMS 5535 should represent at least 50% of all applied color within any application. Up to 40% may feature PMS 390 or 396. Yellow 012 and PMS 151 should represent no more than 10%. Black, white, photography, and illustration are not calculated as part of applied color.

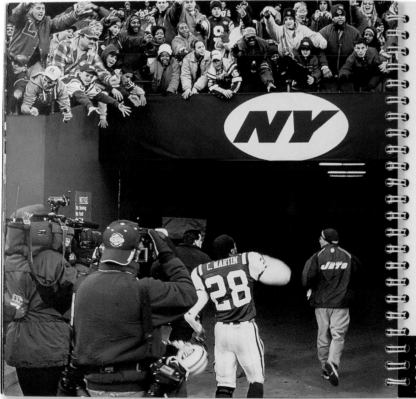

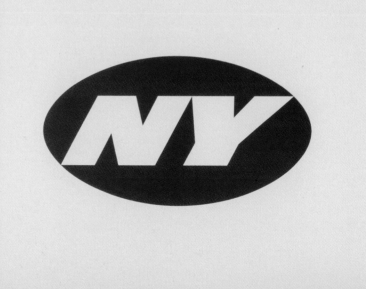

THE MONOGRAM: The monogram acknowledges and honors the great city and state for which we play. It features the distinctive Jets Bold typeface within the familiar oval shape of our logotype. The oval may appear as PMS 5535, 390, 396, black, or white. When the oval appears in PMS 5535 (shown here) or black, the NY letterforms within it are white. For dark backgrounds, the oval may appear in PMS 390, 396, or white, and the letterforms within may appear in PMS 5535 or black.

THE GAMEFACE: The closest thing to a Jets mascot, the "Gameface" mark represents the passion and fervor of our fans, players and coaches. It is derived from the little football shape that has long been anchored at the base of the New York Jets logotype. It may appear in PMS 5535, 390, 396, or black, but is most effective when the background is lighter in color than the mark itself. Showing the Gameface mark in white on dark backgrounds is not recommended.

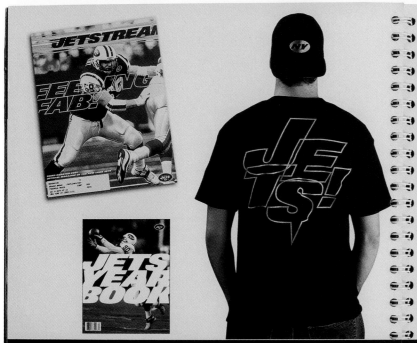

EXPRESSIONS OF THE BRAND: Sample applications of brand identity elements and the guidelines defined in this manual are shown on this spread. As important as it may be to continuously find new and fresh ways to implement and expand the Jets brand, it is just as important to retain an element of continuity across everything produced, even when these items are made by different people in different parts of the world. Consistency is ensured when we work within the specifications of type and color, and when our marks and symbols are used where, when, and how they are intended. It is important to consider the medium in which the item is being produced and to be sensitive to materials and production processes. Variety and surprise can be achieved through the use of scale, style of photography and illustration, as well as meaningful and cleverly written copy. Paying equal attention to all of these should result in a consistent, but unique application of brand identity. This is how we build the Jets brand.

Right
A signature
part of the
Jets brand is
aural: the chant
"J! E! T! S! JETS!
JETS! JETS!"
that is heard
as a rallying cry
at every game.
Its graphic
interpretation
became still
another element
in the Jets
brand identity.

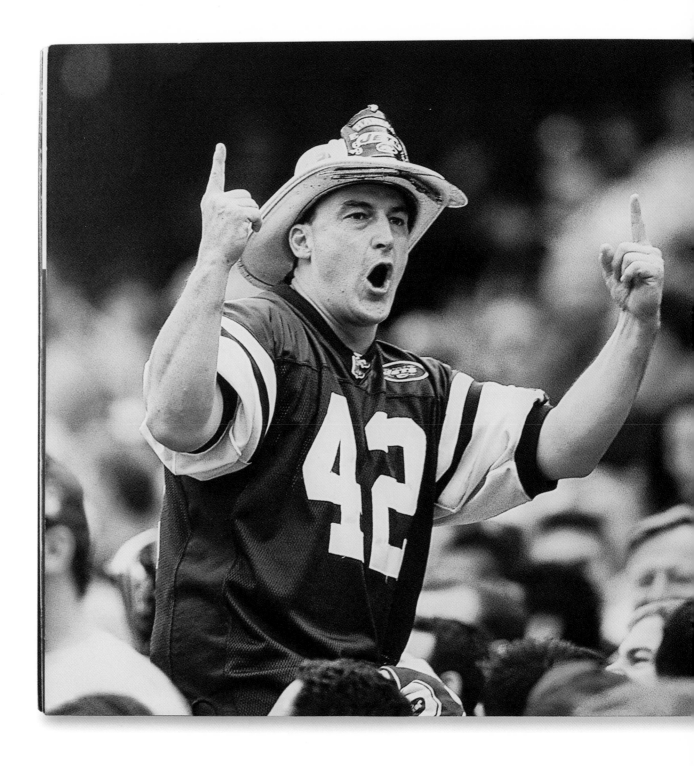

New York Jets

THE CHANT: Perhaps the most dynamic and inspiring element of the Jets personality is the Chant: J! E! T! S! JETS! JETS! JETS!... as shouted by thousands of Jets fans at our games throughout the country. So simple and authentic, the Chant unites entire stadiums in support for their team. A graphic treatment of the chant, in multiple colors and configurations, has been adopted as an official part of the Jets brand identity. Options and variations for Chant graphics are illustrated on the next spread.

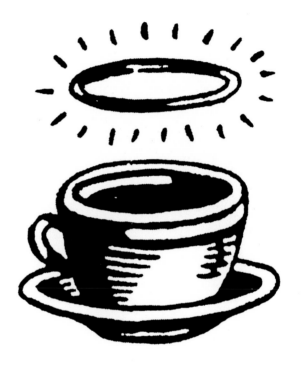

(BAD) (GOOD)

How to be good
The Good Diner

Sheldon Werdiger and Evan Carzis were smart architects. The recession of the late 1980s had brought building in New York to a halt. So they decided to open a diner. They didn't want it to be fancy, they explained to us. Not a retro, Fabulous Fifties place. Not a hip, reverse chic place. Just a plain diner where you could get two eggs, bacon, and toast for $4.99. The location was the corner of Eleventh Avenue and 42nd Street. Sheldon and Evan wanted to cast a wide net: "We'll get tourists on their way to the Circle Line, UPS drivers on their way to the morning shift, club kids on their way home after last call." This place had to appeal to all of them.

Our challenge was to deliver populist design, short-order style on a no-design budget, starting with the name. I suggested Jersey Luncheonette, and a logo with the state's silhouette on a plate like a piece of veal scaloppine. That didn't fly. Nor did they like Wild West Diner, or Sunset Café, or The Last Stop. Too clever. Finally I suggested The Good Diner. Not great, not fantastic, just…good. For the logo, our partner Woody Pirtle put a halo on a coffee cup.

We installed the logo in hand-cut linoleum at the front door. My partner Jim Biber, who had created some of Manhattan's best restaurants, explained that diners weren't really designed as much as ordered from catalogs. So he ordered one of everything, upholstering the booths and the counter seats with every color available. With no art budget, we decorated the walls with photocopied images of kitchen implements. Light shades shaped like milkshake containers and a single bespoke railing were the only concessions to custom manufacturing.

As is often the case, we took part of our design fees in trade for food. Eating our third helping of $4.99 bacon and eggs in a week, Jim and I realized we would be dead from cholesterol poisoning before we ever made our money back.

The Good Diner was an experiment in vernacular design processes. No drawing was made for the neon sign; I simply dictated the words to the fabricator over the phone and said to make the second line the biggest, the first and third lines the next biggest, and so on, and to use whatever colors he thought looked nice. It was a tense but ultimately satisfying moment when the final product was delivered.

Right bottom
At one point, our clients hesitated about the name, fearing that the equivocal adjective might be too wimpy for their truck-driving clientele. "Okay, how about The Fuckin' Good Diner?" I suggested. We kept the original name.

Above
For a diner, matchbooks serve as the annual report, corporate image campaign, and 60-second Super Bowl ad, all in one.

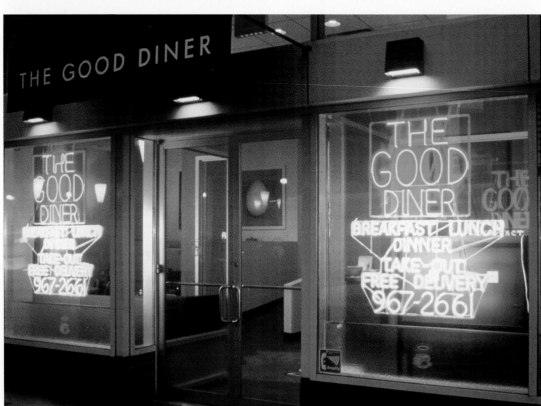

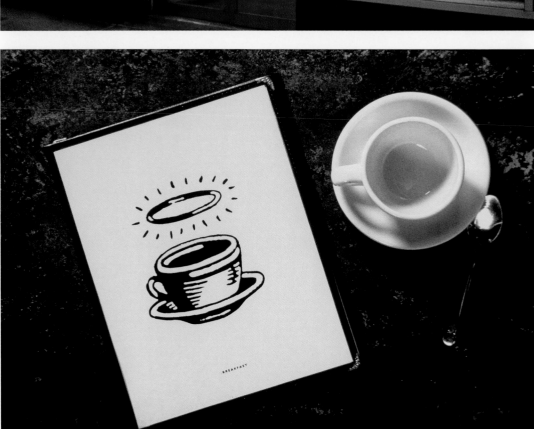

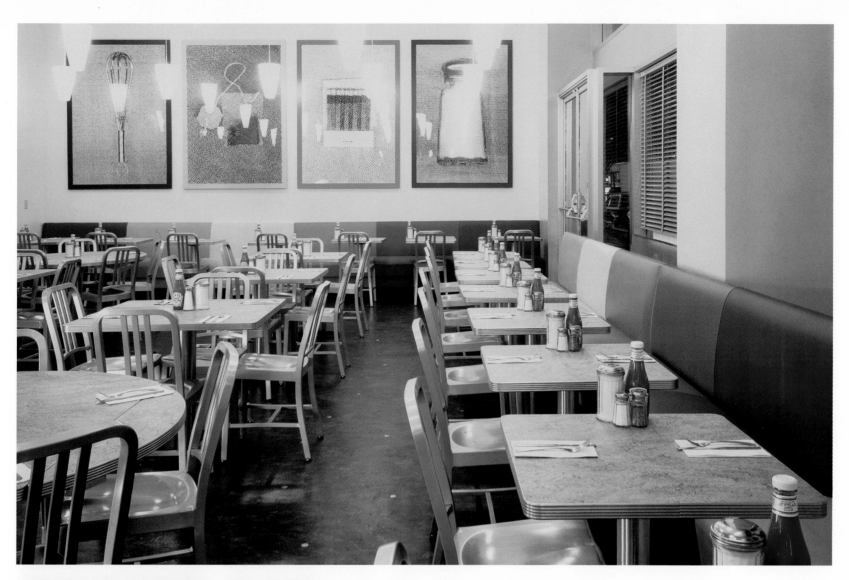

Far left
In a luxurious gesture, Woody Pirtle's logo was installed in hand-cut linoleum at the entrance.

Left
The railing connecting the counter area to the main dining room could be read alternately as "Good" or "Goop" depending on your reaction to the food.

Above
With no budget for art but lots of walls to fill, we simply put objects on a photocopier and blew them up. The framed images represent the four primal elements: wind, water, fire, and earth. We're not sure anyone noticed.

Next spread
Why settle for one color of Naugahyde when you can have them all? The installers determined the order of colors at the counter.

How to run a marathon
The Architectural League of New York

A few weeks into my first job, my boss Massimo Vignelli summoned me into his office. I was a naive kid from Ohio and I barely knew what I was doing. Massimo and his wife and partner, Lella, were going to Italy for a month, and he told me to follow up on a project he was doing for an organization called the Architectural League of New York. I liked architecture but my knowledge didn't extend much beyond Frank Lloyd Wright and Howard Roark. Suddenly I was on the phone with Richard Meier, Michael Graves, and Frank Gehry, chasing down material for the organization's centennial exhibition. My education was about to begin. My postgraduate academy was the Architectural League.

Founded in 1881 to bring together architects with other creative practitioners, the League has always included artists and designers of all disciplines in its leadership. As a board member, Massimo Vignelli served as the organization's pro bono graphic design consultant. As Massimo's assistant, I took over the (free) work we were doing on their behalf. Ten years later I was appointed to the board myself. Twenty-plus years after that I am still working for them. This marathon run is the longest sustained relationship I've enjoyed in my professional life.

Designers are often asked to create images for organizations. We come in from the outside, get our bearings, and give the best advice we can. Working as an external consultant like this, I design systems for others to implement and hope and pray they get it right after I'm gone. Working for the League year after year after year, I learned the pleasures of working from the inside. There are no formal graphic standards, but there is an evolving portrait of an organization where the paint never quite dries. For years, I resisted designing a logo, viewing each new assignment as an open brief, a chance to extend the League's visual profile. Over time, certain patterns began to emerge—we finally did create a logo, for instance—but still each assignment offers the very best (and scariest) kind of challenge: if you could do anything you wanted, what would you do?

Right

Early in my time working for the Architectural League, I designed several lecture invitations that also functioned as miniature posters. These were the first instances that Massimo Vignelli encouraged me to sign my own work.

Opposite

Working for the League's ongoing programs has been a special pleasure. Its Emerging Voices series, which mounts lectures by up-and-coming architects from around the world, began in 1981 and continues today. Its poster series is a not-so-subtle homage to my childhood obsession with the album covers designed by John Berg and Nick Fasciano for the band Chicago.

The Architectural League of New York

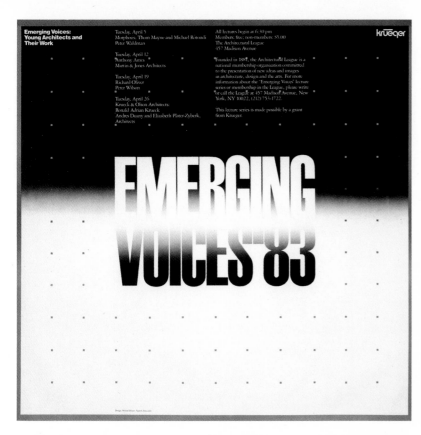

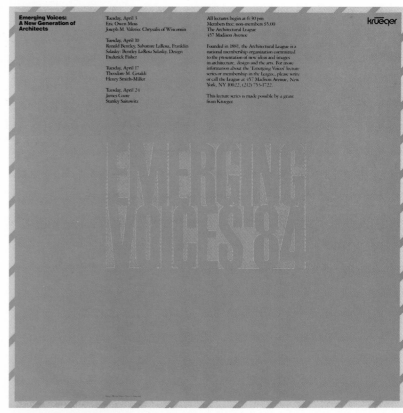

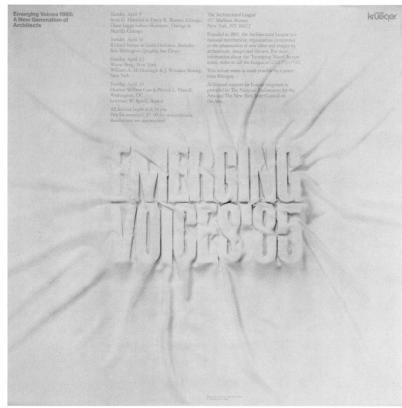

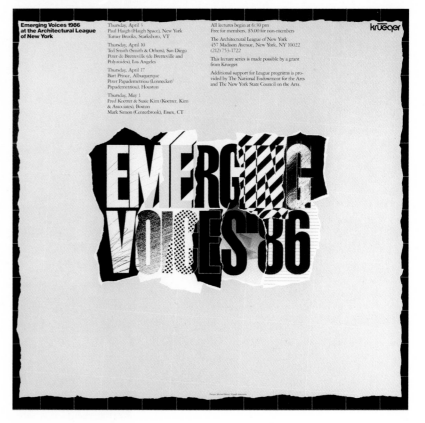

The remarkable 30-year legacy of the Emerging Voices series culminated with our design for *Idea, Form, Resonance*, a 300-page book documenting the League's remarkable ability to identify mid-career architects destined for worldwide influence. These have included Brad Cloepfil, James Corner, Marion Weiss and Michael Manfredi, Teddy Cruz, SHoP, and Jeanne Gang.

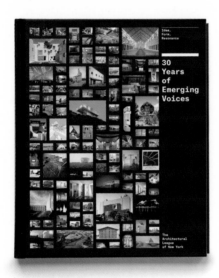

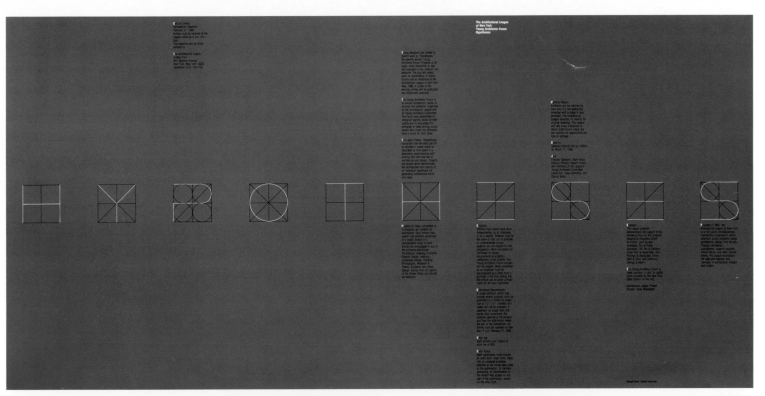

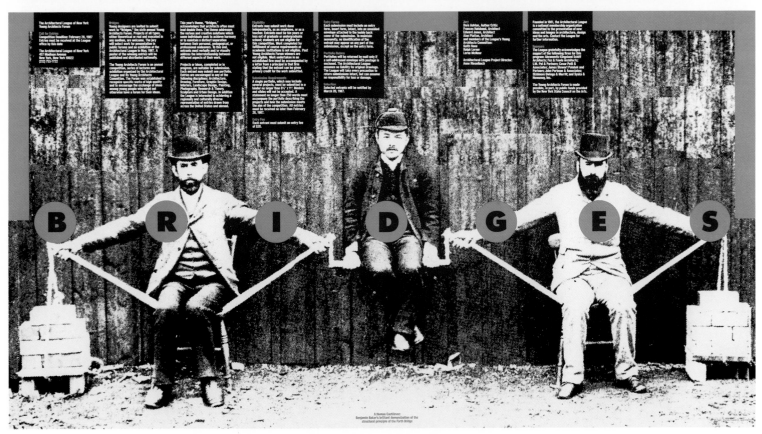

A Human Cantilever:
Benjamin Baker's brilliant demonstration of the
structural principle of the Forth Bridge

Left

Since the early 1980s, my clients at the League have been executive director Rosalie Genevro and program director Anne Rieselbach. By now, our communication is nearly telepathic. Nonetheless, they still reject as many of my ideas as they accept. The Architectural League's competition for young designers has a different theme every year, and my feigned exasperation with it is a cherished part of our relationship. I recall that 1987's Bridges theme was particularly vexing.

Right
The poster
for the 1999
competition
responded
directly to
the theme,
Scale, with
an oversized
poster that
would be
unlikely in
today's
sustainability-
conscious
digital age.

SCALE

The Architectural League of New York
Young Architects Forum

Call for Entries
Competition Deadline February 1, 1999

Eligibility

Entry fee

Entry forms

Portfolio return

Theme

Submission requirements

Selection

Jury

Architectural League Program Director

Sponsors

Entry form

General Information

Eligibility Agreement

Portfolio Identification

The Architectural League of New York

Below
When the
League moved
to new offices
in Soho, we
created this
homage to
the cover of
Paolo Soleri's
Visionary Cities.

94

Below
The Beaux Arts
Ball is the high
point of the
social calendar
for any trendy
New York
architect.

In 2006, the
theme was
Dot Dot
Dot, with
appropriately
customized
typography.

Right
The poster
for the
1999 Beaux
Arts Ball
became
one of the
League's
most enduring
images.

Light Years The Architectural League of New York's 1999 Beaux Arts Ball at th

rrett-Lehigh Building, Saturday March 13, 1999. For tickets please call (212) 753 1722. Corporate Sponsor **Artemide**

The Architectural League of New York

Opposite
The 2014 Beaux Arts Ball was held at the staggeringly ornate Williamsburgh Savings Bank in Brooklyn. The theme, Craft, was memorialized with an illegibly baroque insignia.

Right
For years, I felt the Architectural League's logo wasn't important, that dramatic posters communicated more powerfully than any symbol could.

This changed with the rise of digital communications and social media. In response, we created a wordmark that imbeds their colloquial name within their formal one.

Above and right
In 2011, Massimo and Lella Vignelli were the recipients of the League's prestigious President's Medal. The programs we designed featured five different Vignelli quotes—in Helvetica, of course. The untrimmed press sheet became an informal poster, and a way for me to honor the man whose generosity transformed my life.

99

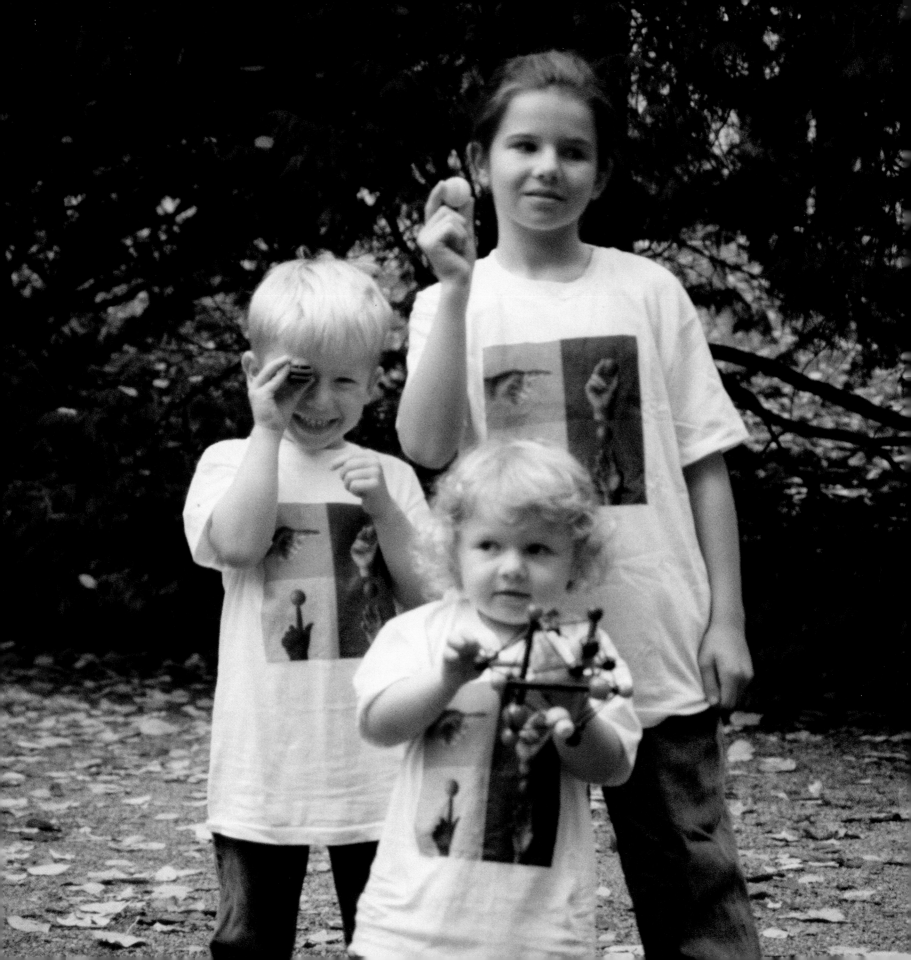

How to avoid the obvious
Minnesota Children's Museum

Graphic designers have a love/hate relationship with clichés ("love/hate relationship" being itself a cliché). In design school, we're taught that the goal of design is to create something new. But not entirely new. A jar of spaghetti sauce should stand out from its competitors. But if it looks too different, say, like a can of motor oil, it will disorient shoppers and scare them away. Every graphic design solution, then, must navigate between comfort and cliché. Pentagram founder Alan Fletcher admired this "ability to stroke a cliché until it purrs like a metaphor."

In 1995, the Minnesota Children's Museum was moving from a cramped but cozy space in a shopping mall to a beautiful new building in downtown St. Paul designed by up-and-coming architects Julie Snow and Vincent James. We were asked to do the signage and graphics. Inevitably, the clichés poured out. Crayon markings. Bright primary colors. Building blocks, balloons, smiley faces.

In design, as in life, the antidote to stereotype is experience. Forget about the abstract idea of "children's museums." What makes this particular children's museum special? Ann Bitter, the museum's dynamic director, described her ambitions and confessed her fears. The new building was beautiful, she said, but she worried about losing the intimacy that visitors were accustomed to in the museum's old home. Like most children's museums, this one provided "hands-on experiences" (another cliché). Would kids feel as comfortable amid the big, beautiful, brand-new architecture?

Sometimes avoiding the obvious means embracing it— and wrestling it to the ground. Children's hands, with their invitation to touch and their inherent sense of scale, provided the key. Instead of trying to draw them (silhouettes? crayon scribbles?) we recruited local kids to serve as hand models and photographed them pointing, counting, playing. Today, at the Minnesota Children's Museum, these hands—of children that are now in their twenties—continue to point the way, and pick out that delicate path between what's expected and what surprises.

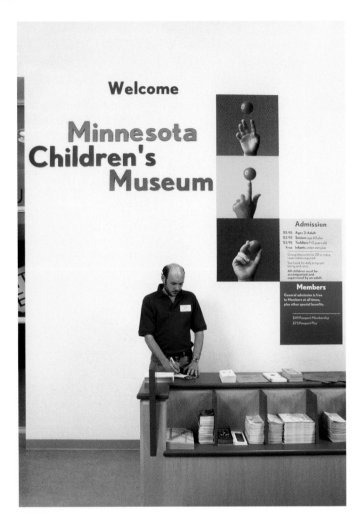

Welcome

Minnesota Children's Museum

Admission

$5.95 Ages 3–Adult
$3.95 Seniors age 60 plus
$3.95 Toddlers 1–2 years old
Free Infants under one year

Group discounts for 20 or more, reservation required.

See kiosk for daily program listing and rates.

All children must be accompanied and supervised by an adult.

Members

General admission is free to Members at all times, plus other special benefits.

$49 Passport Membership
$75 Passport Plus

Left
Instead of a logo, the museum combines two dozen photographs of children's hands in various ways.

Right
A sculptural hand balancing a clock serves as a central meeting place and reinforces the graphic theme.

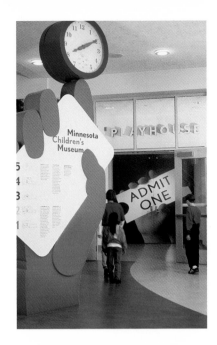

Right
Having decided on hands as a motif, we were lucky that the building had five floors rather than six.

Above
A giant ticket on the auditorium door is torn in half each time the door opens.

Next spread
For the museum's grand opening, it celebrated its audience by merging identity and architecture.

It is five minutes to midnight.

How to avoid doomsday
Bulletin of the Atomic Scientists

The most powerful piece of information design of the 20th century was designed by a landscape painter. In 1943, nuclear physicist Alexander Langsdorf Jr. was called to Chicago to join hundreds of scientists in a secret wartime project: the race to develop an atomic bomb. Their work on the Manhattan Project made possible the bombs that were dropped on Hiroshima and Nagasaki and ended World War II. But Langsdorf, like many of his colleagues, greeted the subsequent peace with profound unease. What were the implications of the fact that the human race had invented the means to render itself extinct?

To bring this question to a broader audience, Langsdorf and his fellow scientists began circulating a mimeographed newsletter called the *Bulletin of the Atomic Scientists*. In June 1947, the newsletter became a magazine. Langsdorf's wife, Martyl, was an artist whose landscapes were exhibited in Chicago galleries. She volunteered to create the first cover. There wasn't much room for an illustration, and the budget permitted only two colors. But she found a solution. The Doomsday Clock was born.

Arguments about nuclear proliferation have been complicated and contentious. The Doomsday Clock translates them into a brutally simple visual analogy, merging the looming approach of midnight with the drama of a ticking time bomb. Appropriately for an organization led by scientists, the Clock sidesteps overwrought imagery of mushroom clouds in favor of an instrument of measurement. Martyl set the minute hand at seven to midnight on that first cover "simply because it looked good." Two years later, the Soviets tested their own nuclear device. The arms race was officially on. To emphasize the seriousness of these circumstances, the clock was moved to three minutes to midnight. It has been moved 20 times since. What a remarkable, clear, concise piece of communication!

Several years ago, the organization was looking for a logo. We told them they already had one. That began a relationship with the *Bulletin of the Atomic Scientists* that still continues. Each year, we publish the report that accompanies the announcement of the Clock's position. And each year, we hope we turn back time.

Designer Armin Vit and I suggested that the Doomsday Clock be adopted as the organization's logo. Its non-specific neutrality has permitted the *Bulletin* to integrate data on bioterrorism and climate change into the yearly scientific assessment, which has led to 20 changes to the position of the clock's hands over the past 65 years.

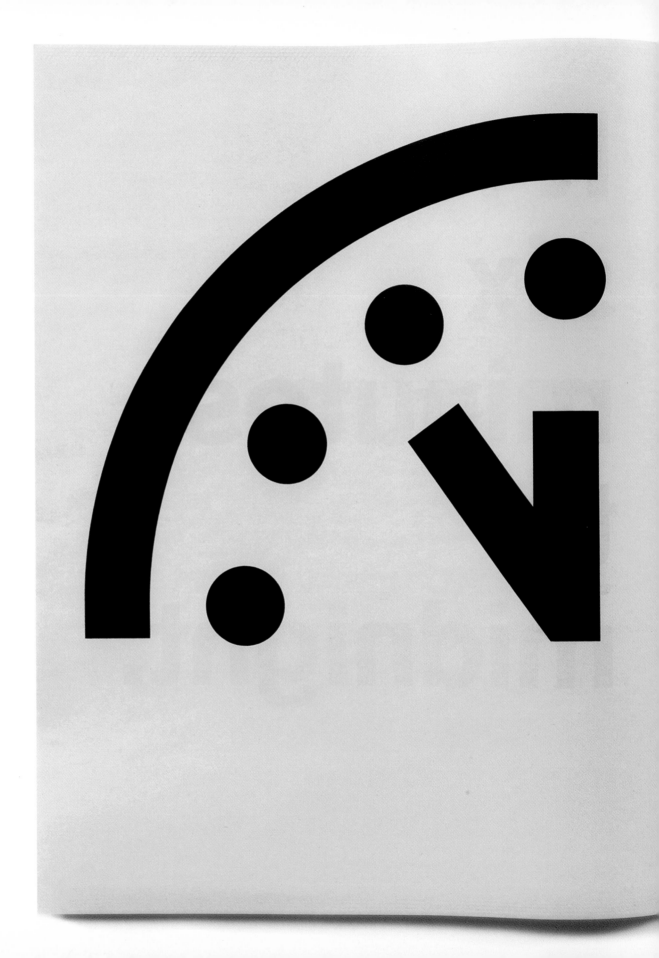

How close are we to catastrophic destruction? The Doomsday Clock monitors "minutes to midnight," calling on humanity to control the means by which it could obliterate itself. First and foremost, these include nuclear weapons, but they also encompass climate-changing technologies and new developments in the life sciences that could inflict irrevocable harm.

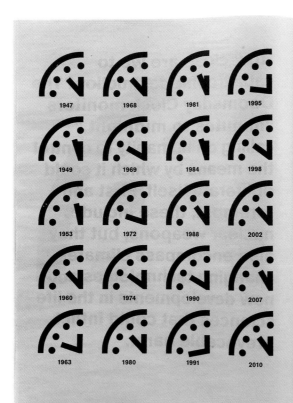

1947	1968	1981	1995
1949	1969	1984	1998
1953	1972	1988	2002
1960	1974	1990	2007
1963	1980	1991	2010

In 1947, the Bulletin first displayed the Doomsday Clock on the cover of the print magazine to convey, through a simple design, a sense of urgency and peril posed by nuclear weapons. The minute hand of the Clock has moved 19 times since, based on a global risk assessment by the Bulletin's Science and Security Board in consultation with other experts, and the Board of Sponsors, which currently includes 19 Nobel Laureates.

1947 As the Bulletin evolves from a newsletter into a magazine, the Clock appears on the cover for the first time. It symbolizes the urgency of the nuclear dangers that the magazine's founders – and the broader scientific community – are trying to convey to the public and political leaders around the world. **It is seven minutes to midnight.**

1949 The Soviet Union denies it, but in the fall, President Harry Truman tells the American public that the Soviets tested their first nuclear device, officially starting the arms race. "We do not advise Americans that doomsday is near and that they can expect atomic bombs to start falling on their heads a month or year from now," the Bulletin explains. "But we think they have reason to be deeply alarmed and to be prepared for grave decisions." **It is three minutes to midnight.**

1953 After much debate, the United States decides to pursue the hydrogen bomb, a weapon far more powerful than any atomic bomb. In October 1952, the United States tests its first thermonuclear device, obliterating a Pacific Ocean islet in the process; nine months later, the Soviets test an H-bomb of their own. "The hands of the Clock of Doom have moved again," the Bulletin announces. "Only a few more swings of the pendulum, and, from Moscow to Chicago, atomic explosions will strike midnight for Western civilization." **It is two minutes to midnight.**

1960 Political actions belie the tough talk of "massive retaliation." For the first time, the United States and Soviet Union appear eager to avoid direct confrontation in regional conflicts such as the 1956 Egyptian-Israeli dispute. Joint projects that build trust and constructive dialogue between third parties also quell diplomatic hostilities. Scientists initiate many of these measures, helping establish the International Geophysical Year, a series of coordinated, worldwide scientific observations, and the Pugwash Conferences, which allow Soviet and American scientists to interact. **It is seven minutes to midnight.**

1963 After a decade of almost non-stop nuclear tests, the United States and Soviet Union sign the Partial Test Ban Treaty, which ends all atmospheric nuclear testing. While it does not outlaw underground testing, the treaty represents progress in at least slowing the arms race. It also signals awareness among the Soviets and Americans that they need to work together to prevent nuclear annihilation. **It is twelve minutes to midnight.**

1968 Regional wars rage. U.S. involvement in Vietnam intensifies, India and Pakistan battle in 1965, and Israel and its Arab neighbors renew hostilities in 1967. Worse yet, France and China develop nuclear weapons to assert themselves as global players. "There is little reason to feel sanguine about the future of our society on the world scale," the Bulletin laments. "There is a mass revulsion against war, yes, but not sign of conscious intellectual leadership in a rebellion against the deadly heritage of international anarchy." **It is seven minutes to midnight.**

1969 Nearly all of the world's nations come together to sign the Nuclear Non-Proliferation Treaty. The deal is simple – the nuclear weapon states vow to help the treaty's non-nuclear weapon signatories develop nuclear power if they promise to forego producing nuclear weapons. The nuclear weapon states also pledge to abolish their own arsenals when political conditions allow for it. Although Israel, India, and Pakistan refuse to sign the treaty, the Bulletin is cautiously optimistic: "The great powers have made the first step. They must proceed without delay to the next one – the dismantling, gradually, of their own oversized military establishments." **It is ten minutes to midnight.**

1972 The United States and Soviet Union attempt to curb the race for nuclear superiority by signing the Strategic Arms Limitation Treaty (SALT) and the Anti-Ballistic Missile (ABM) Treaty. The two treaties force a nuclear parity of sorts. SALT limits the number of ballistic missile launchers either country can possess, and the ABM Treaty stops an arms race in defensive weaponry from developing. **It is twelve minutes to midnight.**

1974 South Asia gets the Bomb, as India tests its first nuclear device. And any gains in previous arms control agreements seem like a mirage. The United States and Soviet Union appear to be modernizing their nuclear forces, not reducing them. Thanks to the deployment of multiple independently targetable reentry vehicles (MIRV), both countries can now load their intercontinental ballistic missiles with more nuclear warheads than before. **It is nine minutes to midnight.**

1980 Thirty-five years after the start of the nuclear age and after some promising disarmament gains, the United States and the Soviet Union still view nuclear weapons as an integral component of their national security. This stalled progress discourages the Bulletin: "[The Soviet Union and United States have] been behaving like what may best be described as 'nucleoholics' – drunks who continue to insist that the drink being consumed is positively 'the last one,' but who can always find a good excuse for 'just one more round.'"

1981 The Soviet invasion of Afghanistan hardens the U.S. nuclear posture. Before he leaves office, President Jimmy Carter pulls the United States from the Olympics Games in Moscow and considers ways in which the United States could win a nuclear war. The rhetoric only intensifies with the election of Ronald Reagan as president. Reagan scraps any talk of arms control and proposes that the best way to end the Cold War is for the United States to win it. **It is four minutes to midnight.**

1984 U.S.-Soviet relations reach their iciest point in decades. Dialogue between the two superpowers virtually stops. "Every channel of communications has been constricted or shut down; every form of contact has been attenuated or cut off. And arms control negotiations have been reduced to a species of propaganda," a concerned Bulletin informs readers. The United States seems to flout the few arms control agreements in place by seeking an expansive, space-based anti-ballistic missile capability, raising worries that a new arms race will begin. **It is three minutes to midnight.**

1988 The United States and Soviet Union sign the historic Intermediate-Range Nuclear Forces Treaty, the first agreement to actually ban a whole category of nuclear weapons. The leadership shown by President Ronald Reagan and Soviet Premier Mikhail Gorbachev makes the treaty a reality, but public opposition to U.S. nuclear weapons in Western Europe inspires it. For years, such intermediate-range missiles had kept Western Europe in the crosshairs of the two superpowers. **It is six minutes to midnight.**

1990 As one Eastern European country after another (Poland, Czechoslovakia, Hungary, Romania) frees itself from Soviet control, Soviet General Secretary Mikhail Gorbachev refuses to intervene, halting the ideological battle for Europe and significantly diminishing the risk of all-out nuclear war. In late 1989, the Berlin Wall falls, symbolically ending the Cold War. "Forty-four years after Winston Churchill's 'Iron Curtain' speech, the myth of monolithic communism has been shattered for all to see," the Bulletin proclaims. **It is ten minutes to midnight.**

1991 With the Cold War officially over, the United States and Russia begin making deep cuts to their nuclear arsenals. The Strategic Arms Reduction Treaty greatly reduces the number of strategic nuclear weapons deployed by the two former adversaries. Better still, a series of unilateral initiatives remove most of the intercontinental ballistic missiles and bombers in both countries from hair-trigger alert. "The illusion that tens of thousands of nuclear weapons are a guarantee of national security has been stripped away," the Bulletin declares. **It is seventeen minutes to midnight.**

1995 Hopes for a large post-Cold War peace dividend and a renouncing of nuclear weapons fade. Particularly in the United States, hard-liners seem reluctant to soften their rhetoric or actions, as they claim that a resurgent Russia could provide as much of a threat as the Soviet Union. Such talk slows the rollback in global nuclear forces; more than 40,000 nuclear weapons remain worldwide. There is also concern that terrorists could exploit poorly secured nuclear facilities in the former Soviet Union. **It is fourteen minutes to midnight.**

1998 India and Pakistan stage nuclear weapons tests only three weeks apart. The tests are a symptom of the failure of the international community to fully commit itself to control the spread of nuclear weapons – and to work toward substantial reductions in the numbers of three weapons," a dismayed Bulletin reports. Russia and the United States continue to serve as poor examples to the rest of the world. Together, they still maintain 7,000 warheads ready to fire at each other within 15 minutes. **It is nine minutes to midnight.**

2002 Concerns regarding a nuclear terrorist attack underscore the enormous amount of unsecured – and sometimes unaccounted for – weapon-grade nuclear materials located throughout the world. Meanwhile, the United States expresses a desire to design new nuclear weapons, with an emphasis on those able to destroy hardened and deeply buried targets. It also rejects a series of arms control treaties and announces it will withdraw from the Anti-Ballistic Missile Treaty. **It is seven minutes to midnight.**

2007 The world stands at the brink of a second nuclear age. The United States and Russia remain ready to stage a nuclear attack within minutes, North Korea conducts a nuclear test, and many in the international community worry that Iran plans to acquire the Bomb. Climate change also presents a dire challenge to humanity. Damage to ecosystems is already taking place; flooding, destructive storms, increased drought, and polar ice melt are causing loss of life and property. **It is five minutes to midnight.**

2010 A new spirit of international cooperation and negotiation gives hope that our leaders will act to rid the world of nuclear weapons. Governments are also proposing collaborative action on global warming. By shifting the hand back by only one minute, we emphasize how much needs to be accomplished as we affirm the new initiative that the United States, Russia, the European Union, India, China, Brazil, and others are displaying on nuclear security and on climate change. With 23,000 nuclear weapons in the world, the potential for use, inadvertent launches, accidents, and proliferation remains high. Scientists also believe that humanity has less than a decade to arrest greenhouse gas emissions before Earth cascades into irreversible climate disaster. History shows that progress toward disarmament and environmental protection occurs when citizens are engaged and express their concerns to policy makers.

Turn back the Clock.

Join the Clock Coalition.

Engage with experts, policy makers, and citizens around the world through our web resources, blogs, online debates, discussions, and publications. Share information, express your opinion, hold leaders accountable, and help to build international momentum toward nuclear weapons disarmament and climate stabilization. Beginning January 13–14, 2010, start every year by participating online when the Bulletin gathers experts and scientists at a Doomsday Clock Symposium to sustain a worldwide forum about the perils we face and what we can do to meet them. Participate at: www.turnbacktheclock.org.

1 2 3

Nuclear Weapons

The nuclear age dawned in the 1940s when scientists learned how to release the energy stored within the atom. Immediately, they thought of two potential uses – an unparalleled weapon and a new energy source. The United States built the first atomic bombs during World War II, which they used on Hiroshima and Nagasaki, Japan in August 1945. Within two decades, Britain, the Soviet Union, China, and France had also established nuclear weapon programs. Since then, Israel, India, Pakistan, and North Korea have built nuclear weapons as well.

For most of the Cold War, overt hostility between the United States and Soviet Union, coupled with their enormous nuclear arsenals, defined the nuclear threat. The U.S. arsenal peaked at about 30,000 warheads in the mid-1960s and the Soviet arsenal at 40,300 warheads in the 1980s, dwarfing all other nuclear weapon states. The scenario for nuclear holocaust was simple: Heightened tensions between the two superpowers would lead to an all-out nuclear exchange. Today, the potential for an accidental or inadvertent nuclear exchange between the United States and Russia remains, with both countries anachronistically maintaining more than 1,000 warheads on high alert, ready to launch within tens of minutes, even though a deliberate attack by Russia or the United States on the other seems improbable.

Unfortunately, however, in a globalized world with porous national borders, rapid communications, and expanded commerce in dual-use technologies, nuclear know-how and materials travel more widely and easily than before—raising the possibility that terrorists could obtain such materials and construct a nuclear device of their own. The materials necessary to construct a bomb pervade the world.

As a result, according to the International Panel on Fissile Materials, substantial quantities of highly enriched uranium, one of the materials necessary for a bomb, remain in more than 40 non-weapon states. Save for Antarctica, every continent contains at least one country with civilian highly enriched uranium. Even with the improvement of nuclear reactor design and international controls provided by the International Atomic Energy Agency (IAEA), proliferation concerns persist, as the components and infrastructure for a civilian nuclear power program can also be used to construct nuclear weapons.

Climate Change

Fossil-fuel technologies such as coal-burning plants powered the industrial revolution, bringing unparalleled economic prosperity to many parts of the world. But in the 1950s, scientists began measuring year-to-year changes in the carbon dioxide concentration in the atmosphere that they could relate to fossil-fuel combustion, and they began to see the implications for Earth's temperature and for climate change.

Today, the concentration of carbon dioxide is higher than at any time during the last 650,000 years. These gases warm Earth's continents and oceans by acting like a giant blanket that keeps the sun's heat from leaving the atmosphere, melting ice and triggering a number of ecological changes that cause an increase in global temperatures. Even if carbon-dioxide emissions were to cease immediately, the extra gases already added to the atmosphere, which linger for centuries, would continue to raise sea level and change other characteristics of the Earth for hundreds of years.

The most authoritative scientific group on the issue, the Intergovernmental Panel on Climate Change (IPCC), suggests that warming on the order of 3-10 degrees Fahrenheit over the next 100 years is a distinct possibility if the industrialized world doesn't curb its carbon dioxide emissions habit. Effects could include wide-ranging, dramatic changes. One drastic result is a 3- to 34-inch rise in sea level, leading to more coastal erosion, increased flooding during storms, and in some regions such as the Indus River Delta in Bangladesh and the Mississippi River Delta in the United States, permanent inundation. This sea-level rise will affect coastal cities (New York, Miami, Shanghai, London) the most, compelling major shifts in human settlement patterns.

Inland, the IPCC predicts that another century of temperature increases could place severe stress on forests, alpine regions, and other ecosystems, as forests sustain human health as mosquitoes and other disease-carrying insects and rodents spread lethal viruses and bacteria over larger geographical regions, and harm agriculture by reducing rainfall in many food-producing areas while at the same time increasing flooding in others—any of which could contribute to mass migrations and wars over arable land, water, and other natural resources.

Biosecurity

Advances in genetics and biology over the last five decades have inspired a host of new possibilities – both positive and troubling.

With greater understanding of genetic material and of how physiological systems interact, biologists can fight disease better and improve overall human health. Scientists already have begun to develop bioengineered vaccines for common diseases such as dengue fever and certain forms of hepatitis. They are using these tools to develop other innovative medical solutions, including cells that have been bioengineered to serve as physiological "pacemakers." The mapping of the complete human genome in 2001 allows for even greater understanding of human functioning. As a consequence of the Human Genome Project, scientists have already identified more than 1,800 genes associated with particular diseases.

But along with their potential benefits, these technological advances raise the possibility that individuals or non-state actors could create dangerous known or novel pathogens. Additionally, researchers with the best intentions could inadvertently create new pathogens that could harm humans or other species. For example, in 2001, researchers in Australia reported that they had accidentally created a new, virulent strain of the mousepox virus while attempting to genetically engineer a more effective rodent control method.

Unlike the biological weapons of the last century, these new tools could create a limitless variety of threats, from new types of "nonlethal" agents, to viruses that sterilize their hosts, to others that incapacitate whole systems within an organism. The wide availability of bioengineering knowledge and tools, along with the ease with which individuals can obtain specific fragments of genetic material (some can be ordered through the mail or over the internet), could allow these capabilities to find their way into unspecified hands or even those of backyard hobbyists. Such potential dangers are forcing scientists, institutions, and industry to develop self-governing mechanisms to prevent misuse. But developing a system to ensure the safe use of bioengineering, without impeding beneficial research and development, could pose the greatest international science and security challenge during the next 50 years.

You can help.

From a small publication founded and distributed by scientists who worked on the Manhattan Project, the Bulletin has become a 501 (c) (3) nonprofit communications organization that is a vital information network for people all over the world. More than 80 percent of the Bulletin's revenues are directed into program areas to organize, produce, and disseminate information needed by policy makers and citizens. Every gift to the Bulletin is tax deductible to the fullest extent allowable by law.

To learn more about supporting the Bulletin and the Clock Coalition, contact the Development office at 312.364.9710, ext 17, or write kgladish@thebulletin.org. Secure online donations can be made at www.turnbacktheclock.org or www.thebulletin.org.

"With a growing digital publishing program, expert forums, fellowships, and awards, the Bulletin has more ways to bring substance and clarity to public debates. We need it."
Stephen Hawking, Author and Scientist

"The Bulletin remains relevant today because of its persuasive insight into the range of causes for our eroding global security. Its iconic atomic clock now ticks more urgently than ever."
Cynthia Levine, President, American Society of Magazine Editors

"That the Bulletin is expanding its digital publishing can only mean good things for the level of our national debates and the clarity of our decisions."
William Perry, former U.S. Secretary of Defense

"Rigorously sober."
Chicago Tribune

"Scientists can be counted upon to continue searching for solutions and to keep deep channels of communication open among nations, great and small, in the hope that no government will misjudge the gravity of the world situation."
John A. Simpson, Bulletin co-founder

Join the Clock Coalition

Turn Back the Clock with facts, reason, and civic engagement.

Get regular updates about nuclear disarmament, climate change, and biotechnology around the world—and take action to advance efforts to improve global security.

Sign up now at www.turnbacktheclock.org.

Support the Clock Coalition

Cash or authorized credit: Make an online contribution through our secure portals at "www.turnbacktheclock.org" or "www.thebulletin.org", or send a check or credit authorization WITH YOUR EMAIL ADDRESS to the Bulletin of the Atomic Scientists, 77 W. Washington St., Suite 3120, Chicago, IL 60605.

Turn back the Clock

Thank you.

It is six minutes to midnight.

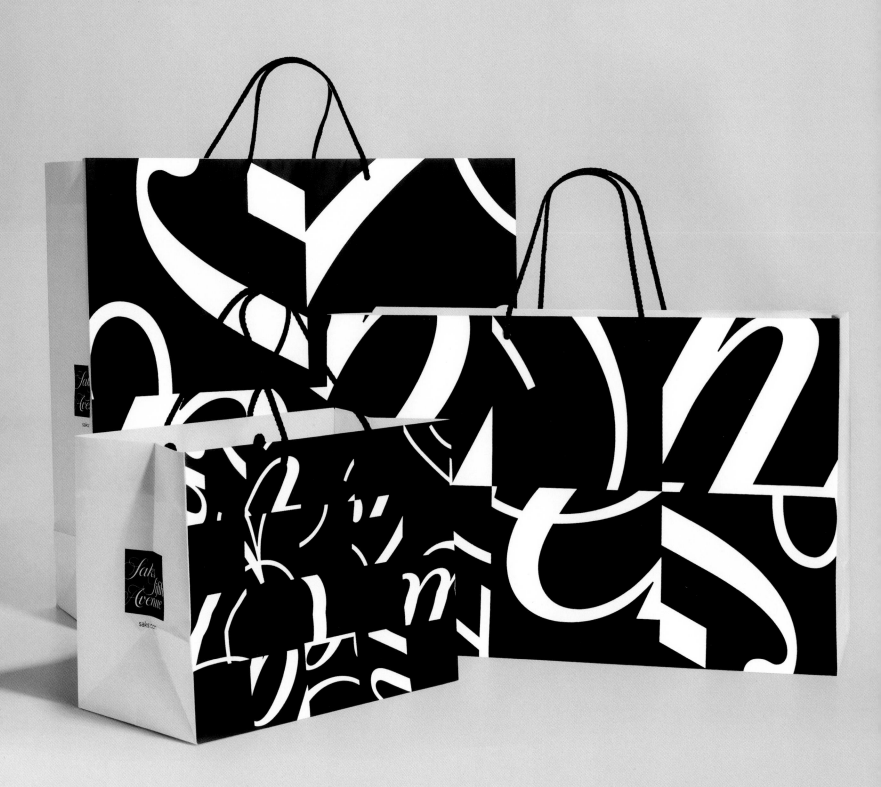

How to be fashionably timeless
Saks Fifth Avenue

Terron Schaefer told me I could do anything I wanted. As head of marketing at Saks Fifth Avenue, the New York retail mecca founded in 1924, he had decided the store was ready for a new graphic program. He offered me a blank slate.

There is nothing I like less than a blank slate. Where other designers yearn for assignments without constraints, I do best when straining against thorny problems, baggage-burdened histories, and impossible-to-reconcile demands. Luckily, buried in Terron's assignment was a tantalizing challenge. The store was proud of its heritage and the authority it conferred. Yet it also offered up-to-the-minute fashions. And in merging opposites—timelessness and trendiness—they wanted a brand as immediately recognizable as Tiffany with its blue boxes or Burberry with its signature plaid.

We tried everything. We set the name in dozens of different typefaces: they looked inauthentic. We tried images of their flagship building: too old. We invented patterns: frustratingly arbitrary. Finally, sensing our exhaustion, Terron made a suggestion: a lot of people, he said, still liked a cursive logo from the 1970s by lettering artist Tom Carnase. A florid bit of stylized Spencerian script, it looked dated to me, but I asked our designer Kerrie Powell to see if it could be refined. Later than afternoon, I glanced at Kerrie's computer screen from across the room. On it was a small fragment of that dated 1970s logo. The enlarged detail looked as fresh and dramatic as the Nike swoosh. I realized this was it.

Solving a design problem happens like so many other things: slowly, then all at once. We divided the cursive logo into 64 squares. Each square was a dramatic abstract composition. Together, they generated a nearly infinite number of combinations, perfect for boxes and bags. The new graphic language at once evoked the history of the store and the promise of perpetual newness. For Saks Fifth Avenue, the answer was there all along.

When seeking the new, the question is: compared to what? Deconstructing the vintage Saks logo signaled change more effectively than inventing a new one. The jumbled puzzle was solved on each package by the inclusion of the whole logo in the bag gusset or on the underside of the box lid.

Above and right
A lighter and more graceful logo was redrawn by artist Joe Finocchiaro. Saks was looking for flexibility, so we divided the logo into 64 squares. Our designer Jena Sher's fiancé was a physics PhD at Yale. He calculated that the squares could be arranged in more configurations than there are particles in the known universe.

The logo pattern, wrapped around premade boxes at small scale, resembles houndstooth.

Saks Fifth Avenue

Left top
The new pattern complements the filigree of the flagship store's classic architecture.

Left bottom
When the packaging was launched in 2007, Saks store windows diagrammed the new graphic program. Even without this help, shoppers quickly came to associate the new look with Saks.

Below
Some felt the dramatic collision of details, always in black and white, echoed the work of New York School artists like Franz Kline, Barnett Newman, and Ellsworth Kelly. My real inspiration was the typographic collages of Yale School of Art professor Norman Ives.

Next spread
The logo pattern unifies the store's block-long presence in midtown Manhattan.

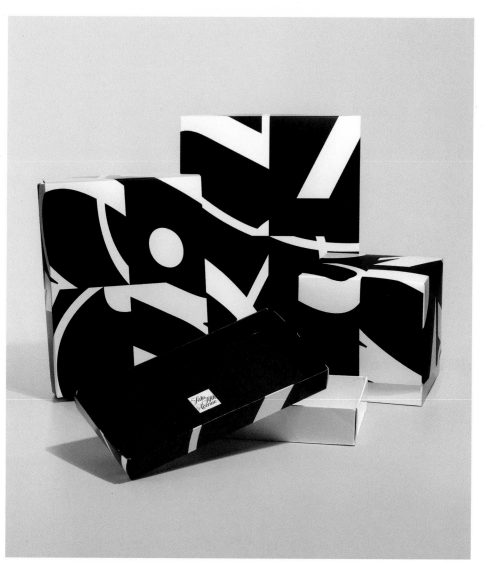

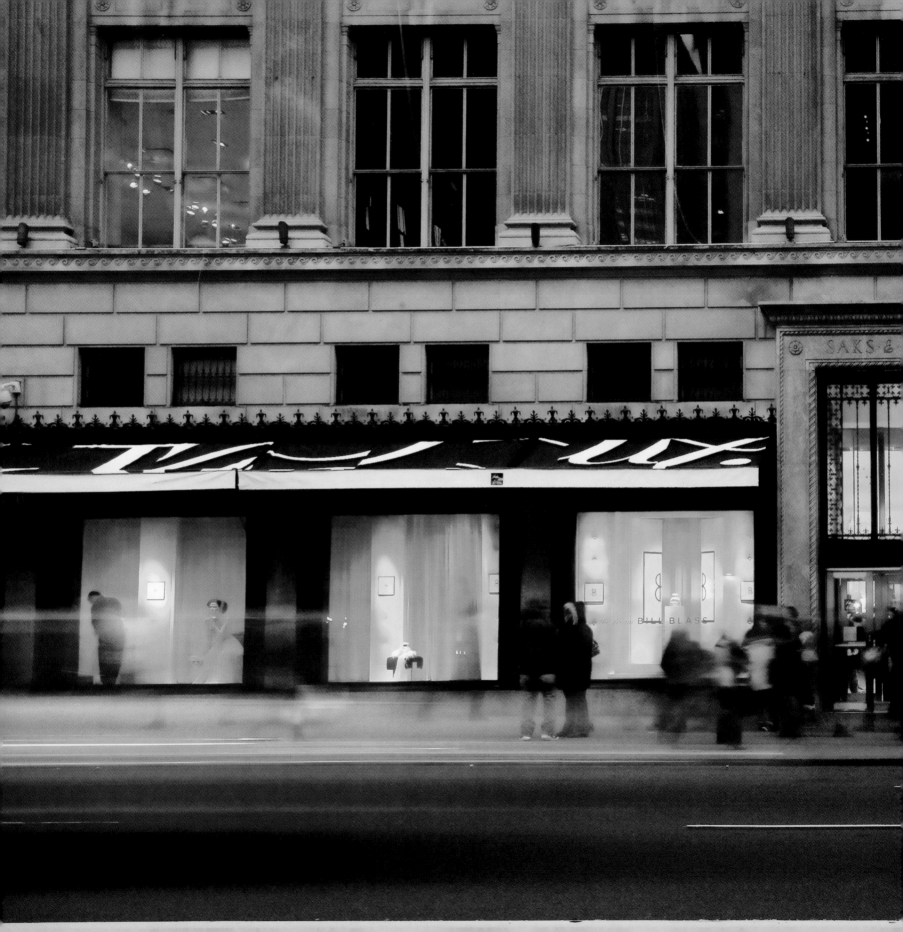

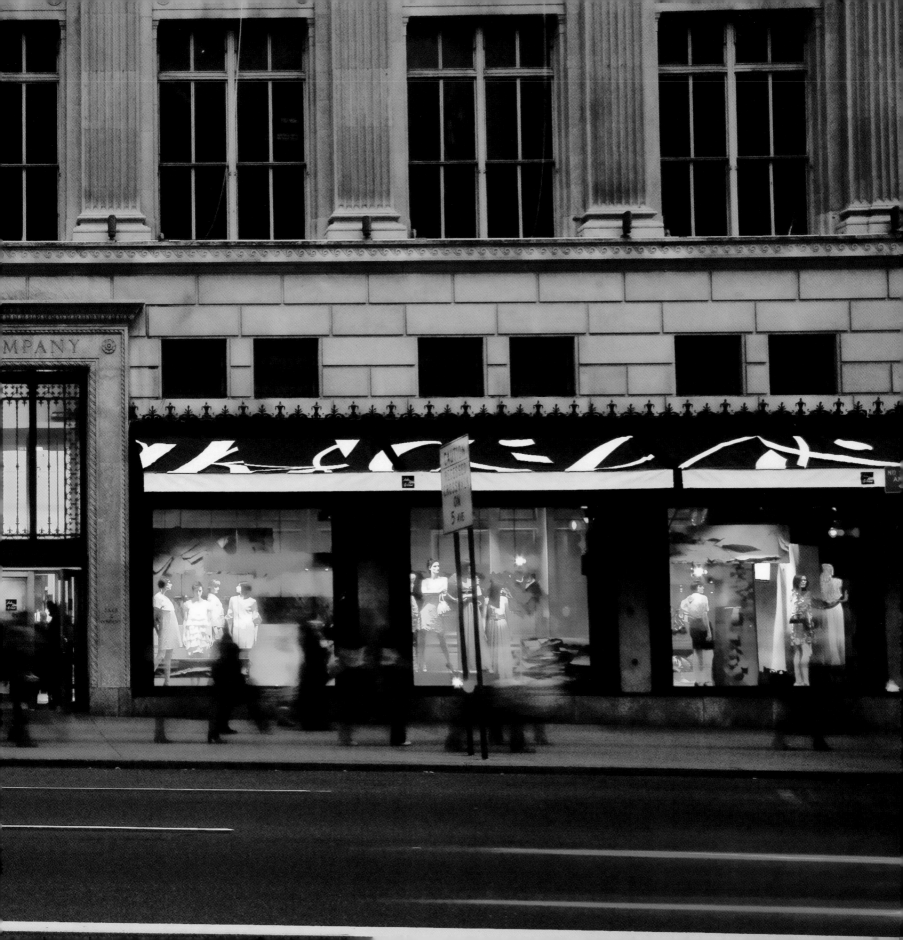

With the new look firmly established, Terron Schaefer commissioned a series of seasonal campaigns, each based on a different theme. We used this as an opportunity to stretch the brand's basic premises, keeping certain elements constant (a black-and-white color scheme, the use of a square layout grid) while varying others. This provided a way to simultaneously refresh and reinforce the basic identity.

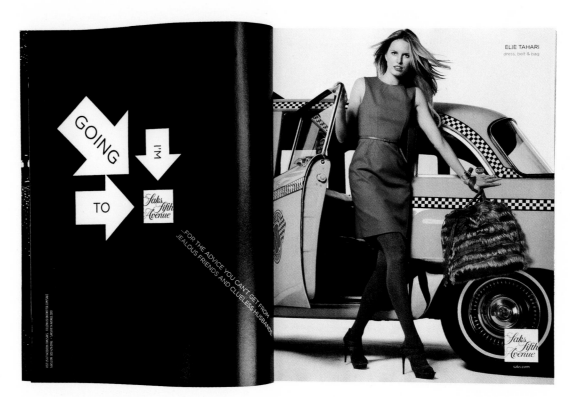

Left
Anders Overgaard's photography for the fall 2010 "I'm going to Saks" campaign paired models with modes of transportation, from taxis to skateboards.

Opposite
The campaign was literally directional, with arrows guiding shoppers to the store. Designer Jennifer Kinon worked out the intricate patterns.

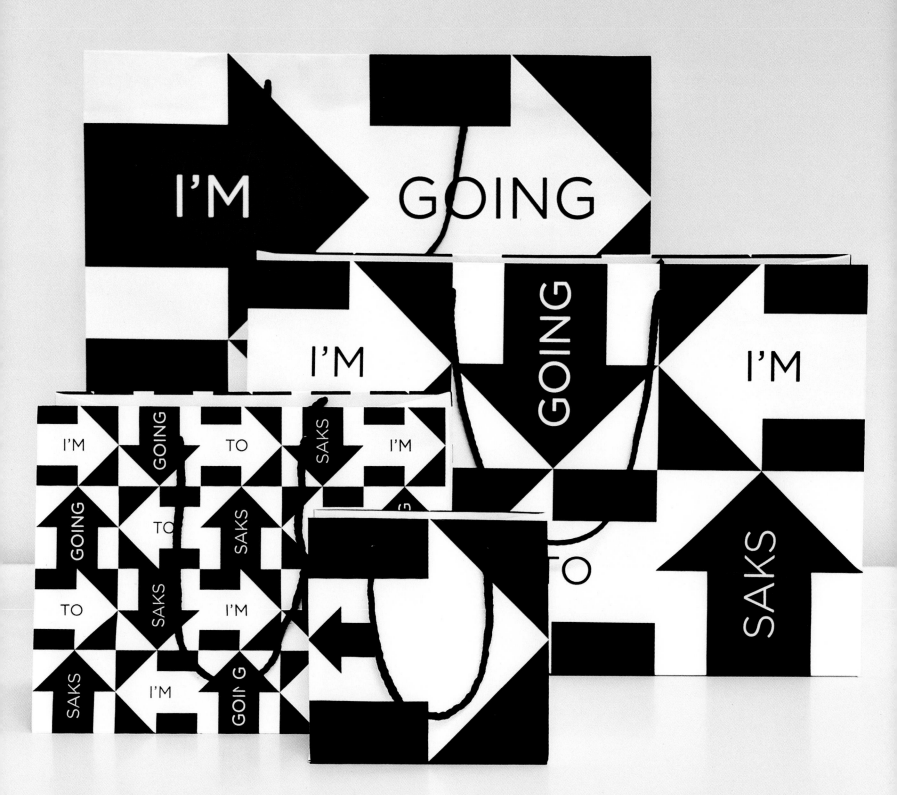

Below
"Think about…,"
the spring
2010 campaign,
was inspired
by Diana
Vreeland's
longtime
Harper's Bazaar
column, "Why
don't you…"
Each of the
ten letters in
the theme was
associated
with one of the
ten catalogs
Saks publishes
each year.

Right
Pentagram's
Jennifer Kinon
and Jesse
Reed used
tiny silhouettes
to render
the theme's
typography
and tie each
catalog back
to its subject:
animal prints,
shoes,
jewelry, men's
accessories,
and so on.

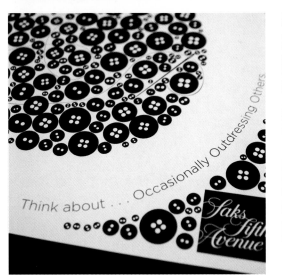

Below and right
"At Saks," the store's campaign for fall 2011, reflected the rise of social media. Joe Finocchiaro created a custom @ symbol to match the Saks calligraphy.

Pentagram's Katie Barcelona deployed the symbol in a range of hypnotic patterns.

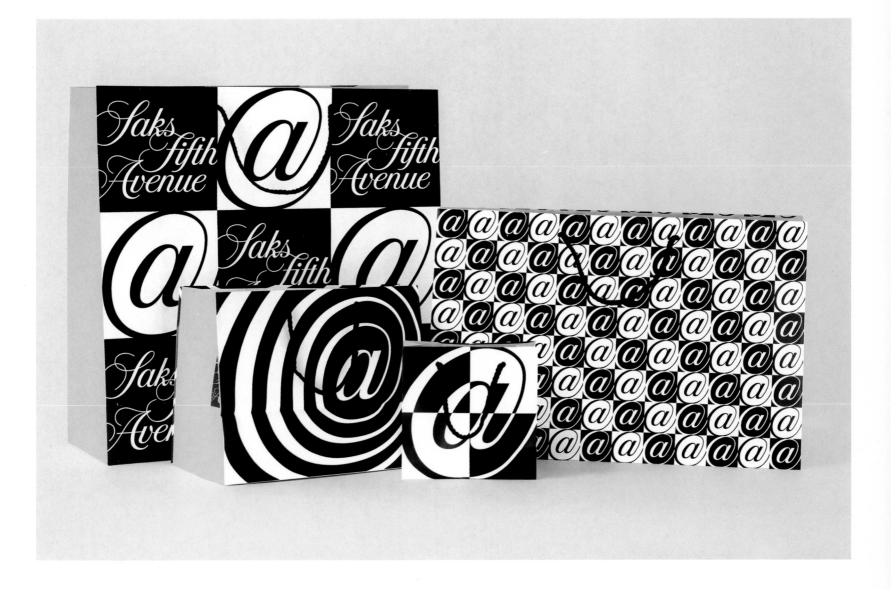

Above, right, and opposite
Our last project for Saks, 2013's "Look" campaign, was based on geometric letterforms that could be stacked, repeated, and used as windows. Designer Jesse Reed created a wide range of patterns that, as in each of our campaigns for this client, both extended the basic identity and demonstrated the identity's capacity to surprise.

How to cross cultures
New York University Abu Dhabi

In 2007, New York University's dynamic and outspoken president, John Sexton, announced the next step in his vision to create what he called "the world's first global university in the world's first truly global city." NYU Abu Dhabi would be much more than a typical study-abroad program. A complete campus, 40 acres of academic facilities and dormitories built from the ground up in Abu Dhabi's cultural district on Saadiyat Island, it is designed to serve a projected 2,000 students and faculty members, bringing Western-style liberal arts education to this emerging world capital.

Scattered among nearly 100 buildings in New York's Greenwich Village and beyond, NYU is the quintessential urban university. Instead of a leafy quad ringed with stately neo-Georgian halls is a celebration of the messy vitality of the city. As a result, the university's most important, if not only, means of coherence is its graphic design. We have worked with NYU for years, doing projects for its School of Law, Stern School of Business, and Wagner School of Public Service, and had come to appreciate the unifying power of its symbol, a simplified torch on a purple background. Now the power of this graphic identity would be put to a new test in Abu Dhabi. How could NYU use design to assert its global presence while celebrating this new local context?

An institution's graphic assets are usually inviolable. But in this case the most effective way to signal both continuity and change was to demonstrate what the NYU torch could do. Inspired by the dazzling chromatics and hypnotic repetition so typical of Islamic art, we created an arabesque pattern by expanding the university color palette and rotating and repeating the torch. This new signature motif, applied in print, online, and on campus, confirms that the new campus is at once part of New York University, of Abu Dhabi, and of the world.

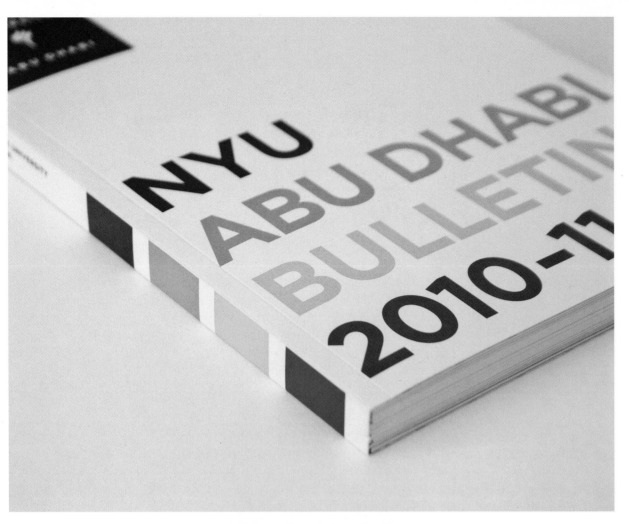

Above left
New colors, complementing NYU's purple, were meant to evoke (but not copy) the rich decorative traditions of Islamic art.

Above right
The NYU Abu Dhabi pattern is a familiar sight in the campus bookstore. The school has been overwhelmed with applications, and has an acceptance rate nearly as low as Harvard's.

Right
The brochure that introduced the new campus to potential students paired images from the two cultures.

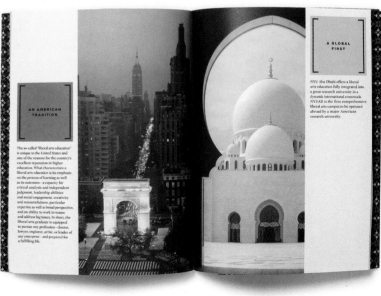

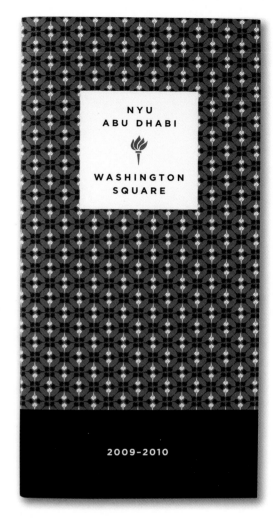

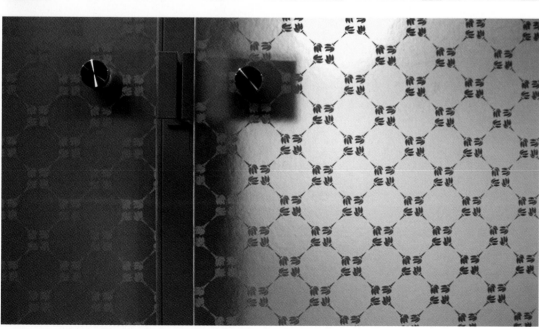

Above left
Even before
a single student
was accepted,
NYU Abu
Dhabi had
inaugurated a
robust program
of lectures,
presentations,
and symposia.

Left
The arabesque
pattern
provides
decorative
relief in campus
architecture.

Above right
Supporting
John Sexton's
vision of a
worldwide
network, NYU
Abu Dhabi
maintains an
active presence
in Washington
Square, the
heart of
the school's
New York
campus.

Next spread
Pentagram
designer
Katie Barcelona
worked out
an intricate
set of formats
for NYU
Abu Dhabi's
broad suite
of materials,
using color,
pattern, and
typography
to create
a complex
but coherent
graphic
program.

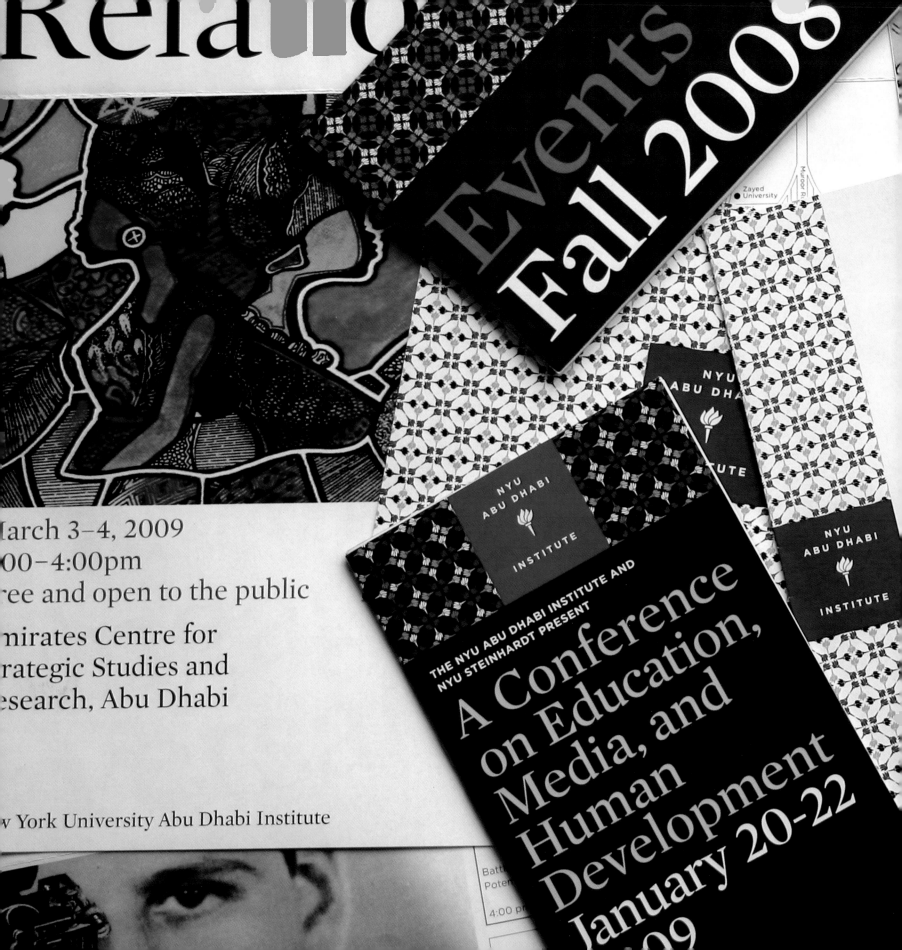

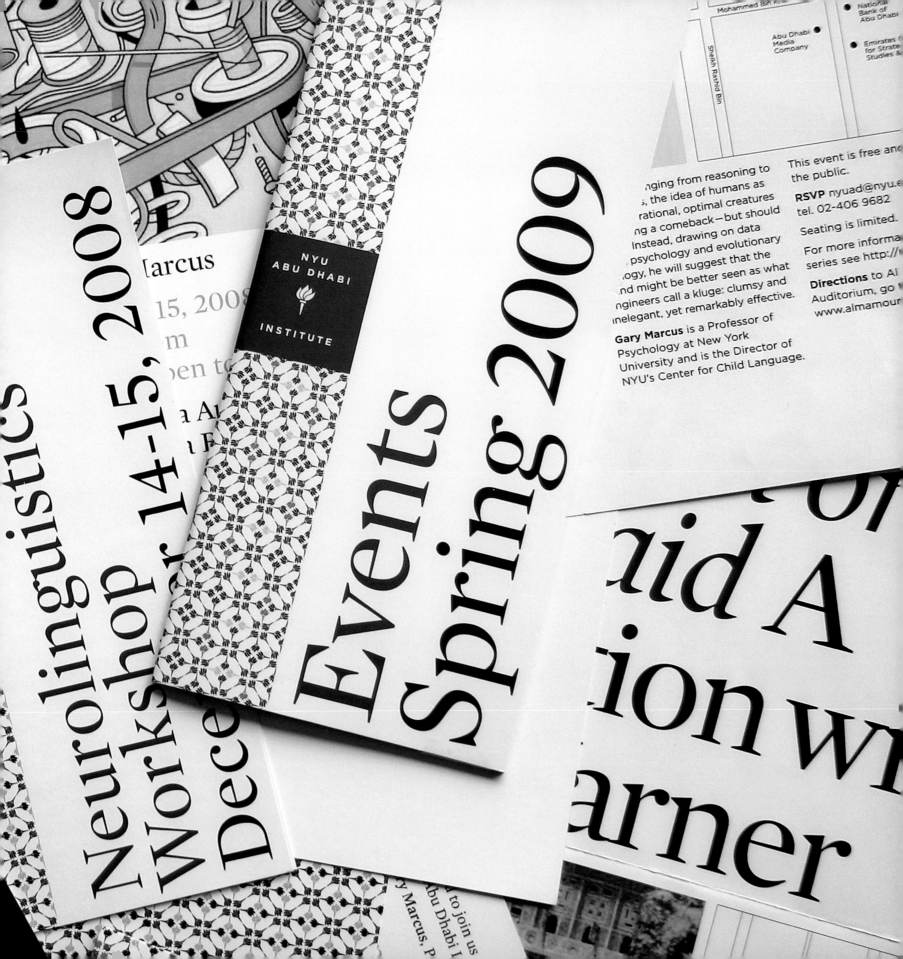

How to behave in church
The Cathedral Church of St. John the Divine

Opposite
To unify
the voice of the
Cathedral
Church of
St. John the
Divine and
to create a
distinctive
personality
that no other
institution
could match,
we asked
typeface
designer Joe
Finocchiaro
to redraw
1928's Goudy
Text, creating
a proprietary
font that we
named "Divine."

Above
The cathedral,
located on
Manhattan's
Upper West
Side, has
been under
intermittent
construction
for over 100
years, and is
still unfinished.
It is one of
New York's
most popular
destinations.

Organizations seeking an identity often think what they want is a logo. But this is like acquiring a personality by buying a hat. The way you look can be an important signal of who you are, but it's not the only signal. More important is what you say and how you say it. And most important of all, of course, is what you do.

The Cathedral Church of St. John the Divine does remarkable things. It is the fourth largest Christian church building in the world, begun in 1892 and never finished, with a 124-foot-high nave that is a mandatory destination for tourists visiting New York. But more than a beautiful Gothic structure, St. John's hosts concerts, art exhibits, and idiosyncratic events. Its soup kitchen serves 25,000 meals a year. And people from a wide range of faiths worship together in 30 services a week. What is the best way to signal that a stone monument over 120 years old is a vibrant, indispensable part of 21st-century life?

We were mesmerized by this combination of old stones and modern life, and sought a way to replicate the surprise that visitors experience when they step through its great west doors. We started with a frankly contemporary, even humorous, tone of voice. But then we took that voice and set it in a new version of an old typeface: Divine, a redrawn, digitized version of a 1928 blackletter by Frederic Goudy, who in turn had based his designs on the type in Gutenberg's 42-line Bible. This contrast between historical form and contemporary content became our way to echo the contrasting but symbiotic relationship of the container and the thing it contains.

My boss Massimo Vignelli used to quote an old Italian saying, "Qui lo dico, e qui lo nego" ("Here I say it, here I deny it"). People are complex. So are organizations. The ability of graphic design to synthesize multiple, and sometimes contradictory, codes never fails to surprise me.

Opposite
St. John's communications program combines contemporary language, lively layouts, bright colors, and its century-old typeface.

Below
The cathedral's symbol is based on its stunning rose window, the largest in the United States. The wordmark, in contrast, is set in a simple sans serif typeface that subtly emphasizes its colloquial name.

The Cathedral
Church of **Saint John
the Divine**

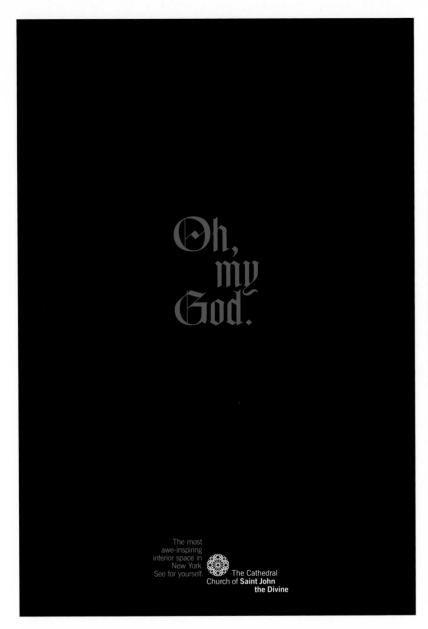

Oh, my God.

The most
awe-inspiring
interior space in
New York.
See for yourself.
The Cathedral
Church of **Saint John**
the Divine

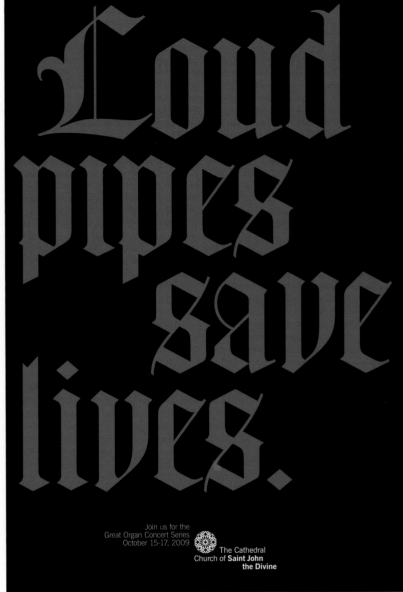

Loud pipes save lives.

Join us for the
Great Organ Concert Series
October 15-17, 2009
The Cathedral
Church of **Saint John**
the Divine

Above

In late 2001,
a fire that
covered
much of the
cathedral's
interior with
soot led to
its first cleaning
in 100 years.
When it
reopened,
its grandeur
newly restored,
expressions
of awe were
common.

Above

The Great
Organ series
is just one
example of the
many music
programs held
at this venue.
This poster
appropriates
a slogan usually
associated with
Harley-Davidson
riders.

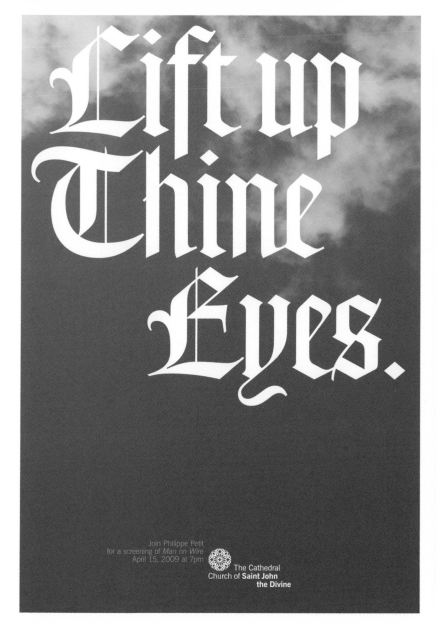

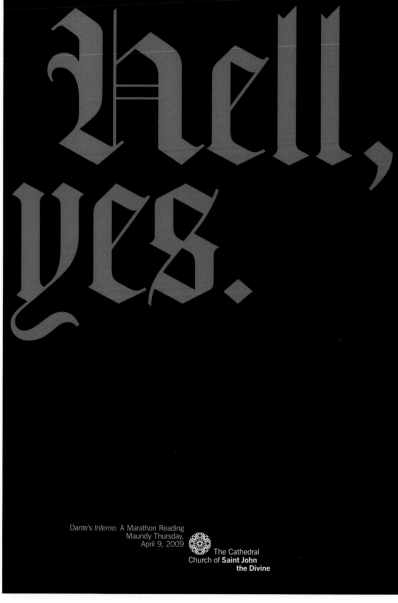

Above
Tightrope artist
Philippe Petit
has been
the cathedral's
artist in
residence
since 1982.
This poster
promoted
a benefit
showing of the
biographical
movie *Man
on Wire*.

Above
A poster
to promote
the annual
marathon
reading of
Dante's *Inferno*
held on
Holy Week's
Maundy
Thursday.

Right
For the
cathedral's
2012 exhibition
*The Value
of Water*,
we rendered
Goudy's
blackletter in
liquid form.

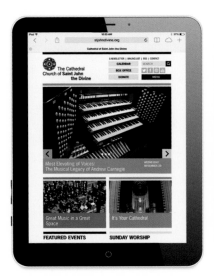

Left
The identity
carries through
to digital
applications,
from desktop
to mobile.

Right
St. John's
communica-
tions director
Lisa Schubert
always seeks
opportunities
to surprise
visitors. Each
year, on
the Feast of
St. Francis
of Assisi,
the cathedral
convenes its
traditional
Blessing of
the Animals.
We created
T-shirts to mark
the event.

The Cathedral Church of St. John the Divine

Above and left
Canine commandments? The signs I created with Pentagram's Jesse Reed to encourage visitors to respect the cathedral grounds have become attractions in their own right.

10 January – 3 March
Exhibition

Third Floor North Wall
**Takenaka Internship Work
of Brian Papa**

Third Floor South Wall
Visual Studies

13 May – 3 June
Exhibition

Seventh Floor
North South Galleries
Graduating Student Wo
Seventh Floor Central Ga
Other Student Work

13 May – 18 August
Exhibiton

Second Floor North Gal
**Nominees for H.I.
Feldman Prize**

17 January
Lecture

Tod Williams & Billie Tsien
Paul Rudolph Lecturers
"To Be Continued"

31 January
Lecture
James Glymph
Gordon Smith Lecturer in Practical Architecture
"Practical Architecture?"

3 April – 5 May
Exhibition
North Gallery
**Steven Harris:
The Weiss Houses**

10 April
Lecture

Greg Lynn
Davenport Visiting Professor
"On the Surface"

6 April
Lecture
Zaha H
Eero

How to disorient an architect
Yale University School of Architecture

YALE
SCHOOL
OF ARCHI-
TECTURE

Architecture as an Art
PIONEERING PRECEDENCE
Commitment to Education
Professional Nature of the Program
ECLECTIC APPROACH
An important milestone
Accelerating Urbanization
Rapid, abrupt changes

Opposite
The posters
for Yale use
hundreds
of typefaces
but only one
color: black.

Above
My original
presentation
to Robert
A. M. Stern
contrasted
what was
expected
(classicism)
with what
we delivered
(eclecticism).

"I want to surprise people."

Robert A. M. Stern was being watched, and he knew it. He was the newly appointed dean of the Yale University School of Architecture, from where he had graduated in 1965. Expectations were running high, and so were suspicions. As editor of *Perspecta*, the school's student magazine, he had been an early promoter of the then-radical postmodernist theories of Robert Venturi and Denise Scott Brown. He took up the practice himself as an idealistic young designer in New York City.

35 years later, he was one of the most successful architects in the world, effortlessly moving between Shingle Style vacation homes for millionaires and impeccably detailed dormitories for Georgian Revival college campuses. But Stern's mastery of the language of architectural history was a red flag for some of his modernist colleagues, one of whom had already dismissed him as a "suede-loafered sultan of suburban retrotecture." Would he remake Yale into a 21st-century Beaux-Arts finishing school?

Stern relished the prospect of overturning expectations. The school had been dormant too long, predictable and easy to ignore, he told me in 1999. He laid out an aggressive program of lectures, exhibitions, and symposia, filled with complexity and contradiction, and asked me to create a graphic program to broadcast it to the world. It was an intimidating challenge. Stern's previous appointment was at Columbia University, in a program famous for a long-running series of posters designed by Swiss-born Willi Kunz, which used only a single typeface family, Univers. They were immediately identifiable and impossible to compete with. What single typeface could possibly sum up Stern's agile eclecticism?

The answer seems obvious in retrospect. Instead of using a single typeface, I proposed never using the same typeface twice: a graphic system that would achieve consistency through diversity. Fifteen years in and counting, including encounters with a few fonts I may never use again (cf. Brush Script, Robert E. Smith, 1942), our posters for Yale Architecture still surprise even me.

Right and opposite
Stern has turned Yale's architecture program into a hothouse of activity, with an overstuffed calendar of events emphasizing contrasting points of view.

Next spread
Each year, posters announce the school's fall and spring program of events. How many different ways can we find to present the same information?

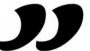

Yale School of Architecture
**Lectures and Exhibitions
Fall 2000**
A&A Building
180 York Street
New Haven, CT
Phone: 203.432.2889
Email: architecture.pr@yale.edu

Lectures begin at 6:30 PM in
Hastings Hall—located on
the basement floor. Doors Open
to the General Public at 6-15 PM

Exhibition hours are
Monday through Saturday,
10:00 AM to 5:00 PM.
Main, North, and South Galleries
are located on the second floor.

Cesar Pelli: Building Designs 1965-2000
Exhibition: Main, North and
South Galleries
September 5–November 3

Bernard Cache[2]
September 7
"Current Work"

Marion Weiss and Michael Manfredi
Paul Rudolph Lecture
September 11
"Site Specific"

Steven Holl[2]
September 14
"Parallax"

Dietrich Neumann
September 18
"Architecture of the Night"

Douglas Garofalo
Bishop Visiting Professor
September 25
"Materials, Technologies, Projects"

Elizabeth Diller[2]
September 28
"Blur–Babble"

Herman D. J. Spiegel
Myriam Bellazoug Lecture
October 2
**"Gaudi's Structural Expression and
Its Implications for Architectural
Education"**

William McDonough[1,2]
October 5
"Future Work"

Hon. Anthony Williams[3]
Mayor, Washington, D.C.
Eero Saarinen Lecture
October 6
**"Recasting the Shadows: The District
in the Twenty-First Century"**

Richard Sennett[3]
Roth-Symonds Lecture
October 7
"Urbanism and the New Capitalism"

Aaron Betsky
October 9
"Architecture Must Burn"

Julie Bargmann[1]
October 12
**"Toxic Beauty: Regenerating
the Industrial Landscape"**

Beatriz Colomina[2]
October 23
"Secrets of Modern Architecture"

Ken Yeang[1]
October 26
**"The Ecological Design of
Large Buildings and Sites:
Theory and Experiments"**

Charles Jencks
Brendan Gill Lecture
October 30
"The New Paradigm in Architecture"

Craig Hodgetts and Ming Fung[2]
Saarinen Visiting Professors
November 2
"By-products: Form Follows Means"

Kathryn Gustafson
Timothy Lenahan Memorial Lecture
November 6
**"European and American
Landscape Projects 1984-2000"**

Jacques Herzog[3]
November 9
"Architecture by Herzog & de Meuron"

Ignacio Dahl Rocha
November 13
**"Learning From Practice:
the Architecture of
Richter and Dahl Rocha"**

The British Library
Colin St. John Wilson & M. J. Long
Exhibition: Main Gallery
November 13–December 15

(a)way station
a project by KW:a
Paul Kariouk & Mabel Wilson
Exhibition: North Gallery
November 13–December 15

in.formant.system
Douglas Garofalo
Exhibition: South Gallery
November 13–December 15

Max Fordham and Patrick Bellew[1]
November 16
"Labyrinths and Things"

Barry Bergdoll
November 20
**"Siting Mies: Nature and Consciousness
in the Modern House"**

Richard Foreman[1]
November 30
**"Landscape, Ecology and
Road System Ecology: Foundation
for Meshing Nature and People
So They Both Thrive"**

1 These lectures are part of "Issues in Environment and Design"
seminar given in collaboration with Yale School of Forestry and
Environmental Studies.

2 These lectures are part of "The Millennium House" seminar.

3 These lectures are part of "Next Cities" symposium.

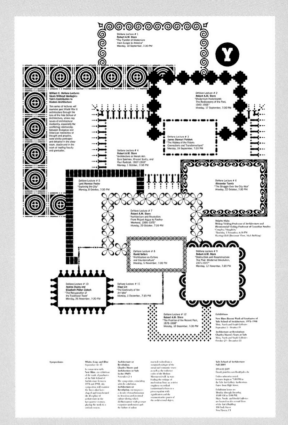

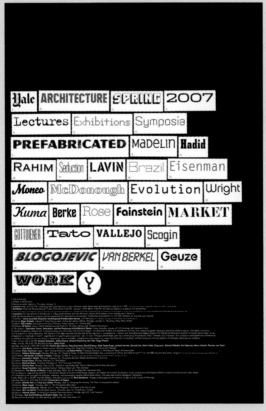

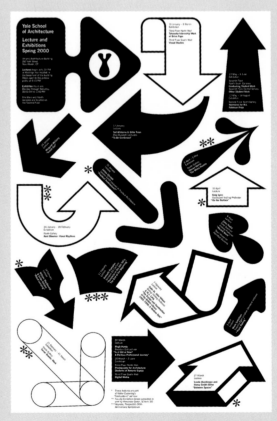

Yale University School of Architecture

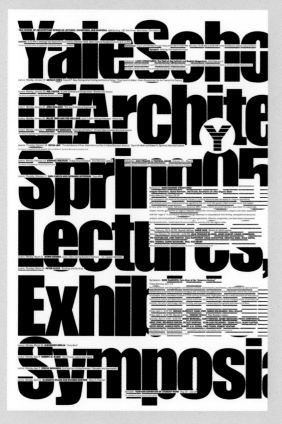

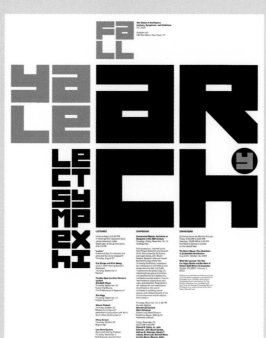

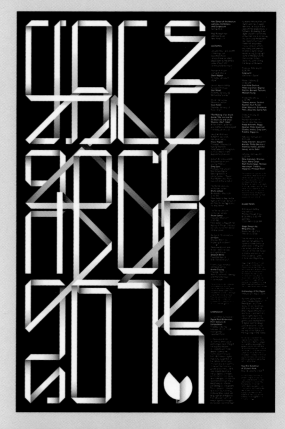

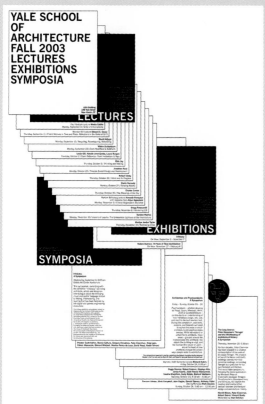

Right and opposite

Designing posters for symposia is an opportunity to make direct references to specific subject matter, including the density of urban life, the architecture of Charles Moore, the signage of the Las Vegas strip, the lost art of drawing, or the legacy of George Nelson.

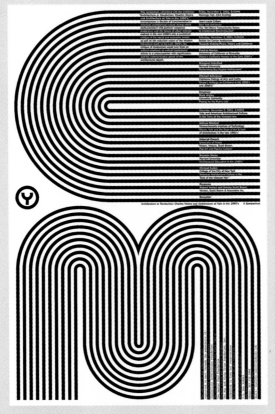

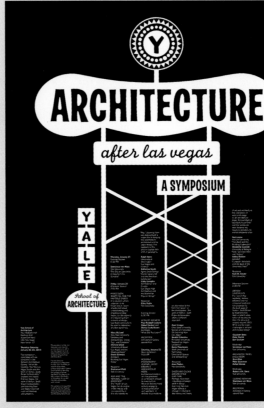

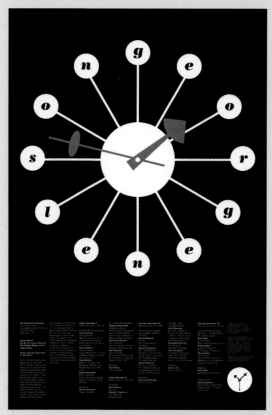

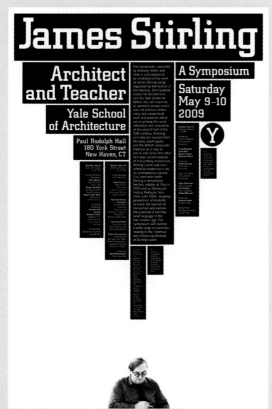

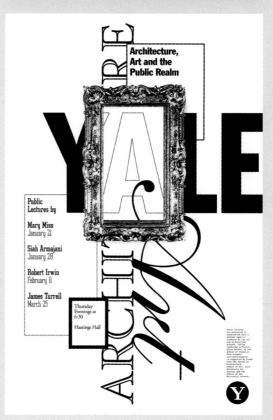

Each year, Yale holds an open house for prospective architecture students. Many of the accompanying posters have exploited the geometry of the letter Y or the implied invitation of the letter O.

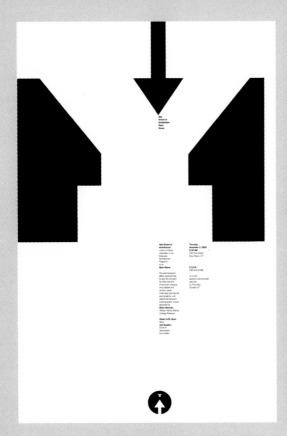

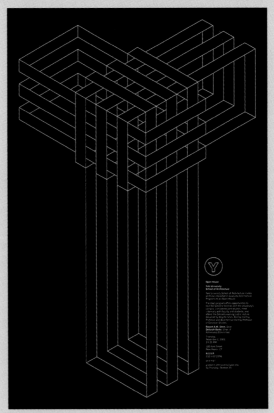

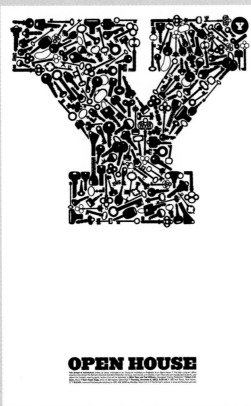

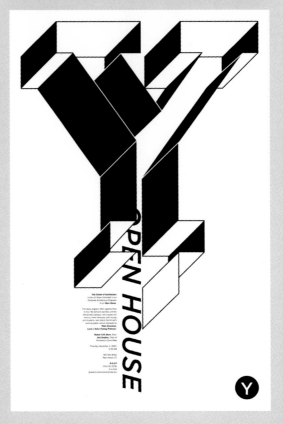

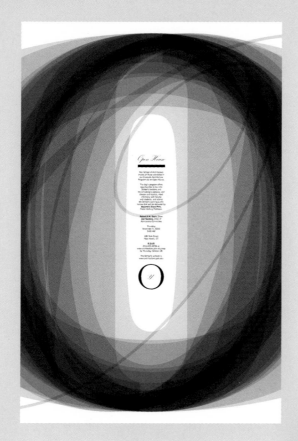

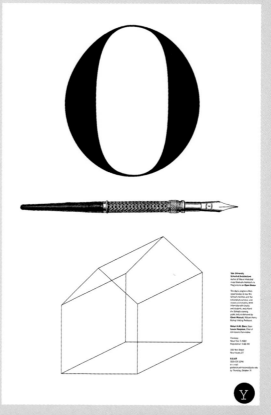

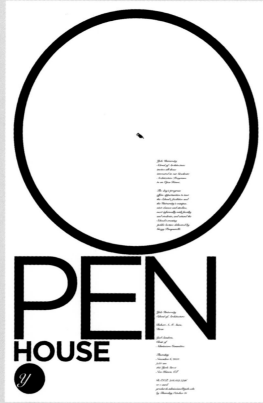

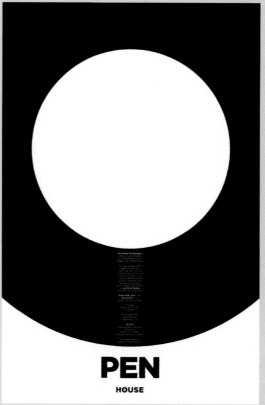

Right

Our clients at Yale have been remarkably tolerant. When we proposed a poster using only one size of type (the smallest), and indicating emphasis with cues like bold weight and underlines, they acquiesced, and politely asked us not to do it again.

YALE SCHOOL OF ARCHITECTURE

Lectures, Symposia, Special Events, and Exhibitions • Fall 2012

Paul Rudolph Hall, 180 York Street, New Haven, CT

LECTURES

Lectures begin at 6:30 PM in Hastings Hall (basement floor). Doors open to the general public at 6:15 PM.

Thursday, August 30 • **Peter Eisenman** • "Palladio Virtuel: Inventing the Palladian Project"

Thursday, September 6 • **Amale Andraos and Dan Wood** • "Nature-City"

Thursday, September 13 • **Tom Wiscombe**, Louis I. Kahn Visiting Assistant Professor • "Composite Thinking"

Thursday, September 20 • **Diana Balmori**, William Henry Bishop Visiting Professor, **and Joel Sanders** • "Between Landscape and Architecture"

Thursday, October 4 • **Paul Rudolph Lecture** • **Brigitte Shim** • "Ways of Seeing Sound: The Integral House" • Opening lecture of the symposium "The Sound of Architecture"

Friday, October 5 • **Elizabeth Diller** • "B+/A−" • Keynote to the symposium "The Sound of Architecture"

Thursday, October 11 • **Keller Easterling** • "The Action is Form"

Thursday, November 1 • **Brendan Gill Lecture** • Panel Discussion • **Mary Ann Caws, Jean-Louis Cohen, Beatriz Colomina, Peter Eisenman, Mark Jarzombek, Kevin Repp** • "The Eisenman Collection: An Analysis"

Thursday, November 8 • **Billie Tsien and Tod Williams**, William B. and Charlotte Shepherd Davenport Visiting Professors • "The Still Place"

Friday, November 9 • **Marc Newson with Edward S. Cooke, Jr.** • "A Conversation" • Keynote to the symposium • "George Nelson: Design for Living, American Mid-Century Design and Its Legacy Today"

Thursday, November 15 • **Eero Saarinen Lecture** • **Dr. Richard Jackson** • "We Shape Our Buildings: They Shape Our Bodies"

The School of Architecture fall lecture series is supported in part by Elise Jaffe + Jeffrey Brown, the Brendan Gill Lectureship Fund, the Paul Rudolph Lectureship Fund, and the Eero Saarinen Visiting Professorship Fund.

SYMPOSIA

Thursday–Saturday, October 4–6, 2012 • The J. Irwin Miller Symposium • **THE SOUND OF ARCHITECTURE** • Hastings Hall (basement floor) unless otherwise noted

Architecture is not tone deaf: It can create silent places and eddies of noise, deeply affecting our experience and facilitating or frustrating communication. Buildings have long been thought of in visual and practical terms, leaving their aural dimension largely unconsidered. Today, the ways we listen in built spaces have been transformed by developments in media, music, and art. New design tools are helping architects shape the soundscapes of their buildings, while new audio technologies afford access to previously undetected sonic environments. This symposium will draw on a variety of disciplinary expertise in its quest for an understanding of architecture as an auditory environment. Leading scholars from fields as diverse as archeology, media studies, musicology, philosophy, and the history of technology will converge to discuss critical questions alongside major architects, acoustical engineers, composers, and artists. This symposium aims to stake out a new set of questions for ongoing scholarly inquiry and to reaffirm architecture as a place of convergence among old and emerging disciplines.

Thursday, October 4, 6:30 PM • **Brigitte Shim** • "Ways of Seeing Sound: The Integral House"

Friday, October 5, 9:00 AM–6:00 PM • **Dorothea Baumann, Barry Blesser, Mario Carpo, Carlotta Darò, Ariane Lourie Harrison, Craig Hodgetts, Mark Jarzombek, Randolph Jordan, Brian Kane, Graeme Lawson, Ingram Marshall, Raj Patel, John Durham Peters, Linda-Ruth Salter, Joel Sanders, Jonathan Sterne, Peter Szendy, Jack Vees, Beat Wyss**

Friday, October 5, 6:30 PM • Keynote Address • **Elizabeth Diller** • "B+/A−"

Saturday, October 6, 9:30 AM–3:30 PM • Whitney Humanities Center • 53 Wall Street • **Michelle Addington, Niall Atkinson, Timothy Barringer, Joseph Clarke, J.D. Connor, Veit Erlmann, Brandon LaBelle, Alexander Nemerov, John Picker, William Rankin, Karen Van Lengen, Sabine von Fischer**

Friday–Saturday, November 9–10, 2012 • **GEORGE NELSON: DESIGN FOR LIVING, AMERICAN MID-CENTURY DESIGN AND ITS LEGACY TODAY** • Hastings Hall (basement floor)

Coinciding with the exhibition "George Nelson: Architect, Writer, Designer, Teacher" at the School, this symposium will examine the work of the designer George Nelson in the context of his time and the legacy of mid-century modern design today. Nelson and his contemporaries (among them Edward Wormley, Eero Saarinen, Harry Bertoia, Charles and Ray Eames, Jens Risom, and Florence Knoll) helped to evolve the Bauhaus aesthetic into a more colorful, playful, technically savvy, and versatile idiom evocative of the American lifestyle in the mid-century. From the Marshmallow Sofa for Herman Miller to the multimedia extravaganza "Visions of the U.S.A.," designed for the 1959 Sokolniki Park exhibition in Moscow, Nelson's highly collaborative approach to design has had a lasting influence. The challenges and opportunities that framed and inspired Nelson's work are matched by the paradigm shifts contemporary designers face today.

Friday, November 9, 2:00 PM–6:00 PM • **Kurt W. Forster, John Stuart Gordon, John Harwood, Juliet Kinchin, Murray Moss, Dietrich Neumann, Margaret Maile Petty, Kristina Wilson**

Friday, November 9, 6:30 PM • Keynote Address • **Marc Newson with Edward S. Cooke, Jr.** • "A Conversation"

Saturday, November 10, 9:30 AM–4:00 PM • **Donald Albrecht, Ralph Caplan, Beatriz Colomina, Jochen Eisenbrand, Rob Forbes, Paul Makovsky, Christopher Pullman, Alice Rawsthorne, Jane Thompson**

"The Sound of Architecture" is supported by the J. Irwin Miller Endowment Fund. "George Nelson: Design for Living, American Mid-Century Design and Its Legacy Today" is supported in part by the generosity of the Edward and Dorothy Clarke Kempf Fund. The Yale School of Architecture is a Registered Provider with The American Institute of Architects Continuing Education Systems. Credit earned by attending these symposia will be reported to CES Records for AIA members. Certificates of Completion for non-AIA members are available upon request.

SPECIAL EVENT

Friday–Saturday, November 30–December 1, 2012 • **YALE WOMEN IN ARCHITECTURE: A REUNION AND CELEBRATION OF THE 30TH ANNIVERSARY OF THE SONIA SCHIMBERG AWARD**

This first-ever gathering of the alumnae of the Yale School of Architecture will celebrate the accomplishments of women architects across the years and mark the 30th anniversary of the Sonia Albert Schimberg Award. Sonia Albert (M.Arch. 1950) was one of two women architecture graduates that year and her daughters created the award in her memory to recognize the most promising woman graduate each year. The gathering will present and discuss the legacy of women graduates of Yale and take stock of the current conditions in architecture and related fields. Topics include the roles of client and architect, social change, shifting and enlarging the definition of practicing and teaching architecture. Alumnae spanning over 30 years of graduating classes as well as current students and experts from other disciplines, will participate in the program. Come and take part in helping to shape the future for Yale women in architecture.

EXHIBITIONS

Architecture Gallery, second floor • Monday through Friday, 9:00 AM to 5:00 PM • Saturday, 10:00 AM to 5:00 PM

August 20–October 27, 2012 • **PALLADIO VIRTUEL**

November 8, 2012–February 2, 2013 • **GEORGE NELSON: ARCHITECT, WRITER, DESIGNER, TEACHER**

"Palladio Virtuel" is supported in part by the Graham Foundation for Advanced Studies in the Fine Arts and by Elise Jaffe + Jeffrey Brown. "George Nelson: Architect, Writer, Designer, Teacher" is an exhibition of the Vitra Design Museum, Weil am Rhein, Germany. The American tour of the exhibition has been generously sponsored by HermanMiller, who is also the presenting sponsor of the exhibition at the Yale School of Architecture. The Yale School of Architecture's exhibition program is supported in part by the James Wilder Green Dean's Resource Fund, the Kibel Foundation Fund, The Nitkin Family Dean's Discretionary Fund in Architecture, the Pickard Chilton Dean's Resource Fund, the Paul Rudolph Publication Fund, the Robert A.M. Stern Fund, and the Rutherford Trowbridge Memorial Publication Fund.

I asked Marian Bantjes to hand-letter a poster on seduction in architecture, specifying a treatment that was "sick with lust." She delivered. In a bizarre turn of events, the design was stolen by P. Diddy's fashion label; with a few deft changes, they changed "Seduction" to "Sean John." How strange and wonderful to live in a world with such porous borders.

SEDUCTION:
FORM,
SENSATION,
AND
THE
PRODUCTION
OF
ARCHITECTURAL
DESIRE
A SYMPOSIUM
JANUARY 19-20,
2007

A decade of explosive development in communication and information retrieval technologies, from Bluetooth to GPS and Blackberries to iPods, has produced a global datascape where the ability to access information, anywhere, and at anytime, is nearly ubiquitous. The alliance of this datasaturated scenario with similar advances in computational, material, and fabrication technologies requires the field of architecture to question its historic presumption as an embodiment of meaningful content—regardless of its specific posturing as icon, sign, or index.

Through presentations given by a select group of architects, critics, theorists, and innovators this symposium will explore how architecture is shedding its burden of communication in favor of new formal ambitions, including the customization of moods, the influences of sensation, and the emergence of a new species of irrefutably contemporary aesthetics.

FRIDAY
JANUARY 19, 2007
3:30 PM

WELCOME
Robert A.M. Stern

MAKING APPEARANCES

Introduction
Ben Pell
Architect,
Yale University

Herbert Muschamp
Critic
Peggy Phelan
Performance Theorist,
Stanford University
Gregory Crewdson
Photographer,
Yale University
Jeffrey Kipnis
Theorist,
Ohio State
University

Response
Sarah Whiting
Theorist,
Princeton University

FRIDAY
JANUARY 19, 2007
6:30 PM

KEYNOTE
Sylvia Lavin
Theorist,
University of California,
Los Angeles
"As If"

RECEPTION
Architecture Gallery
2nd floor
A&A Building

SATURDAY
JANUARY 20, 2007
9:30 AM

WELCOME
Mark Foster Gage
Architect, Yale University

PRACTICING SEDUCTION

Introduction
Henry Urbach
Curator,
San Francisco MoMA

Hernan Diaz-Alonso
Architect,
Southern California
Institute of Architecture,
Columbia University
David Erdman
Architect,
University of California,
Los Angeles
Mark Foster Gage
Architect,
Yale University
Kivi Sotamaa
Architect,
Ohio State
University

Response
Peter Eisenman
Architect,
Yale University

SATURDAY
JANUARY 20, 2007
1:15 PM

FORMS OF SEDUCTION

Introduction
Edward Mitchell
Architect,
Yale University

Roemer Van Toorn
Theorist,
Berlage Institute
Sanford Kwinter
Theorist,
Rice University
Greg Lynn
Architect,
Yale University
Chrissie Iles
Curator,
Whitney Museum
of American Art

Response
Mark Linder
Theorist,
Syracuse University

Concluding
Conversation
Gregory Crewdson
Peter Eisenman
Chrissie Iles
Sylvia Lavin

RECEPTION
Architecture Gallery
2nd floor
A&A Building

YALE SCHOOL
OF ARCHITECTURE
A & A Building
Hastings Hall
(basement floor)
180 York Street,
New Haven, CT

This
symposium
is free,
but
reservations
are required
prior to
January 12,
2007.
Phone
203.432.2889
or email
archevents@
yale.edu.

The Yale
School of
Architecture
is a Registered
Provider with
The American
Institute of
Architects
Continuing
Education
Systems.
Credit earned
by attending
this symposium
will be reported
to CES Records
for AIA members.
Certificates
of Completion
for non-AIA
members
are available
upon request.

Architecture and Psychoanalysis

Yale School of Architecture **Symposium**

A&A Building, Hastings Hall
180 York Street, New Haven, CT

This symposium is partially funded by a grant from the Graham Foundation for the Advanced Studies in the Fine Arts and the David W. Roth and Robert H. Symonds Memorial Lecture Fund.

This symposium is free but reservations prior to Oct 10, 2003 are required.

Yale School of Architecture
P.O.Box 208242
New Haven, CT 06520

Phone: 203.432.2889
Fax: 203.432.7175
email: jennifer.castellon@yale.edu

Friday
October 24, 2003
Evening Session
6:30 pm

KEYNOTE
Roth-Symonds Lecture
Richard Kuhns, Professor of Philosophy, Columbia University
"Constructive and Destructive Passion: Architecture and Psychoanalytic Thought"

RECEPTION
Architecture Gallery, 2nd floor A&A Building

Saturday
October 25, 2003
Morning Session
9:30 am

THE CREATIVE SUBJECT: ARCHITECTS / ARCHITECTURE

IDENTITY
Juliet Flower MacCannell, Professor Emeritus, English and Comparative Literature, U.C. Berkeley
"Breaking Out"
Suely Rolnik, Professor, Dept. of Social Psychology, Catholic University of Sao Páulo
"Beyond the Pumping of Creation"

ORGANIZATION
Robert Gutman, Lecturer in Architecture, Princeton University
James Krantz, Organizational Consultant
"The Psychodynamics of Architectural Practice"

Saturday
October 25, 2003
Afternoon Session
1:15 pm

THE OBJECT: BUILDING / CITY

THE BUILDING
Stephen Kite, Architect and Professor, University of Newcastle
"Adrian Stokes and the 'Aesthetic Position': Psycho-analysis and the Spaces In-Between"
Peggy Deamer, Associate Professor, Yale University
"Form and (Dis)Content"

THE CITY
Sandro Marpillero, Adjunct Associate Professor of Architecture, Columbia University
"Urban Operations: Unconscious Effects"
Richard Wollheim, Professor in Residence, Dept. of Philosophy, U.C. Berkeley; faculty, San Francisco Psychoanalytic Institute
"Why We Hate the Modern City"

Sunday
October 26, 2003
Morning Session
9:30 am

Anthony Vidler, Dean, Cooper Union School of Architecture
"The Psychogeography of Vienna: Little Hans from Freud to Lacan"
Joan Copjec, Professor of English, Comparative Literature, and Media Studies and Director, Center for the Study of Psychoanalysis and Culture, SUNY Buffalo
"Disorientation"
Parveen Adams, Convenor M.A. and Ph.D. program, Psychoanalytic Studies, Brunel University
"Sexual Accidents"

REPRESENTING / WRITING THE SPATIAL EXPERIENCE
Donald Spence, Clinical Professor of Psychiatry, UMDNJ
"Boundary Violations and Other Un-Heimlich Maneuvers"
Mark Campbell, Managing Editor, Grey Room
"Geoffrey Scott and the Dream-Life of Architecture"

CLOSING REMARKS
Mark Cousins, Director of History and Theory Program, Architectural Association
"Two Principles of Architectural Functioning"

RECEPTION
Architecture Gallery, 2nd floor A&A Building

Photo: Knoll / Barcelona 1929 / Mies van der Rohe

Left
To reinforce the theme of constant variation, the logo for the school is a Y in a circle, but a different Y each time. Here it appears as a Rorschach blot.

Next spread
The posters for Yale are a favorite project in the studio, and countless designers and interns on my team have contributed to them over the past 15 years, most notably Kerrie Powell, Michelle Leong, Yve Ludwig, Laitsz Ho, and Jessica Svendsen. John Jacobson at Yale has supervised the work from the start. And, of course, my greatest thanks go to Robert A. M. Stern, whose support has been continuous and inspiring throughout my career.

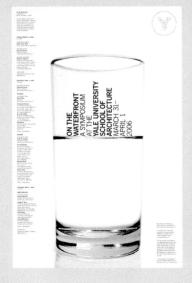

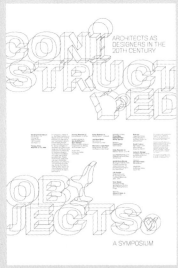

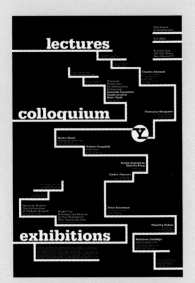

Yale University School of Architecture

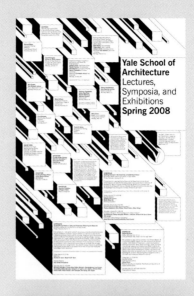

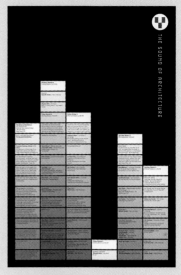

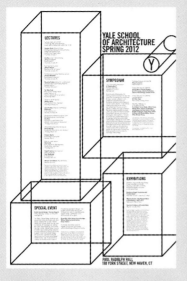

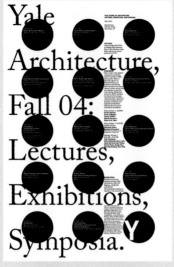

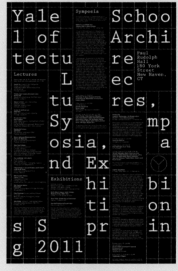

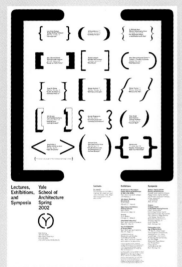

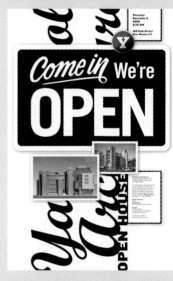

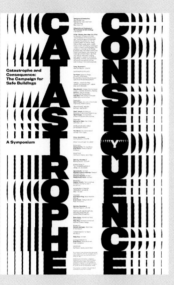

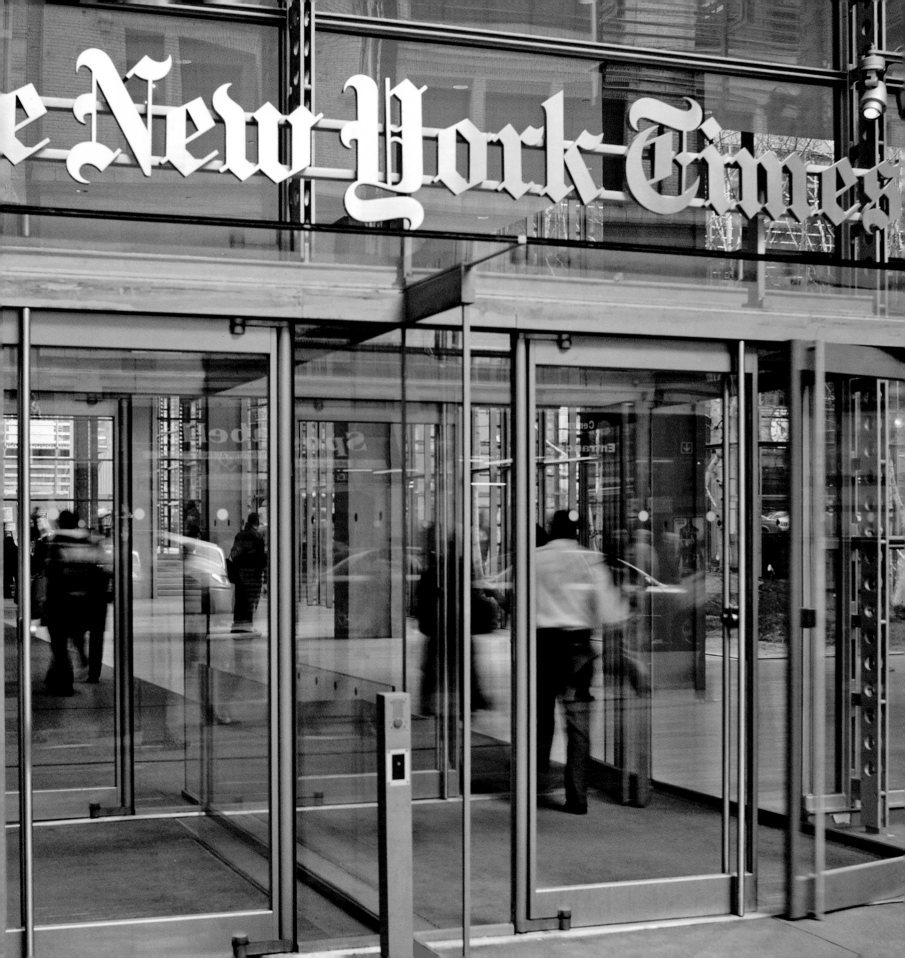

How to put a big sign on a glass building without blocking the view
The New York Times Building

In 2001, the *New York Times* hired the Pritzker Prize-winning architect Renzo Piano to design its new headquarters. For nearly 90 years, the *Times* had operated out of a drab masonry heap on West 43rd Street. It looked like a factory because that's what it was. The newspapers were printed in its basement and loaded on trucks that departed each morning before dawn to deliver the news to the world.

Piano's design, located three blocks south, was radically different: clad in glass from top to bottom, veiled with a sunscreen of horizontal ceramic rods that evoke the lines of type on the paper's front page, it is a hymn to digital immateriality and journalistic transparency.

But there was a problem. The new building sits within a district that is governed by signage restrictions that are unlike any in the nation. Created to preserve the cacophonous character of Times Square, instead of minimizing the size and quantity of signs, they mandate more, bigger, and flashier signs, signs that by law must be attached to buildings rather than integrated into their facades. But where could a sign go on a building that was glass from top to bottom? As the project's sign designers, this was our problem to solve.

Our solution was to install the paper's iconic nameplate, 110 feet long, on the building's Eighth Avenue facade. The sign is made of 959 small teardrop-shaped pieces, each applied precisely to the grid of ceramic rods. The two-inch projections that form the tail of the drops make the sign seem opaque when viewed from below. Viewed straight on—from inside the building—they are nearly invisible.

The building is beautiful, but some feared the staff might miss the decades-old patina of their previous home. In response, we made each sign inside the building—all 800 of them from conference rooms to bathrooms—unique. Each features a different image from the *Times'* vast photo archive, rendered in an exaggerated dot pattern as an homage to the presses that once rumbled each night beneath the reporters' offices.

Like many other designers, my earliest assignments from the *New York Times* were illustrations for their opinion pages: reductive, telegraphic images meant to tempt readers to engage with complex and sometimes dense ideas. This is high-pressure design at its most exciting: you get the job a few days before presentation, your design must be submitted and approved within 24 hours, and it runs in the paper a day later. This immediate gratification is refreshing compared with the months- (or years-) long process associated with most design projects.

Right
George Kennan argues against the expansion of NATO. Extending the acronym negates it.

Below
Invading an oil-rich region as the odometer turns.

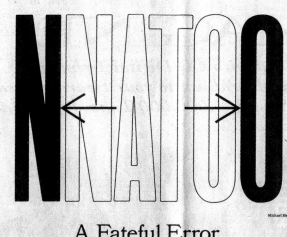

THE NEW YORK TIMES **OP-ED** WEDNESDAY, FEBRUARY 5, 1997

Foreign

THOMAS L

The Neut

A Fateful Error

DAVOS, Switzerland
In virtually every article about the dispute between Swiss bankers and Jewish groups over the bank accounts of Holocaust victims, there is a historical reference that is blandly repeated over and over: "Switzerland was neutral during World War II." Every time I read that reference I can't help thinking: What does it mean to be neutral between the perpetrators of the worst crimes against humanity in modern history and their victims? What does it mean to say that the same rules should apply to the money of both? What does it mean to put yourself outside history?

The reason this Nazi banking issue continues to fester is because too many Swiss still insist on being morally neutral, on trying to live off the international system without being fully part of it. As one senior Swiss official remarked to me: "The Swiss people are shocked by this banking affair, because they are not used to seeing themselves on CNN." In their view, they are the victims of a plot to take their quiet little country away, to drag them back into history.

Michael Bierut

THE NEW YORK TIMES **OP-ED** WEDNESDAY, APRIL 23, 2003

THOMAS L.

Regime Ch

While the war in Iraq has rightly grabbed all the attention in the Middle East, another effort at regime change has also been going on in the neighborhood, and it's been quite a drama. It's the silent coup that Palestinian moderates, led by Mahmoud Abbas, have been trying to undertake against Yasir Arafat.

Mr. Arafat was forced by the Palestinian legislature to designate Mr. Abbas (a k a Abu Mazen) as his first prime minister. The move was openly designed to diminish Mr. Arafat's power and to ease him upstairs, if not out the door. Mr. Abbas has been trying to assemble a cabinet, and Mr. Arafat has been fighting him at every turn — trying to stuff the cabinet with his cronies and deny Mr. Abbas the key security portfolios. Mr. Arafat "fears he will not be the strongman in the coming phase," a Palestinian legislator, Hassan Khraisheh, told The Associated Press in Jerusalem.

He's right, but Mr. Arafat is no pushover, and if Mr. Abbas and his allies in the Palestinian legislature are to prevail, they will need help. America, Europe, Israel and the Arab states should all pitch in.

The Bush team has a huge strategic stake in the outcome of this Palestinian struggle, because it will affect America's room for maneuvering in Iraq. Let me explain. What does America want in Iraq? It wants the emergence of an Iraqi political center, of both parties and politicians, who are authentically Iraqi, authentically nationalist and respectful of Islam — but with a progressive, modernizing agenda and a willingness to

Michael Bierut

Why the Mullahs Love a Revolution

By Dilip Hiro

LONDON
The Bush team's vision for a postwar Iraq was founded on the dreams of exiles and defectors, who promised that Iraqis would shower American troops with flowers. Now, with the crowds shouting, "No to America; no to Saddam," and most Iraqis already referring to the American "occupation," the Bush administration seems puzzled.

ity south and the Shiite neighborhoods of Baghdad. Over the centuries, as members of a community that was discriminated against and repressed, the Shiites learned to find comfort in religion and piety to a much greater extent than the ruling Sunnis. In recent decades, Shiite clerics devised clandestine networks of communication that even Saddam Hussein's spies failed to infiltrate. Eschewing written messages or telephones, they used personal envoys who spoke in code. In the wake of Iraq's collapse, this messenger system has proved remarkably efficient.

solid: although he is a Shiite, he lacks any constituency inside Iraq. Nor is he likely to inspire new followers. Had he joined the hundreds of thousands of Shiites who made the pilgrimage to Karbala this week he might have enhanced his standing. But apparently he couldn't be bothered.

Compare this luxury-loving, highly Westernized banker (who was convicted by Jordan in absentia of embezzlement and fraud) with Ayatollah Khomeini, the ascetic Iranian Shiite cleric who shunned worldly goods and and led a popular revolution that over-

nial government had to call in troops from the Indian Army to quell it. By the time they restored order, 6,500 people were dead, all but 500 Iraqi civilians. The 1920 revolt is the crucible in which Iraqi nationalism was formed. That unity showed its durability during Iraq's armed conflict with the predominantly Shiite Iran in the 1980's. To the complete surprise of the Iranians, Saddam Hussein managed to retain the loyalty of the Iraqi Army, where Shiite conscripts formed a majority.

Thus the only viable solution for

The New York Times Building

The Art Of Being No One

By Joyce Carol Oates

Joe Klein has literary history

Left top
Joyce Carol Oates on the passive-aggressive ironies of anonymity.

Left bottom
The formerly pacifist left supports armed intervention in Kosovo.

Below top
The consequences of split decisions from the Supreme Court. Lucky for me, their building has eight columns.

Below bottom
Readers react to the abrupt finale to *The Sopranos*.

THE NEW YORK TIMES **OP-ED** FRIDAY, APRIL 2, 1999

Michael Bierut

The Supreme Court

The Night We Watched as Tony Went . . .

To create the main sign on the *Times*' building, each letter in its logo was divided into narrow horizontal strips, ranging in number from 26 (the i in "Times") to 161 (the Y in "York"). Pentagram designer Tracey Cameron labored for months with the designers at Renzo Piano Building Workshop and their associated architects, FXFowle, working and reworking the exact pattern. Despite tests, we were never sure it would work. Riding an uptown Eighth Avenue bus, I startled my fellow passengers by clapping when I saw the first letters installed.

Left top
Each precisely located element has a projecting "beak."

Left below
When viewed from below the projections overlap, creating the illusion of opacity.

Above
The horizontal rods that hold the sign were designed to mediate heat gain and loss in the glass-clad skyscraper.

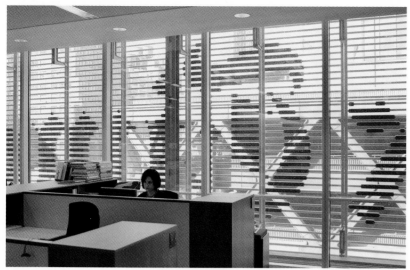

Left
Viewed from inside, the logo barely blocks the view (of, alas, the Port Authority Bus Terminal).

Below
The *Times'* signature Fraktur is a custom version by master type designer Matthew Carter, rendered here at 10,116 point.

Next spread
At one point, I suggested that we consider a subtle white-on-white sign that would disappear at certain times. The paper's CEO, Arthur Sulzberger Jr., looked at me as if I were crazy and said, "Well, the logo is black on the front page, isn't it?"

Following spread
The project manager for the *Times*, the irrepressible David Thurm, asked for ways to bring the paper's history to the new location. The result was 800-plus different room and door signs.

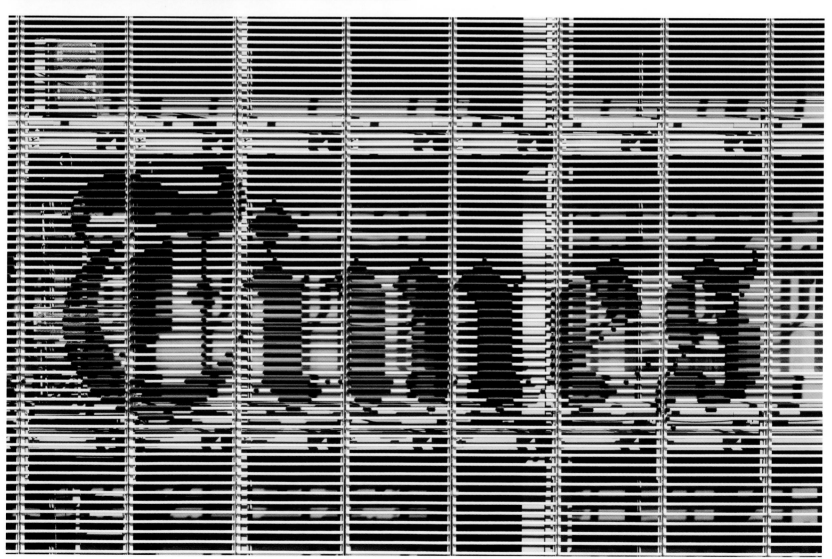

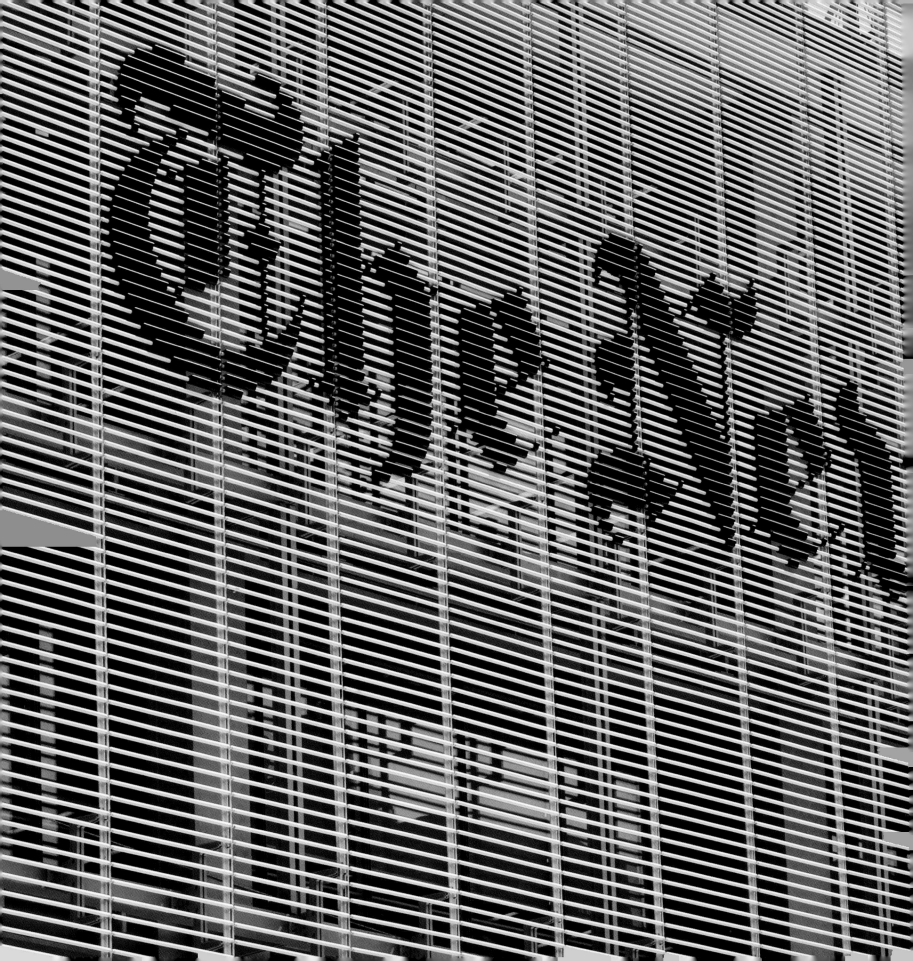

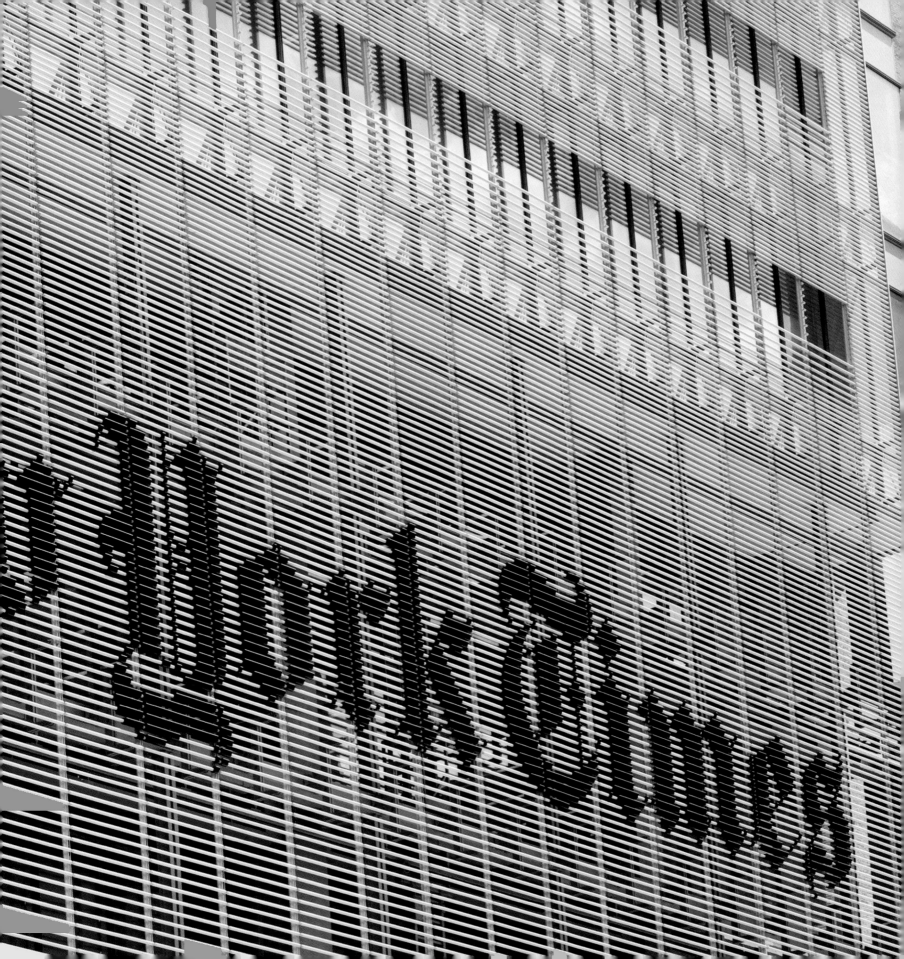

 Men

 03E3-246 Page One

 04P6-352 Video Edit Room

 Women

 04C2-002 Equipment Room

 Men

 02E2-243 Team Room

 21C1-007 Stat Room

 02E2-242 Team Room

10E2-241

Team Room

03E3-246

Conference Room

Conference Center

Women

16N1-205

Copy Room

10W2-215

Team Room

13N2-207

Privacy

Balcony

Riser Closet

How to make a museum mad
Museum of Arts and Design

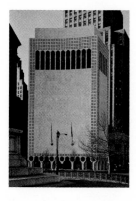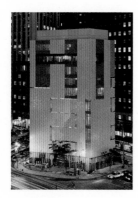

Opposite
Our identity for the Museum of Arts and Design generated a new graphic language for its new home.

Above left
Edward Durell Stone's building at 2 Columbus Circle was one of New York's most polarizing pieces of architecture.

Above right
Brad Cloepfil's controversial redesign transformed a dark warren of rooms into an interconnected series of light-filled spaces.

The Museum of Arts and Design had a long-running identity crisis. Founded in 1956 as the Museum of Contemporary Crafts, it renamed itself the American Craft Museum in 1986. In 2002, it changed its name yet again, to the Museum of Arts and Design, MAD for short. Despite the nifty acronym, five years later most people still hadn't heard of it.

But that was about to change. On Columbus Circle, where Broadway, 59th Street, and Central Park West intersect to form an awkward square, stood a peculiar structure. Completed in 1964 and designed by Edward Durell Stone as a museum for the collection of grocery-store heir Huntington Hartford, it was described by critic Ada Louise Huxtable as a "die-cut Venetian palazzo on lollipops." Hartford's museum lasted only five years. The orphaned building reverted to the city. In 2002, it was offered to the Museum of Arts and Design.

It needed work. Architect Brad Cloepfil proposed a deft transformation, cutting a continuous slot that snaked through its floors, ceilings, and walls. We were asked to create a new graphic identity to mark the rebirth. Inspired by Cloepfil's design, I proposed a logo similarly made of a single line. It was one of the best ideas I ever had.

There was only one problem: it didn't work, at least not with the name MAD. Luckily, I had heard that some people thought the acronym was undignified. I seized on this and proposed a name change to A+D, which emphasized the institution's areas of focus and, conveniently, could be made to work with my idea. I presented this in a series of meetings, armed with ever more elaborate prototypes. But I could not make the sale. If you have a great idea but can't make it work, it isn't a great idea.

That night, I stared at the site. MAD would face the only complete traffic circle in Manhattan. Squares and circles. I looked at the three letters in the name. Could squares and circles be found there as well? The answer was yes. The simplest geometry solved the problem. No longer necessary were straining machinations and feverish salesmanship. Here was that rare thing: a solution that sold itself. It was approved unanimously at the next meeting.

Left top
I was mesmerized by Cloepfil's diagram showing a continuous slot working its way through the building, and used it for my first design concept.

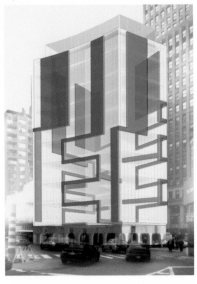

Left middle
Determined to make a logo that echoed the architecture, and finding it would not work with the letters in MAD, I proposed an unlikely name change, to A+D. The client didn't buy it.

Left bottom
Despite multiple meetings and dozens of handmade prototypes, the client was unconvinced. Deep down, so was I.

Below
My second approach abandoned intricate complexity in favor of squares and circles. Once again, simplicity wins.

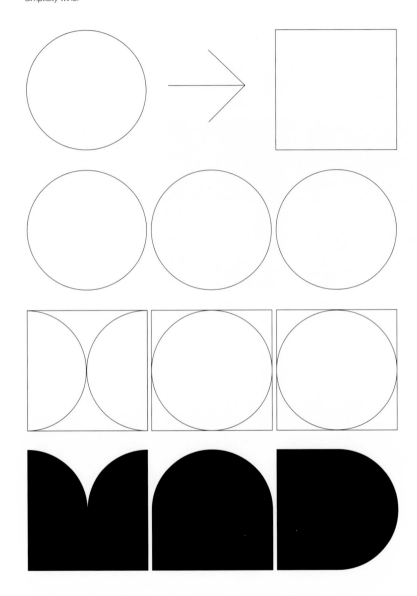

Museum of Arts and Design

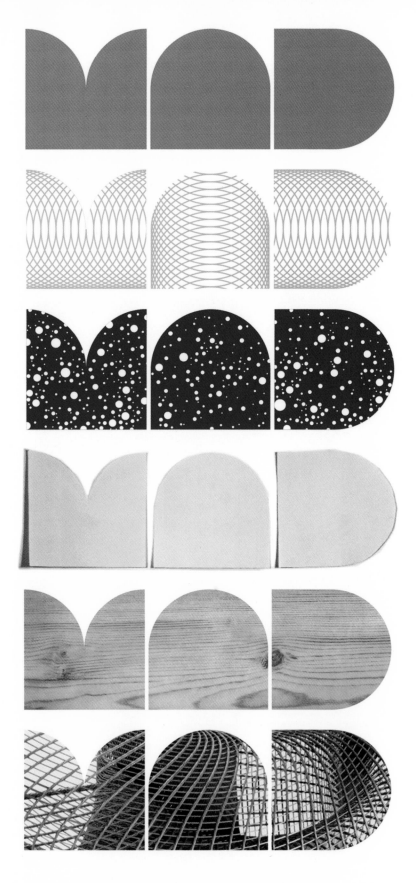

Right
As befits an institution dedicated to craft, the logo is a common form that can be rendered in many materials. Its curved tops are also a sly reference to the building's original "lollipop" columns, visible even after the redesign.

Below
Unlike the original design idea, which required special handling, the new logo was easily adapted to almost any use.

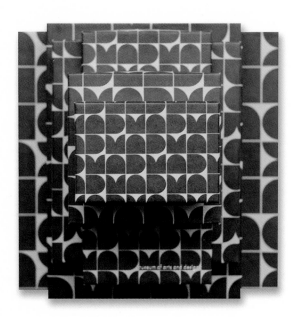

Right top
The graphic language was perfect for repeat patterns for retail shop packaging.

Right middle
Making the solid forms of the logo transparent turned it into an effective window, perfect for shopping bags.

Right bottom
Merchandise sold at MAD celebrates the new identity. Pentagram's Joe Marianek expanded the three letters of the logo into a whole alphabet: MADface. A T-shirt reading "If you can read this, you are MAD" provides commentary on the custom typeface's dubious legibility.

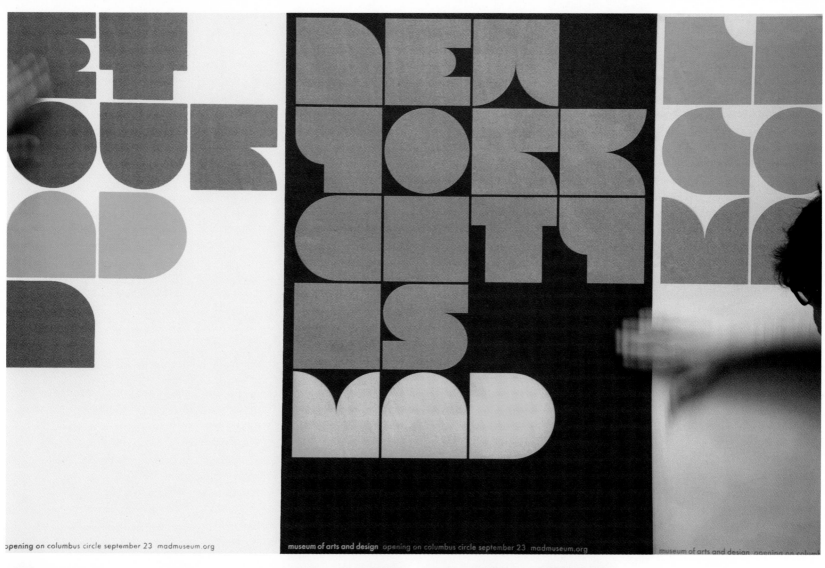

opening on columbus circle september 23 madmuseum.org

museum of arts and design opening on columbus circle september 23 madmuseum.org

museum of arts and design opening on colum

Above
By using MADface, we created a brand that merged logo and message.

Far left
The identity extends into the building both physically and digitally.

Left and next spread
The identity was ubiquitous in New York City when MAD opened in its new home in September 2008.

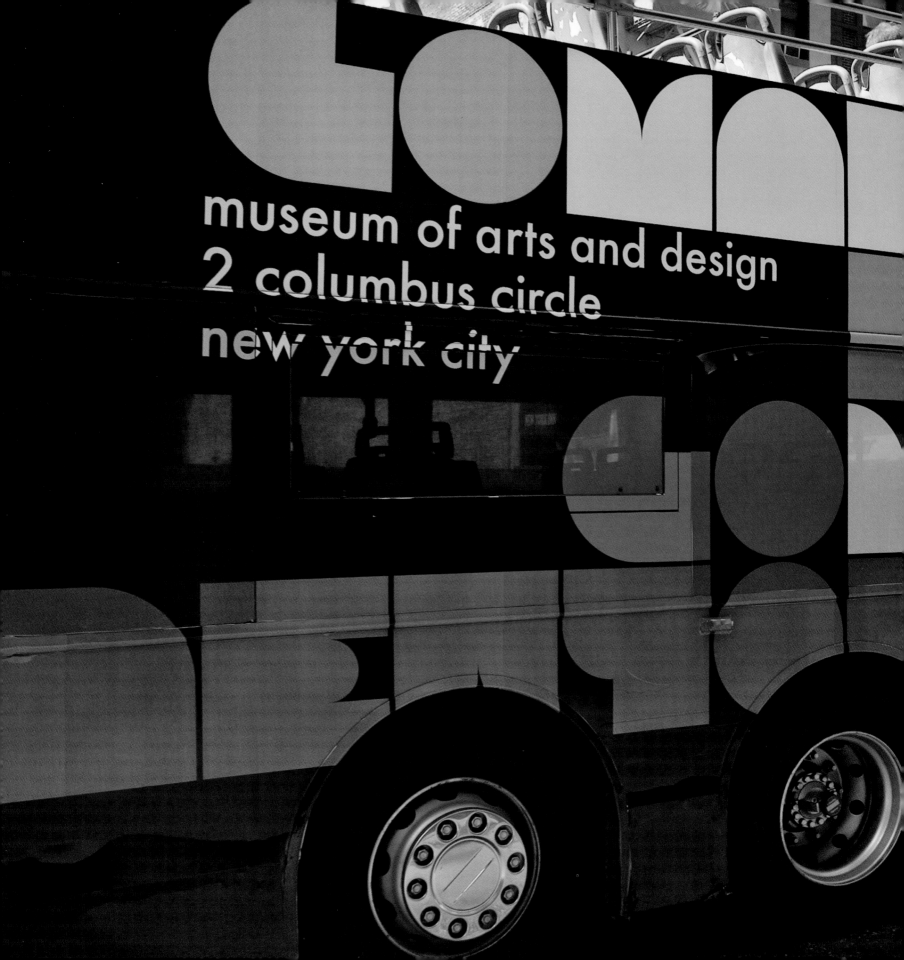

GOD

A BIOGRAPHY

JACK MILES

How to judge a book
Covers and jackets

Opposite
This absorbing analysis by the former Jesuit seminarian Jack Miles subjects the Bible to literary criticism and, remarkably, won the 1996 Pulitzer Prize for biography. Its three-letter title, naturally too big to be contained, designed itself.

Before I took a single design class, I got my education in the aisles of bookstores. In many ways, the design of a book cover is the ultimate challenge. It is inherently, deliciously reductive: whether the book is 48 pages long or 480, it can have only one cover. And that cover, no matter how cerebral the book's contents or how complex its themes, has a single chance to make an impression. Just like a box of cereal or a can of soup, the designer's job is to package a product for sale in a competitive environment.

This is just as true today, if not more so, as both the sales of books and the books themselves move from the physical world to the digital. My goal is to make the package reflect the contents as directly as possible.

I was a bookworm as a child, and I still am today. I read compulsively. Predictably, it has always been hard for me to really enjoy a book with an ugly cover. My most hated were reissues of books newly turned into movies ("Now a Major Motion Picture!"), with covers using portraits of the featured actors to represent fictional characters I would have preferred to cast in my own head. These should really be against the law.

My favorites, naturally, were covers with only type, like the paperback editions of *The Catcher in the Rye* or *Brave New World*. They projected a sense of mystery and importance, daring me to start reading without a single hint of what kind of world I was about to enter. I learned later that many authors shared my bias; J. D. Salinger, in fact, had a clause in his contracts forbidding images of any sort on his book jackets.

It was years before I would have a chance to design a book cover myself. When I finally did, it was no surprise that my best efforts built images from barely more than the contents within: words.

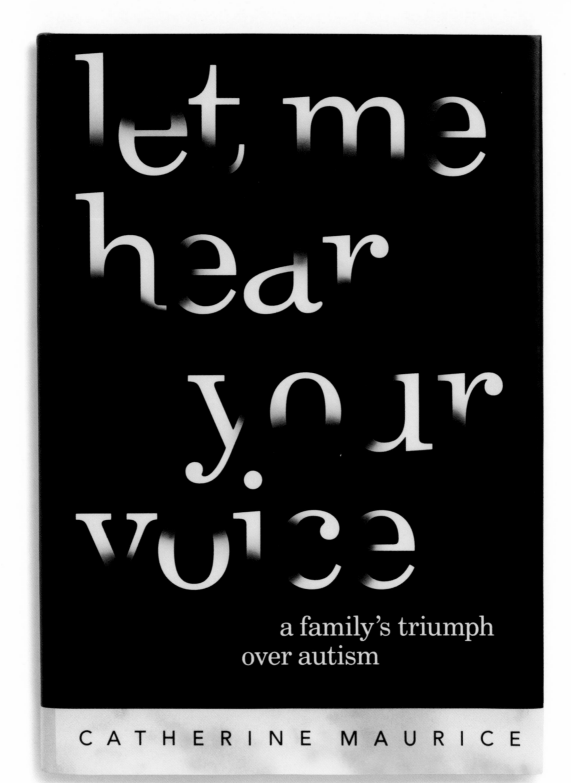

let me
hear
your
voice

a family's triumph
over autism

CATHERINE MAURICE

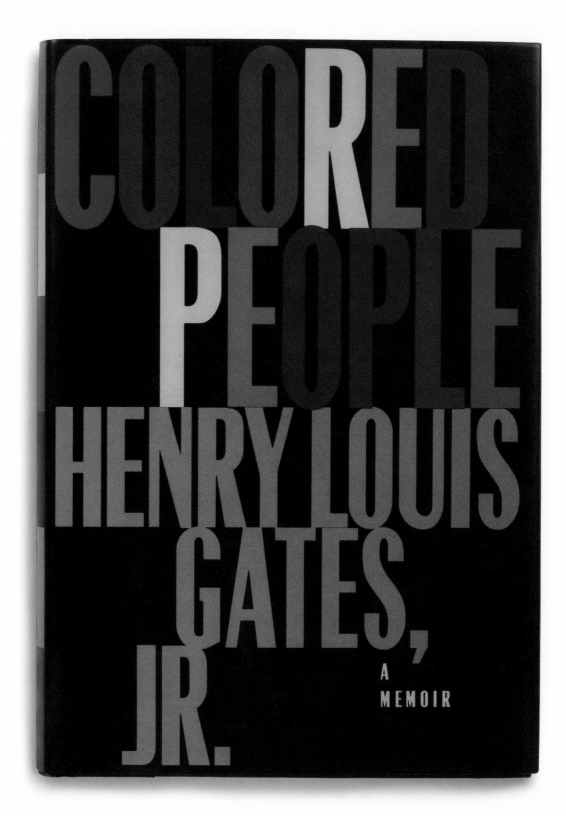

Art director John Gall, facing the challenge of repackaging Vladimir Nabokov's books as paperbacks, had an inspired idea: pick a dozen designers, assign each a title, and hand out specimen boxes, the kind that butterfly collectors (like Nabokov was) use to display their finds. Each designer would fill the box with objects that evoked the book's theme. Gall would get the box photographed, add the author's name, and that would be the finished cover.

My assignment was Nabokov's beautiful memoir *Speak, Memory*. My original design filled the box with vintage photographs pinned under a piece of translucent vellum. What was I thinking? Designer Katie Barcelona, preparing the assembly for shipping, suggested (correctly) that the cover was more evocative without the images.

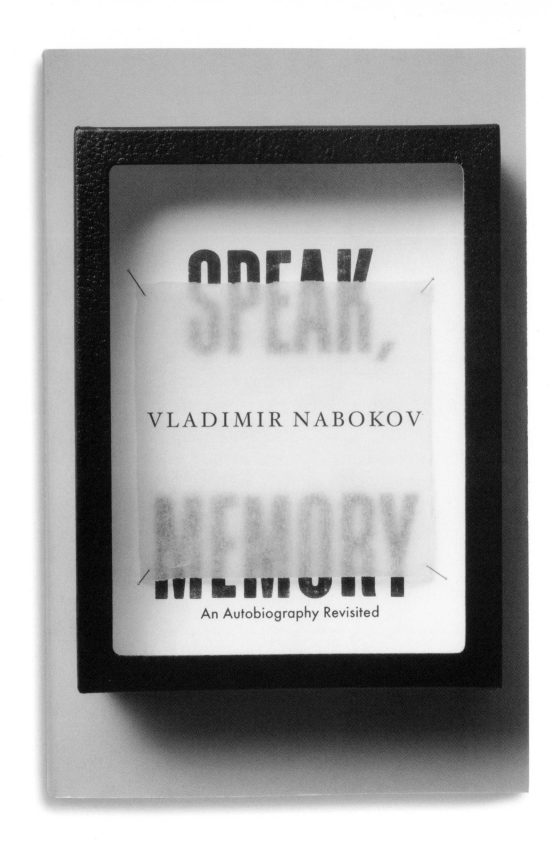

How to make a mark
Logotypes and symbols

The logo is the simplest form of graphic communication. In essence, it is a signature, a way to say, "This is me." The illiterate's scrawled X is a kind of logo, just as much as the calligraphic flourishes we associate with Queen Elizabeth or John Hancock. So are the peace sign and the swastika. And so, of course, are the graphic marks that represent Coca-Cola, Nike, McDonald's, and Apple.

The words we use to describe these things can be confusing. Some logos are essentially typographic, like Microsoft's. I call these logotypes or wordmarks. Others are shapes or images, which I call symbols. Sometimes these can be literal: the symbol for Apple is an apple; the symbol for Target is a target. Sometimes they depict real things but those things may have only an indirect association to what they symbolize. The Lacoste crocodile is derived from founder René Lacoste's nickname; the three stripes of Adidas began as no more than decoration. And sometimes they're utterly abstract, like the Chase Bank "beveled bagel," or the Bass Ale red triangle, which dates to 1777 and is one of the oldest logos in the world.

Everyone tends to get overly excited about logos. If you're a company, communicating with honesty, taste, and intelligence is hard work, requiring constant attention day after day. Designing a logo, on the other hand, is an exercise with a beginning and an end. Clients know what to budget for it, and designers know what to charge for it. So designers and clients often substitute the easy fix of the logo for the subtler challenge of being smart.

When we look at a well-known logo, what we perceive isn't just a word or an image or an abstract form, but a world of associations that have accrued over time. As a result, people forget that a brand-new logo seldom means a thing. It is an empty vessel awaiting the meaning that will be poured into it by history and experience. The best thing a designer can do is make that vessel the right shape for what it's going to hold.

Harlequin
Enterprises,
2011. Publisher
of romantic
literature.

New York City
Economic
Development
Corporation,
1992. A rising
skyline.

Success
Academy,
2014.
A coincidence
of arithmetic
dictates the
design.

S U C C E S S
A C A D E M Y
C H A R T E R
S C H O O L S

21c Hotels,
2005.
Art-infused
boutique
hotels.

Logotypes and symbols

MillerCoors,
2008.
A merger of
two iconic
brewers,
keeping the
focus on
the beer.

Wave Hill,
2002.
A cultural
center and
public gardens
in the Bronx.

Broadway
Books, 1996.
The diagonal
suggests both
an earmarked
page and
the iconic
thoroughfare.

IDEO, 1997.
Refinement
of the original
logo by
Paul Rand.

Gotham
Equities,
1992. New
York-based
real estate
developers.

Logotypes and symbols

Council of
Fashion
Designers of
America, 1991.
Typography
provides the
emphasis.

Amalgamated
Bank, 2014.
Founded to
serve New
York's garment
workers, its
woven acronym
illustrates its
name.

St. Petersburg/
Clearwater Area
Convention and
Visitors Bureau,
2010. Gentle
waves for
America's best
beaches.

Interactive
Advertising
Bureau, 2007.
Subliminal dots
for the dot-com
world.

Grand Central
Terminal, 2013.
The clock
hands hint at
the landmark's
birthdate:
7:13 pm,
or 19:13.

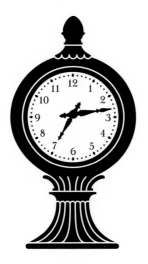

Flatiron/23rd
Street
Partnership
Business
Improvement
District, 2006.
The mark's form
evokes both the
neighborhood's
street plan and
the namesake
building's
silhouette.

Penguin
Press, 2014.
Publisher's
mark based on
the pilcrow, the
typographic
designation for
paragraph.

Fashion Law
Institute, 2011.
A classic
visual pun.

Modern Art
Museum of
Fort Worth,
1999. A new
Tadao Ando
building set
on a reflecting
pool.

Scripps
College, 2009.
The investiture
of the
school's eighth
president.

The Modern

Midwood
Equities, 2014.
Building blocks
for real estate
developers.

Chambers
Hotel, 2001.
Monogram as
infographic.

Logotypes and symbols

Families for
Excellent
Schools, 2014.
Letterforms
create
partnership.

Fulton Center,
2014.
Transportation
hub skylit by a
glass atrium.

Tenement
Museum, 2007.
New York's
most unusual,
and intimate,
historic site.

Yale School of
Management,
2008. The
heraldry of
the conference
table.

Museum
of Sex, 2002.
Nonprofit
dedicated to
human
sexuality.

museumofse**x**

Logotypes and symbols

March of
Dimes, 1998.
Nonprofit
dedicated to
infant health.

How to squash a vote
The Voting Booth Project

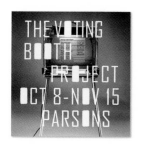

After the debacle of the 2000 elections, when confusion over Palm Beach County's notorious "butterfly ballots" threw the outcome of the presidential election into a weeks-long limbo, the state of Florida decommissioned its Votomatic portable voting booths and put them up for sale on eBay. Seeing a chance to own a piece of history, New York City hotelier André Balazs bought 100 for $10 each and gave some away to friends. What to do with the rest? Paul Goldberger, then dean of the Parsons School of Design, suggested an exhibition in the school's gallery. Fifty designers and artists, including David Byrne, Bonnie Siegler and Emily Oberman, Milton Glaser, and Maira Kalman, were each given a booth and invited to alter it. We were asked to design the exhibition, curated by the ingenious Chee Pearlman, and to contribute a booth of our own. The show opened in October 2004, just in time for that year's presidential election.

Most of the designers transformed the booths in delightfully complex and delicate ways. My partner Jim Biber and I took a much less subtle approach: we drove over the booth with a 1.5-ton steamroller. It turns out it's remarkably easy to rent a steamroller in New York; you don't even need a driver's license to operate it. The spindly-looking Votomatic, however, proved to be surprisingly (and perhaps reassuringly) resilient. It took multiple passes to flatten it. The controlled violence of the entire process was cathartic.

The result was a handsome piece of sculpture in the style of John Chamberlain, but the blunt means seemed to demand an even blunter message. Why bother with subtlety? We bought a tiny plastic elephant—the symbol of the Republican Party—and positioned it atop the pile, leaving no doubt as to who was doing the crushing.

How to travel through time
Lever House

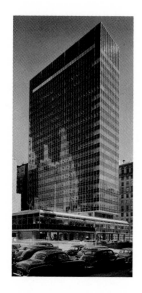

Opposite
SOM and
William Georgis
undertook
a careful
restoration
of Gordon
Bunshaft's
1952 Lever
House for
its 50th
anniversary.
We took the
same approach
to the signage.

Above
Lever House
introduced the
glass and steel
skyscraper
to midtown
Manhattan and
set a standard
for New York
office buildings
for the next
half century.

Architects, product designers, and fashion designers have so much to work with: steel and glass, plastics and polymers, fabrics and finishes. Graphic designers, living in a world of paper and pixels, often find our choices reduced to one: what typeface will we use? But that single choice exerts an outsized influence. "Words have meaning and type has spirit," my partner Paula Scher has said. That spirit can be contentious, elusive, and ineffable, but it is our secret weapon and most powerful tool.

In 1999, we received a call from designer William Georgis. The landmark Lever House was approaching its 50th anniversary. Georgis and the building's original architects, SOM, were working on a careful restoration. All of its old signs would need to be replaced, and new ones would be needed to satisfy 21st-century building codes. Would we join as graphic design consultants?

Lever House transformed New York when it was opened in 1952. SOM's Gordon Bunshaft conceived a glass and steel skyscraper, the first on upper Park Avenue, until then an unbroken wall of brown masonry buildings. The tower rises above a horizontal slab which itself is lifted from the street to create an open, light-filled pedestrian colonnade. The overall effect is surprisingly delicate. Hans and Florence Knoll were recruited to do the interiors, and Raymond Loewy designed public exhibitions and, it was suspected, the signs.

It took only one look at what remained of the signs to confirm that they matched no modern typeface. We decided we had no choice but to use most of our budget to extrapolate an entirely new typeface from the handful of surviving letterforms. Jonathan Hoefler and Tobias Frere-Jones were commissioned to undertake this exercise in forensic font reconstruction. The result, Lever Sans, is perfect. It evokes the *Mad Men* era without resorting to the easy tropes of cliché: typeface as time machine. It's absurd to claim that a single capital R can conjure the New York inhabited by Cary Grant in *North by Northwest*. I make that claim here.

Above
It would have been easy to use an existing typeface like Futura or Neutraface for the Lever House program. But the vintage signs, even though damaged and missing letters, were too distinctive to ignore.

Opposite
Jonathan Hoefler and Tobias Frere-Jones created an entire alphabet from eight letters. Designing the numbers, for which no precedent could be found, was particularly challenging. The result was an original typeface that was as suited to its setting as every other one of the building's details.

LEVER HOUSE
390 PARK AVENUE

9 - 13	ALCOA
3	COSMETICS INTERNATIONAL DISTRIBUTORS CORP.
THIS LEVEL	LEVER HOUSE RESTAURANT
4	LEXA PARTNERS LLC/ GF CAPITAL MANAGEMENT

FIRE COMMAND STATION

A B C D E F
G H I J K L M N
O P Q R S T
U V W X Y Z
1 2 3 4 5
6 7 8 9 0

How to pack for a long flight
United Airlines

Opposite and above
The United symbol, called "the tulip" inside the company, was created in 1973 by the legendary designer Saul Bass. It had fallen into disuse before we decided to reinvigorate it.

Our work with United Airlines included experiments in "branding without branding," such as Daniel Weil's use of the geometry of the symbol to generate the curve of the onboard coffee cup.

The marketing team at United Airlines was looking for a design consultant. I was told later that we were the only designers they met who seemed to express no interest in changing the way the aircraft were painted. "Passengers don't ride on the outside of the planes," I remember telling them. In truth, we had never done an airline before, and had no repainted planes in our portfolio. Instead, at our interview we talked about the things we knew how to design: restaurants, magazines, signs, coffee cups. I reasoned that what an airline really needed was not design as promotion but design as experience.

That began a 15-year relationship. At the very start, I brought in a partner from our London office, the multidisciplinary, multilingual, multitalented Daniel Weil. Danny headed up the three-dimensional projects. I focused on two dimensions. The two of us went to United's headquarters in Chicago for several days once a month, meeting with teams from all over the organization. One client is a challenge. With hundreds of clients, as we had here, the challenges mount geometrically.

Our strategy was not to design a set of abstract guidelines, but to burrow in and work guerilla-style on actual projects, large and small, methodically building a case for what a modern airline could look and feel like. We designed the housing and the user interface for one of the first automatic ticket dispensers. We designed menus, forks and spoons, concourse signage, blankets and pillows. We restored the classic logo designed by Saul Bass. And, about eight years in, we finally managed to repaint the planes.

It was not destined to last. United merged with a rival, and in a series of trade-offs motivated less by marketing theory than by the logic of the deal memo, they married their name to their new partner's symbol. A new era began, without us. It had been an amazing ride.

Below
We persuaded
our client
to omit the
modifier
"Airlines" and
created a new
wordmark to
emphasize
the suggestive
power of their
name, such a
great descriptor
for what makes
air travel
successful.

United Airlines

Above left
Whenever possible, we tried to improve the way passengers were given information, including at departure gates.

Above right
Our redesign of the airline's clubs included new entrance signs.

Below
We introduced a new way of using the United symbol, as a sweeping motif that suggested the drama of flight.

Above left
The passenger's flying experience depends less on branding and more on things to touch and feel. We proposed new blankets long before we suggested changing the logo on the outside of the plane.

Above right
Reducing waste on board meant finding efficient ways to print and recycle items like menus.

Below
Amenities kits, holding toothpaste and eyeshades, were designed to be both lightweight and reusable.

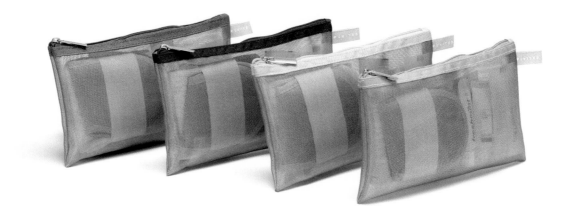

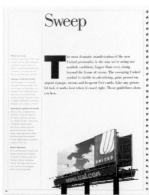

Our Name

Sweep

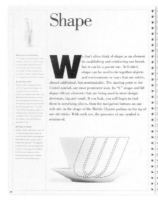

Shape

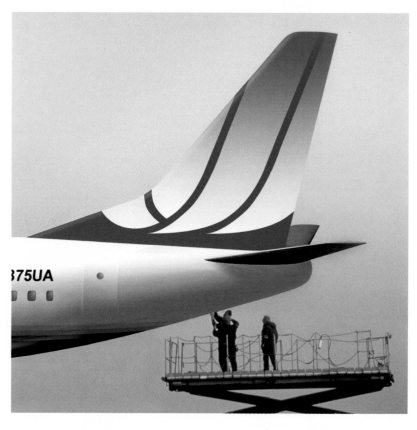

Left
Early on, we produced a guidelines document that set out a set of simple principles for designing the United way.

Above and next spread
Finally, after nearly eight years of work, the time was right to begin painting the plane exteriors to match the airline's new spirit.

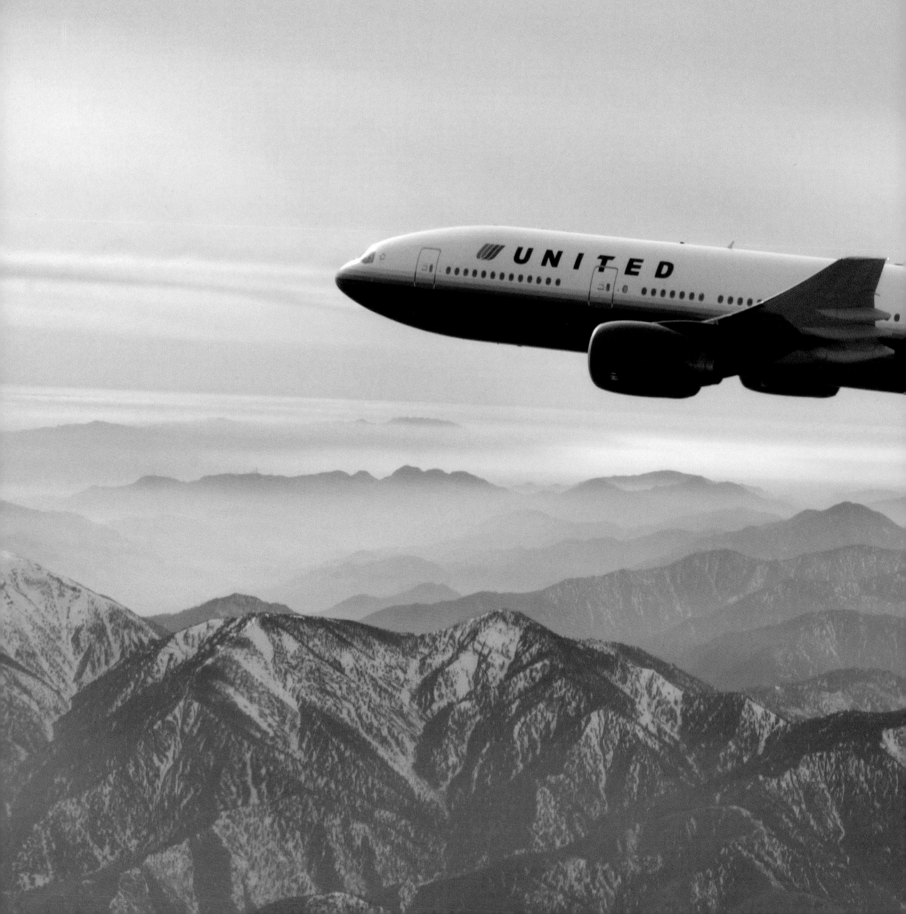

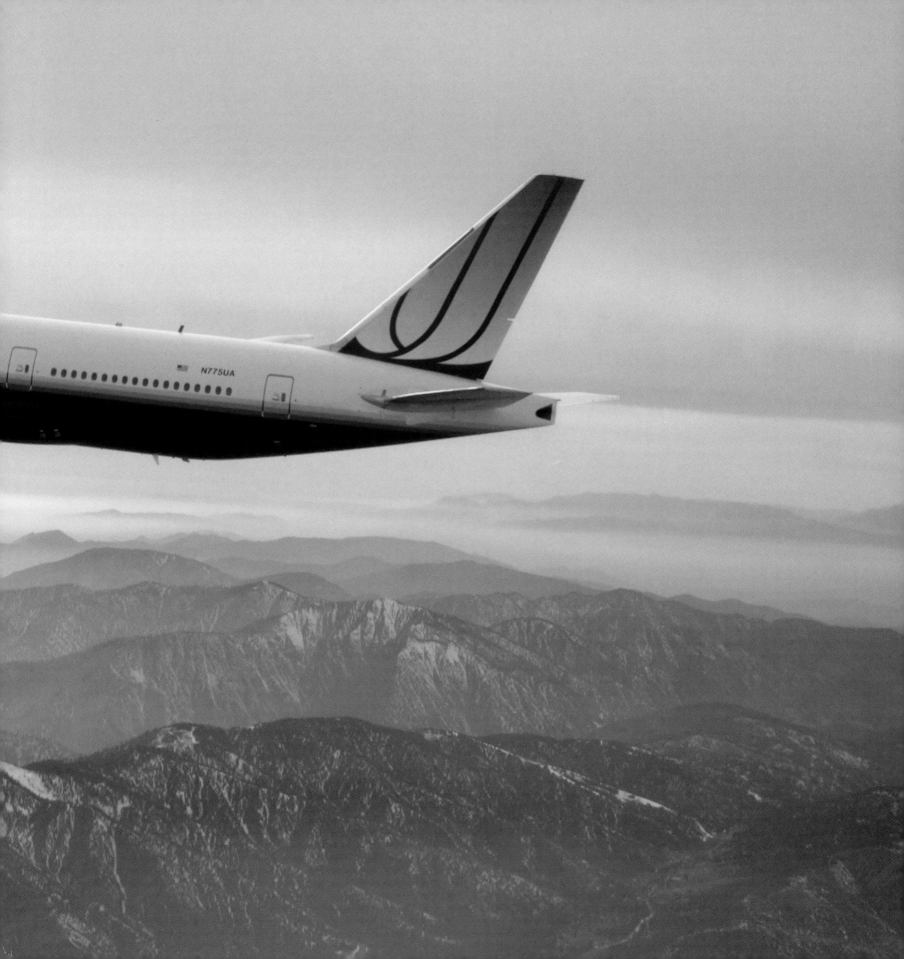

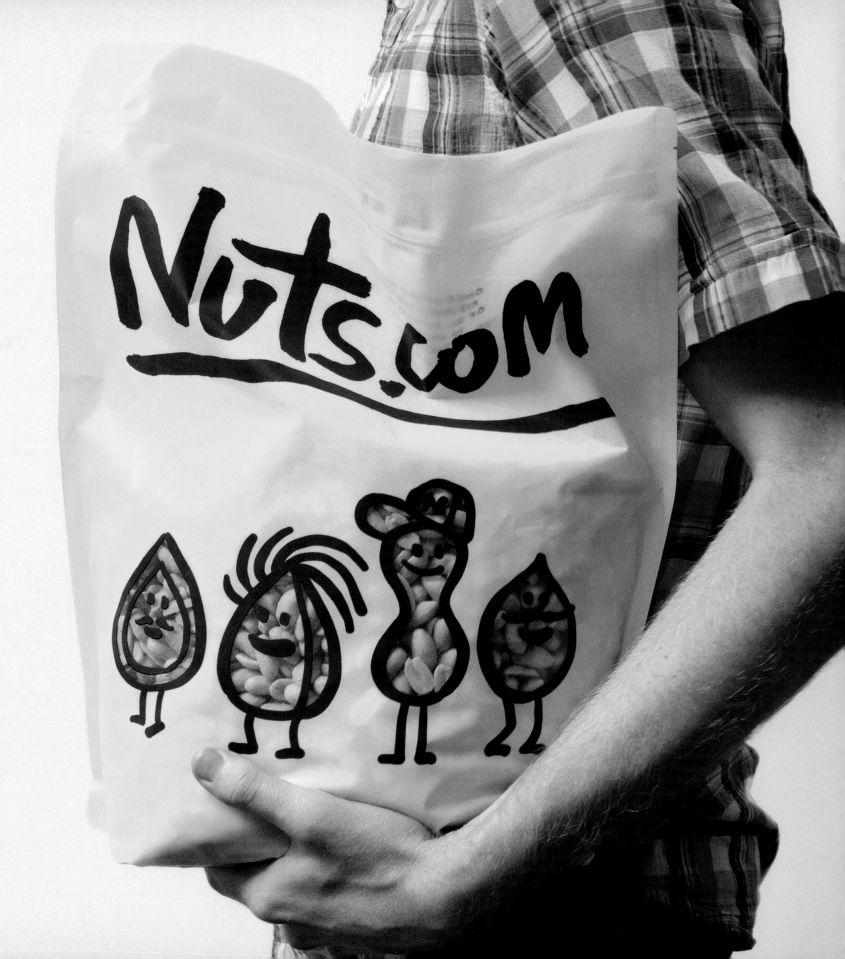

How to have fun with a brown cardboard box
Nuts.com

Jeff Braverman wasn't planning on going into the family business. His grandfather had founded the Newark Nut Company in 1929, selling peanuts from a single cart in the city's Mulberry Street Market. Jeff's father and uncles had turned it into a modest retail operation by the time Jeff went to Wharton School of Business in 1998. He was planning to become a banker.

But in his spare time, he set up a website with a quintessentially redundant Web 1.0 name: nutsonline.com. "My goal for the website was ten orders a day," Jeff told *Inc*. Almost immediately, the online orders overtook the retail sales. Jeff left the world of banking and took over the nut business. Within a dozen years, the site offered nearly 2,000 items and was ringing up $20 million in sales annually. And Jeff could finally get the URL he always wanted: Nuts.com. With a new name in hand, Jeff asked us to redesign the company's packaging.

Consumer packaging is a grim subset of American design. Big corporations, addicted to customer focus groups, dominate the shelves. Minimizing risk inevitably means minimizing beauty, creativity, and distinction. So Jeff's brief was refreshing. He didn't have to compete for attention in grocery stores, since customers assembled their orders online. He saw the packages as the gift wrapping his presents arrived in. "I want that arrival to be a big event," Jeff told us. Nuts.com did no advertising; instead, their shipping cartons functioned as courier-powered billboards.

We took inspiration from Jeff and his family. Sitting in a 60,000-square-foot warehouse overseeing a multimillion-dollar operation, they were as informal and funny as if they were still running a cart in the Mulberry Street Market. So, no typesetting. My hand-lettering was turned into a custom font called Nutcase, which was used to cover their packages with snack-riddled exhortations, all surrounding cartoon portraits of the Bravermans. Within two years, Nuts.com's sales had increased by 50 percent: the power of good design driven by authentic, nutty personality.

ABCDEFGHIJKL
MNOPQRSTUVW
XYZ0123456789
aBCDEFGHIJKLM
NOPQRSTUVWXYZ
0123456789ABC
deFGHIJKLMn
OPQRSTUVWXYZ

Opposite
My hand-painted letters were converted into the proprietary typeface by designer Jeremy Mickel.

Right
Nuts.com is a family business, and the brilliant illustrator (and former Pentagram intern) Christoph Niemann drew a family portrait. Client Jeff Braverman is second from the right.

Next spread
From the brown cardboard box to the individual packages, the receipt of a Nuts.com shipment is meant to be a fun occasion.

Below
The transparent forms of Niemann's characters reveal the package's nutty contents.

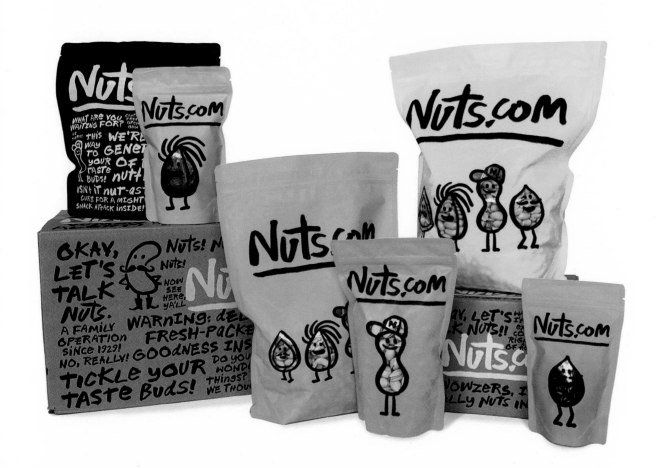

You'l

Nuts?

Nuts.com

Nuts!

CAUTION: YUMMY TREATS INSIDE. OPEN AT YOUR RISK!

HUNGRY YET?

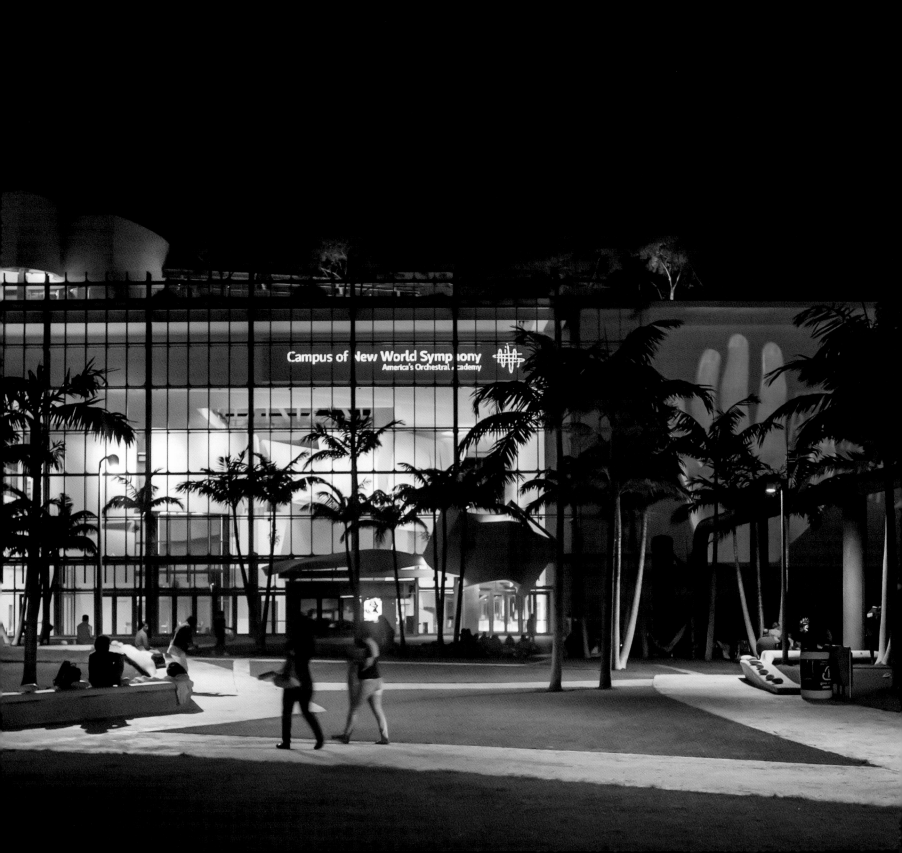

How to shut up and listen
New World Symphony

Opposite and above
Frank Gehry's gestural sketch encapsulates the energy of New World Symphony's Miami Beach home. By coincidence, Gehry had babysat NWS's artistic director, Michael Tilson Thomas, when the two were growing up in Los Angeles.

It all seemed so promising at the beginning. Michael Tilson Thomas, the charismatic and visionary conductor, pianist, and composer, was building a home for his greatest project, New World Symphony. Gifted young musicians from all over the world would come together to study in an extraordinary new building designed by Frank Gehry in the heart of Miami Beach. Music, architecture, learning: when we were asked to design the center's new logo, it seemed as though there was so much to work with. Tilson Thomas asked for something that "flowed."

Yet a solution eluded us. I was so sure I had hit the bull's-eye with my first solution, a morphing collage of curvy typography. Executive vice president Victoria Roberts told me, as politely as possible, that it made some people there feel ill. A second attempt was less idiosyncratic but perhaps too tame. I tried working with the NWS acronym, something I had resisted at first, but the result felt too stiff and corporate. Through the process, Tilson Thomas was encouraging and supportive, but I could sense his growing impatience.

Finally, I got an email with an attachment: six sketches that Tilson Thomas had done for the logo. I was despondent. It was as if he had grown tired of my frantic guesses and just decided to tell me the answer. And the sketches were incomprehensible to me. They showed the three letters of the acronym connected to form something like a swan. Was I just supposed to execute this idea? I wouldn't presume to tell my client how to conduct an orchestra. How dare anyone tell me how to design a logo!

But then I realized that I had been given a gift. Michael Tilson Thomas led a peripatetic life, jetting between engagements all over the world. In the midst of it all, he had found time to think about my problem, and put some thoughts on paper. I looked again at the sketches, and realized the single connected line—like a conductor's gesture—had one thing that all my work did not: flow. It was what he had been asking for all along, and what I had been too busy to hear. Within hours, I had the solution.

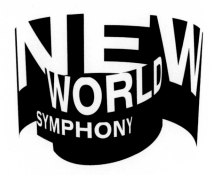

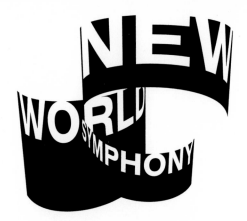

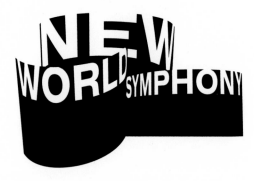

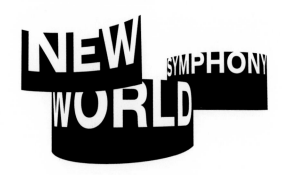

NEWWORLD SYMPHONY

Left
I resisted using the letters NWS, reasoning that it had the same number of syllables as the full name and thus offered no economy when said aloud. I also expressed distaste for acronyms in general, despite the fact that my client himself was often called MTT. Our first try was, again, an attempt to imitate the building's architecture. To suggest more "flow" we also did a hand-drawn version. We liked neither of these.

Above
The building's fragmented, episodic interior spaces suggested a positive/negative treatment of the initial letters. Our designer Yve Ludwig crafted a good solution, but one that I thought looked better suited to a chemical company than a cultural institution.

The result, which emerged over a long weekend with my notebook, had a surprising sense of symmetry and coherence.

New World Symphony

Left
The result has the expressive sense of flow that the client had asked for from the very beginning.

New World Symphony
America's Orchestral Academy
Michael Tilson Thomas, Artistic Director

1 | **1** | **#1 6 WKS** | **LOCKED OUT OF HEAVEN** Bruno Mars | 1 | 15
THE SMEEZINGTONS,J.BHASKER,E.HAYNIE,M.RONSON (BRUNO MARS,P.LAWRENCE II,A.LEVINE) ATLANTIC

5 | **2** | **DG SG** | **THRIFT SHOP** Macklemore & Ryan Lewis Feat. Wanz | 2 | 15
R.LEWIS (B.HAGGERTY,R.LEWIS) MACKLEMORE/ADA/WARNER BROS.

The track crowns Hot Digital Songs (2-1), hiking by 18% to 279,000 downloads sold, according to Nielsen SoundScan. It rules the new Streaming Songs survey (see page 66), registering 1.5 million streams (up 17%) and charges 38-22 on Hot 100 Airplay (44 million audience impressions, up 33%), according to Nielsen BDS.

4 | **3** | **HO HEY** The Lumineers | 3 | 32
R.HADLOCK (W.SCHULTZ,J.FRAITES) DUALTONE

3 | **4** | **AG** | **I KNEW YOU WERE TROUBLE.** Taylor Swift | 2 | 13
MAX MARTIN,SHELLBACK (T.SWIFT,MAX MARTIN,SHELLBACK) BIG MACHINE/REPUBLIC

2 | **5** | **DIAMONDS** Rihanna | 1 | 16
STARGATE,BENNY BLANCO (S.FURLER,B.LEVIN,M.S.ERIKSEN,T.E.HERMANSEN) SRP/DEF JAM/IDJMG

8 | **6** | **SCREAM & SHOUT** will.i.am & Britney Spears | 6 | 7
LAZY JAY (W.ADAMS,J.MARTENS,J.BAPTISTE) INTERSCOPE

11 | **7** | **DON'T YOU WORRY CHILD** Swedish House Mafia Feat. John Martin | 7 | 17
AXWELL,S.INGROSSO,S.ANGELLO (J.MARTIN,M.ZITRON,AXWELL,S.INGROSSO,S.ANGELLO) ASTRALWERKS/CAPITOL

The EDM trio scores its first Hot 100 top 10 with its first chart entry. The cut ranks at No. 2 on the new Dance/Electronic Songs chart (see page 79).

7 | **8** | **BEAUTY AND A BEAT** Justin Bieber Featuring Nicki Minaj | 5 | 14
MAX MARTIN,ZEDD (MAX MARTIN,A.ZASLAVSKI,S.KOTECHA,O.T.MARAJ) SCHOOLBOY/RAYMOND BRAUN/ISLAND/IDJMG

6 | **9** | **HOME** Phillip Phillips | 6 | 29
D.PEARSON (D.PEARSON,G.HOLDEN) 19/INTERSCOPE

10 | **10** | **I CRY** Flo Rida | 6 | 16
THE FUTURISTICS,SOFLY & NIUS,P.BAUMER,M.HOOGSTRATEN (T.DILLARD,A.SCHWARTZ,L.KHAJADOURIAN,R.JUDRIN,P.MELKI,B.RUSSELL,S.CUTLER,J.HULL,M.CAREN) POE BOY/ATLANTIC

22 | **21** | **24** | **LET ME LOVE YOU (UNTIL YOU LEARN TO LOVE Y...**
STARGATE,REEVA,BLACK (S.C.SMITH,S.FURLER,T. E.HERMANSEN,M.HADFIELD,M.DIS CALA)

42 | **34** | **25** | **DAYLIGHT**
A.LEVINE,MDL,MAX MARTIN (A.LEVINE,MAX MARTIN,SAMM,M.LEVY)

28 | **32** | **26** | **HALL OF FAME** The Script Featur...
D.O'DONOGHUE,M.SHEEHAN,J.BARRY (D.O'DONOGHUE,M.SHEEHAN,W.ADAMS,J.BARRY)

38 | **27** | **27** | **LITTLE TALKS** Of Monst...
OF MONSTERS AND MEN,A.ARNARSSON (N.B.HILMARSDOTTIR,R.THO...

30 | **33** | **28** | **I'M DIFFERENT**
DJ MUSTARD (T.EPPS,D.MCFARLANE)

23 | **26** | **29** | **CLIQUE** Kanye West, Ja...
HIT-BOY,K.WEST (C.HOLLIS,S.M.ANDERSON,K.O.WEST,S.C.CARTER,J.E.FAUNTLEROY II)

19 | **23** | **30** | **CRUISE** Florida...
J.MOI (B.KELLEY,T.HUBBARD,J.MOI,C.RICE,J.RICE)

25 | **31** | **31** | **WANTED** H...
D.HUFF,H.HAYES (T.VERGES,H.HAYES) ATLANTI...

46 | **35** | **32** | **I WILL WAIT** Mum...
M.DRAVS (MUMFORD & SONS) GENTLEMAN OF THE...

39 | **40** | **33** | **BETTER DIG TWO** The...
D.HUFF (B.CLARK,S.MCANALLY,T. ROSEN)

44 | **36** | **34** | **ADORN**
MIGUEL (M.J.PIMENTEL) B...

41 | **44** | **35** | **EVERY STORM (RUNS OUT OF RAIN)**
G.ALLAN,G.DROMAN (G.ALLAN,M.WARREN,H.LINDSEY)

33 | **37** | **36** | **LITTLE THINGS** C...
J.GOSLING (E.SHEERAN,F.VEVAN)

34 | **28** | **37** | **TOO CLOSE**
DIPLO,SWITCH,A.RECHTSCHAID (A.CLARE,J.DUGUID)

29 | **38** | **38** | **NO WORRIES** Lil Wayne Fea...
DETAIL (D.CARTER,N.C.FISHER,B.WILLIAMS,J.A.PREYAN,R.DIAZ) YOUNG M...

17 | **25** | **39** | **WE ARE NEVER EVER GETTING BACK TOGET...**
MAX MARTIN,SHELLBACK,D.HUFF (T.SWIFT,MAX MARTIN,SHELLBACK)

27 | **29** | **40** | **CALL ME MAYBE** Carl...
J.RAMSAY (J.RAMSAY,C.R.JEPSEN,T.CROWE) 604/...

51 | **49** | **41** | **RADIOACTIVE** Ima...
ALEX DA KID (IMAGINE DRAGONS,A.GRANT,J.MOSSER) KID...

How to top the charts
Billboard

Like many kids in the 1960s, I was obsessed with music. But, unlike most of my friends, I wasn't content with the Top 40 countdown on the radio. Instead, I went each week to the periodicals room of our local library, where I spent hours with the Bible of the music industry, *Billboard*.

Billboard is one of America's oldest publications, founded in 1894 as a trade magazine for the outdoor advertising industry. It expanded to cover circuses, vaudeville, carnivals, and—with the invention of the jukebox in the 1930s—music, which became its ultimate focus. Responding to the rise of rock and roll, it introduced the legendary Hot 100 singles chart just a few weeks before my first birthday in August 1958.

I'm not sure why I found the Hot 100 chart, and its counterpart list of the top 200 albums, so mesmerizing. Maybe I found comfort in seeing that popularity, a property that utterly confounded me in my junior high school's cafeteria, could be minutely calculated. It was a vicarious triumph every time one of my favorite groups hit number one. No matter that the charts were surrounded by baffling jargon. It was like being an insider at last.

So it was a thrill, 40 years later, to be asked to redesign *Billboard* for the new world of digital music. The logo, for instance, had barely changed since "Hanky Panky" by Tommy James and the Shondells was number one in 1966. But the number of charts had ballooned, tracking everything from regional Mexican albums to ringtones.

This was one of the more complex information design projects I've ever done. Working with *Billboard*'s art director, Andrew Horton, we created a 14-column grid to unify the publication from front to back. We strengthened the logo, focusing on its simple geometry and bright primary colors. And the charts, which had degenerated into a murky pastel-toned backwater, were restored to their former authority in bold black and white, with an emphasis on legibility.

It turns out that even in the digital era, pop artists still displayed the charts showing their first appearance at number one. We created information design that was suitable for framing.

Right

The magazine's name, almost every letter of which is made of either circles, vertical lines, or both, is a designer's dream. Even when we completely deconstructed it, it was still legible. The logo before the redesign is at the top. The final is at the bottom. Some of the dozens of versions we considered are in between.

Billboard

billboard

Billboard

billboard

Billboard

billboard

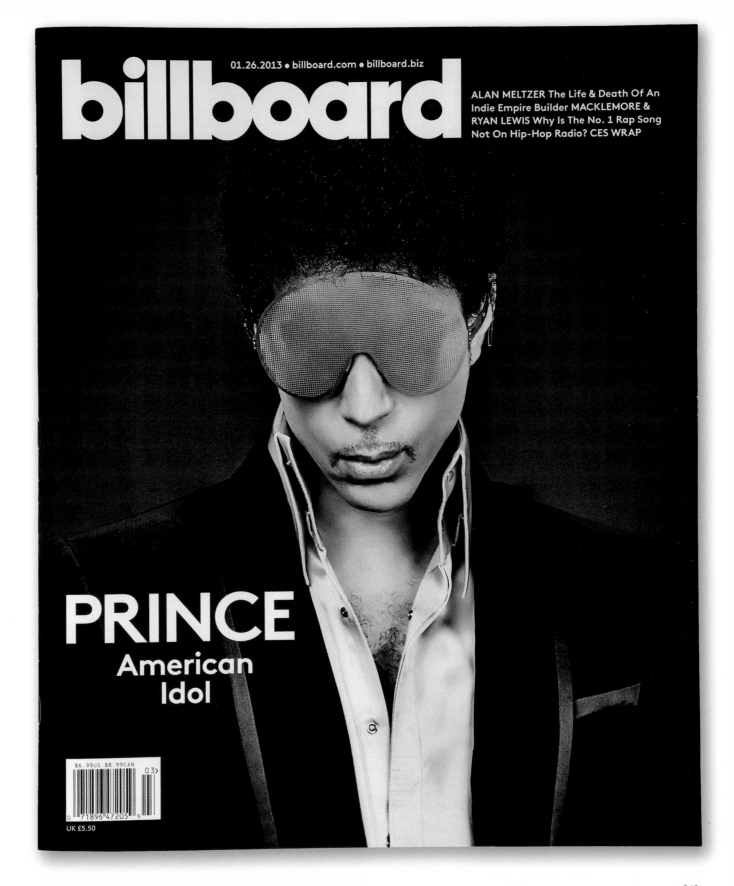

01.26.2013 ● billboard.com ● billboard.biz

billboard

ALAN MELTZER The Life & Death Of An Indie Empire Builder MACKLEMORE & RYAN LEWIS Why Is The No. 1 Rap Song Not On Hip-Hop Radio? CES WRAP

PRINCE
American Idol

$6.99US $8.99CAN

UK £5.50

Right

The bold black-and-white geometry of the logo suggested a similarly constructed headline typeface, as well as an emphasis on high-contrast layout elements.

Opposite

The charts, which had become a cluttered afterthought, were restored to their former iconic glory, thanks to the hard work of Pentagram's Laitsz Ho and Michael Deal.

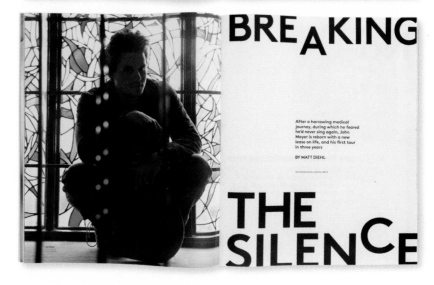

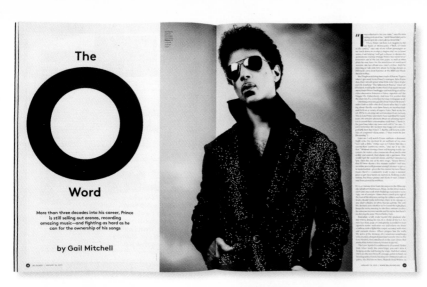
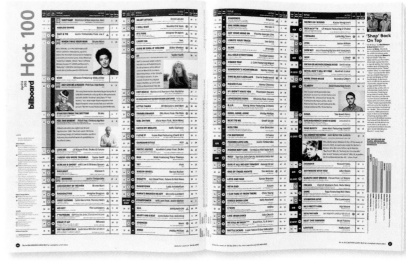

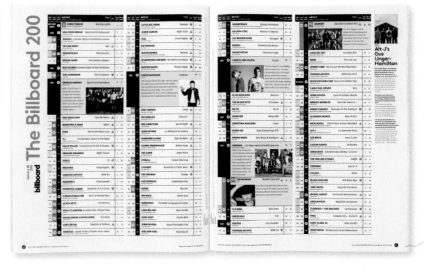
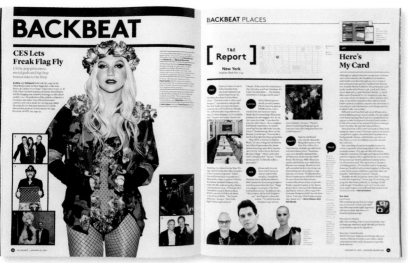

Right

The Billboard Hot 100 chart is an icon of pop culture. In our redesign, readers can easily follow the progression of each song up the chart. Fast-rising hits appear as white "bullets," and weekly awards for biggest gains are marked with red banner icons. Each track's peak position and weeks on the chart appear to the right of the title. The data is set in Christian Schwartz's easy-to-read Amplitude, and chart names, like headlines throughout the magazine, appear in Aurèle Sack's round-as-a-record LL Brown.

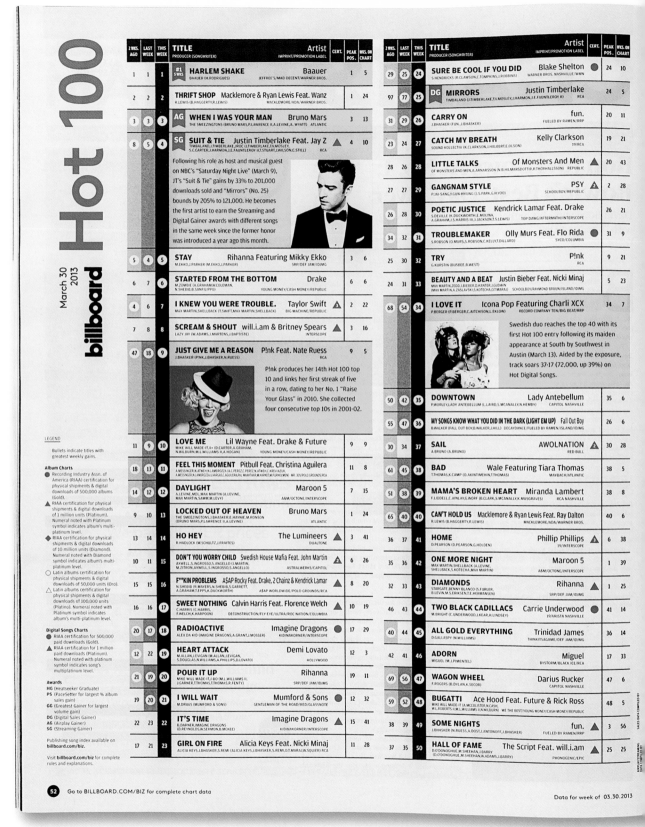

2 WKS AGO	LAST WEEK	THIS WEEK	TITLE — PRODUCER (SONGWRITER)	Artist — IMPRINT/PROMOTION LABEL	CERT.	PEAK POS.	WKS. ON CHART
53	53	51	I DRIVE YOUR TRUCK — K.JACOBS,M.MCCLURE,L.BRICE (J.ALEXANDER,C.HARRINGTON,J.YEARY)	Lee Brice — CURB		51	11
56	50	52	GET YOUR SHINE ON — J.MOI (T.HUBBARD,B.KELLEY,R.CLAWSON,C.TOMPKINS)	Florida Georgia Line — REPUBLIC NASHVILLE		50	8
RE-ENTRY		53	MADNESS — MUSE (M.BELLAMY)	Muse — HELIUM-3/WARNER BROS.		53	26

After a four-week break, the song returns at a new peak. After setting the mark for the longest reign in the Alternative chart's history (19 weeks), it continues gaining on Adult (14-13) and Mainstream Top 40 (30-29).

2 WKS AGO	LAST WEEK	THIS WEEK	TITLE — PRODUCER (SONGWRITER)	Artist — IMPRINT/PROMOTION LABEL	CERT.	PEAK POS.	WKS. ON CHART
60	55	54	SOMEBODY'S HEARTBREAK — D.HUFF,H.HAYES (A.DORFF,L.LAIRD,H.HAYES)	Hunter Hayes — ATLANTIC/WMN		54	17
49	51	55	KISS YOU — C.FALK,RAMI (SHELLBACK,R.YACOUB,C.FALK,S.KOTECHA,K.LUNDIN,K.FOGELMARK,A.NEDLER)	One Direction — SYCO/COLUMBIA		46	12
57	59	56	LOVEEEEEEEE SONG — FUTURE (N.WILBURN,R.FENTY,D.ANDREWS,G.S.JACKSON,L.S.ROGERS)	Rihanna Feat. Future — SRP/DEF JAM/IDJMG		55	7
72	68	57	ALIVE — RAIN MAN (J.YOUSAF,Y.YOUSAF,K.TRINDL,N.LIM,J.UDELL)	Krewella — KREWELLA/COLUMBIA		57	5
66	62	58	PIRATE FLAG — B.CANNON,K.CHESNEY (R.COPPERMAN,D.L.MURPHY)	Kenny Chesney — BLUE CHAIR/COLUMBIA NASHVILLE		58	6
	100	59	GONE, GONE, GONE — G.WATTENBERG (D.FUHRMANN,T.CLARK,G.WATTENBERG)	Phillip Phillips — 19/INTERSCOPE		59	2
80	70	60	POWER TRIP — J.L.COLE (J.COLE,H.LAWS)	J. Cole Featuring Miguel — ROC NATION/COLUMBIA		60	5
63	60	61	R.I.P. — DJ MUSTARD (J.W.JENKINS,D.MCFARLAN,T.EPPS,D.E.VAUGHN,A.YOUNG,E.WRIGHT,PATTERSON, D.JACKSON,G.WEBSTER,A.NOLAND,D.PARKER,M.MIDDLEBROOK,M.MORRISON,M.JONES,M.PIER)	Young Jeezy Featuring 2 Chainz — CTE/DEF JAM/IDJMG		59	6
43	49	62	BETTER DIG TWO — D.HUFF (B.CLARK,S.MCANALLY,T.ROSEN)	The Band Perry — REPUBLIC NASHVILLE	▲	28	20
45	48	63	ONE OF THOSE NIGHTS — B.GALLIMORE,T.MCGRAW (L.LAIRD,R.CLAWSON,C.TOMPKINS)	Tim McGraw — BIG MACHINE	●	32	16
RE-ENTRY		64	22 — MAX MARTIN,SHELLBACK (T.SWIFT,MAX MARTIN,SHELLBACK)	Taylor Swift — BIG MACHINE/REPUBLIC		44	3

Following the start of her *Red* tour in Omaha, Neb. (March 13), the third pop single from her like-titled album re-enters Hot Digital Songs at No. 57 (32,000, up 163%) and arrives as the highest debut (No. 61) on Hot 100 Airplay (18 million in audience, up 115%).

2 WKS AGO	LAST WEEK	THIS WEEK	TITLE — PRODUCER (SONGWRITER)	Artist — IMPRINT/PROMOTION LABEL	CERT.	PEAK POS.	WKS. ON CHART
52	61	65	I'M DIFFERENT — DJ MUSTARD (T.EPPS,D.MCFARLANE)	2 Chainz — DEF JAM/IDJMG		27	18
70	67	66	IF I DIDN'T HAVE YOU — NV (S.THOMPSON,K.THOMPSON,J.SELLERS,P.JENKINS)	Thompson Square — STONEY CREEK		66	11
73	65	67	NEXT TO ME — CRAZE,HOAX (E.A.SANDE,H.CHEGWIN,H.CRAZE,A.PAUL)	Emeli Sande — CAPITOL		65	4
41	58	68	C'MON — DR. LUKE,BENNY BLANCO,CIRKUT (K.SEBERT,L.GOTTWALD,B.LEVIN,MAX MARTIN,B.MCKEE,H.WALTER)	Ke$ha — KEMOSABE/RCA		27	13
62	66	69	NEVA END — MIKE WILL MADE-IT (N.WILBURN,M.L.WILLIAMS II,P.R.SLAUGHTER)	Future — A-1/FREEBANDZ/EPIC		52	15
54	57	70	TORNADO — J.JOYCE (N.HEMBY,D.MAID)	Little Big Town — CAPITOL NASHVILLE	●	51	19
71	72	71	GIVE IT ALL WE GOT TONIGHT — T.BROWN,G.STRAIT (M.BRIGHT,P.O'DONNELL,T.JAMES)	George Strait — MCA NASHVILLE		71	11
95	80	72	LOVE AND WAR — D.CAMPER, JR. (M.RIDDICK,L.DANIELS,T.BRAXTON)	Tamar Braxton — STREAMLINE/EPIC		57	8
76	69	73	MERRY GO 'ROUND — L.LAIRD,S.MCANALLY,K.MUSGRAVES (K.MUSGRAVES,J.OSBORNE,S.MCANALLY)	Kacey Musgraves — MERCURY NASHVILLE		63	14
44	64	74	ONE WAY OR ANOTHER (TEENAGE KICKS) — J.BUNETTA,J.RYAN (D.HARRY,N.HARRISON,L.O'NEILL)	One Direction — SYCO/COLUMBIA		13	5
	98	75	SHOW OUT — MIKE WILL MADE-IT (J.HOUSTON,J.W.JENKINS,S.M.ANDERSON)	Juicy J Featuring Big Sean And Young Jeezy — KEMOSABE/COLUMBIA		75	2
64	71	76	WICKED GAMES — DOC,C.MONTAGNESE,THE WEEKND (A.TESFAYE,C.MONTAGNESE,D.MCKINNEY)	The Weeknd — XO/REPUBLIC		53	20
HOT SHOT DEBUT		77	FREAKS — RICO LOVE,E.THOMASON (K.KHARBOUCH,O.T.MARAJ,RICO LOVE, D.L.DAVIS,Q.RILEY,K.BONNER,S.DUNBAR,J.C.TAYLOR,L.O.WILLIS)	French Montana Feat. Nicki Minaj — BAD BOY/INTERSCOPE		77	1
83	76	78	I CAN TAKE IT FROM THERE — J.STROUD (C.YOUNG,R.AKINS,B.HAYSLIP)	Chris Young — RCA NASHVILLE		76	6
79	78	79	BATTLE SCARS — PRO J (W.JACO,G.SEBASTIAN,D.R.HARRIS)	Lupe Fiasco & Guy Sebastian — 1ST & 15TH/ATLANTIC		73	12
	96	80	KISSES DOWN LOW — MIKE WILL MADE-IT,MARZ (M.L.WILLIAMS II,M.MIDDLEBROOKS,T.THOMAS,T.THOMAS,K.ROWLAND)	Kelly Rowland — REPUBLIC		80	2
	84	81	HIGHWAY DON'T CARE — B.GALLIMORE,T.MCGRAW (B.WARREN,B.WARREN,M.IRWIN,J.KEAR)	Tim McGraw With Taylor Swift — BIG MACHINE		59	3
82	75	82	WE STILL IN THIS B**** — MIKE WILL MADE-IT,MARZ (B.R.SIMMONS, JR.,M.L.WILLIAMS II, M.MIDDLEBROOKS,C.J.HARRIS, JR.,J.HOUSTON)	B.o.B Feat. T.I. & Juicy J — REBELROCK/GRAND HUSTLE/ATLANTIC		75	5
58	63	83	HEY PORSCHE — DJ FRANK E,D.GLASS,M.FREESH,T.MAZUR,H.KIPNER (D.E.GLASS,H.KIPNER,B.S.ISAAC,J.FRANKS,C.HAYNES, JR.)	Nelly — REPUBLIC		42	6
86	81	84	LIKE JESUS DOES — J.JOYCE (C.BEATHARD,M.CRISWELL)	Eric Church — EMI NASHVILLE		81	4
74	73	85	WHO BOOTY — RAW SMOOV (D.J.GRIZZELL,S.A.WILLIAMS,K.KHARBOUCH)	Jonn Hart Featuring IamSU! — COOL KID CARTEL/EPIC		66	14
78	82	86	DON'T JUDGE ME — THE MESSENGERS (C.M.BROWN,N.ATWEH,A.MESSINGER,M.PELLIZZER)	Chris Brown — RCA		67	20
NEW		87	DONE. — D.HUFF (R.PERRY,N.PERRY,J.DAVIDSON,J.BRYANT)	The Band Perry — REPUBLIC NASHVILLE		87	1
75	79	88	THE ONLY WAY I KNOW — M.KNOX (D.L.MURPHY,B.HAYSLIP)	Jason Aldean With Luke Bryan & Eric Church — BROKEN BOW	●	40	19
84	87	89	STUBBORN LOVE — R.HADLOCK (W.SCHULTZ,J.FRAITES)	The Lumineers — DUALTONE		70	14
NEW		90	SO MANY GIRLS — NOT LISTED (NOT LISTED)	DJ Drama Feat. Wale, Tyga & Roscoe Dash — APHILLIATES/EONE		90	1
90	83	91	GOLD — D.MUCKALA (B.NICOLE,D.MUCKALA,J.CATES)	Britt Nicole — SPARROW/CAPITOL CMG/CAPITOL		83	3
98	93	92	MORE THAN MILES — D.HUFF (J.EDDIE,B.GILBERT)	Brantley Gilbert — VALORY		92	3
NEW		93	1994 — M.KNOX (THOMAS RHETT,L.LAIRD,B.DEAN)	Jason Aldean — BROKEN BOW		93	1

Aldean's ode to the year that Joe Diffie ruled Hot Country Songs with two No. 1s becomes the eighth Hot 100 hit whose title is a year. Others include Phoenix's "1901," Bowling for Soup's "1985" and Prince's "1999." See the full list in Billboard.com's Chart Beat column. —Gary Trust

2 WKS AGO	LAST WEEK	THIS WEEK	TITLE — PRODUCER (SONGWRITER)	Artist — IMPRINT/PROMOTION LABEL	CERT.	PEAK POS.	WKS. ON CHART
99	90	94	LEVITATE — LOADSTAR (HADOUKEN!,A.SMITH,N.HILL,G.HARRIS)	Hadouken! — SURFACE NOISE		90	3
85	85	95	CUPS — C.BECK,M.KILIAN (A.P.CARTER,L.GERSTEIN,D.BLACKETT,H.TUNSTALL-BEHRENS,L.FREEMAN)	Anna Kendrick — UME		64	12
87	86	96	DOPE — M.ROBERTS (M.NGUYEN-STEVENSON,N.L.ROBERTS II, M.ROBERTS,J.JACKSON,C.C.BROADUS JR.,C.WOLFE,A.YOUNG)	Tyga Featuring Rick Ross — YOUNG MONEY/CASH MONEY/REPUBLIC		68	8
91	88	97	LOVE SOSA — YOUNG CHOP (K.COZART,T.PITTMAN)	Chief Keef — GLORY BOYZ/INTERSCOPE		56	14
93	92	98	CHANGED — D.HUFF,RASCAL FLATTS (G.LEVOX,N.THRASHER,W.MOBLEY)	Rascal Flatts — BIG MACHINE		73	4
	74	99	BUZZKILL — J.STEVENS (L.BRYAN,R.THIBODEAU,J.SEVER)	Luke Bryan — CAPITOL NASHVILLE		74	2
89	94	100	LITTLE THINGS — J.GOSLING (E.SHEERAN,F.DEVAN)	One Direction — SYCO/COLUMBIA	●	33	18

"I'M NOT 'BOUT TO JUDGE YOU, DON'T JUDGE ME. YOU AIN'T GOTTA REALLY SING ABOUT YOUR RAP SHEET."

"BAD"—WALE FEATURING TIARA THOMAS

Q&A

Tiara Thomas

You co-wrote and sang on Wale's "Bad," which jumps 45-38 on the Billboard Hot 100 this week. You're signed to his Board Administration management/label. How did you first link with him?
[A friend] was like, "Hey, let's go to Atlanta for spring break." We went and I had a fake ID; I was under 21 at the time. We wanted to go to the club. It was like, "There's Wale, let's take a picture with him." Afterward, I sent him some YouTube videos I had online. Three months later, he hits me up: "Yo, I'm gonna fly you out to New York."

How did you come up with "Bad"?
There was this rap song called "Some Cut" by Trillville. It used to be one of my favorite songs when I was younger. It's really vulgar; I wanted to find a way to cover the song and make it sound pretty. Seven months after I dropped it on YouTube, Wale listened to it, and he really liked it. He put his verses on it and took the song to a whole new level.

So it started as your YouTube clip, and now it's the lead single on his new album?
It was just a cover at first. I just had other lyrics on there on top of the hook. Wale kind of created a story out of it—it's like a girl anthem. That's crazy. That's what I like so much about it: A rapper puts out a girl anthem. —Chris Payne

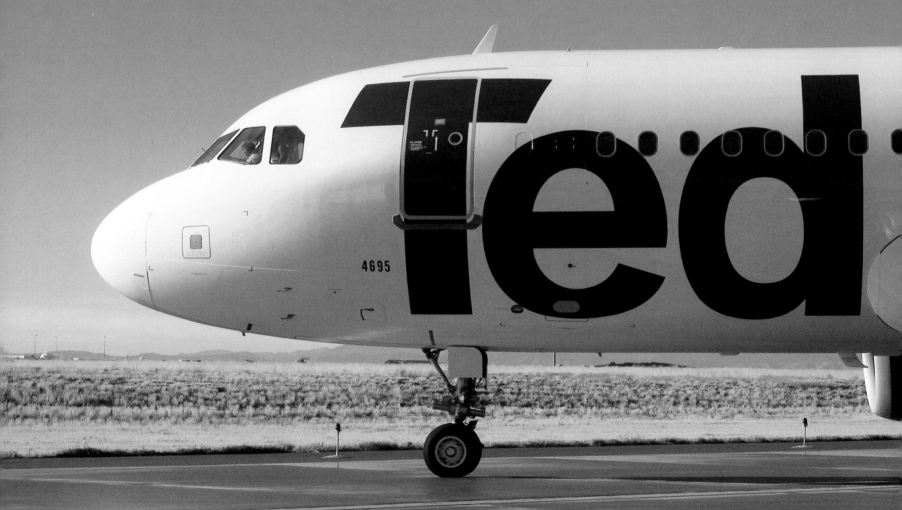

How to convince people
Ted

When I graduated from design school, I thought that a great idea should sell itself. Not true. It turns out coming up with the right solution to a design problem is only the first step. The next, crucial step is convincing other people that your solution is the right one. Why is this so hard?

First, while sometimes we're fortunate enough to have a single strong-minded client, often we have to persuade a group. And the more important the project, the bigger (and more unruly) the group. Second, the correctness of a design decision can seldom be checked with a calculator. Rather, it relies on ambiguous things like intuition and taste. Finally, any good design decision requires, in the end, a leap of faith. To bring our risk-adverse congregations to salvation, we often have to transform boardrooms into revival tents.

In 2003, our client United Airlines decided to launch a low-cost operation to compete with JetBlue and Southwest, as well as newcomers like Delta's Song and Air Canada's Tango. They asked us to design the new carrier and, to make the challenge even harder, to come up with a name. (Not everyone thinks they're a designer, but anyone who's ever had a pet goldfish is a naming expert.)

After several months of work, the review of 100-plus names, and a few abortive presentations, my partner Daniel Weil and our colleague David Gibbs came up with a perfect moniker for a carrier that would be United's personable, friendly, more casual little sibling: Ted, a name that actually was a nickname, derived from the last three letters in its big brother's well-established brandmark.

We were convinced. But we knew that convincing our client would be a delicate process involving people from all over the company, up to and including marketing head John Teague and chairman Glenn Tilton. We assembled a 65-slide presentation that made the decision seem not just inevitable but fun. To this day, of all the presentations I've ever given, this is my favorite.

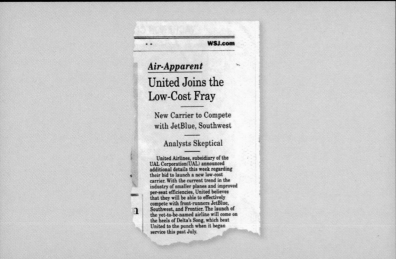

As everyone knows, a good presentation tells a story with a beginning, middle, and end. By the time we got involved, our clients had been working on the business case for United's low-cost carrier for nearly a year. It was important to remind them that the outside world didn't know anything about their strategy, and didn't necessarily care if they succeeded.

A point of distinction for United was that the new airline would be integrated into their huge network. This meant that its design would have to be coordinated with all the work we were doing for the rest of United, including the way the airplanes were painted. We deliberately decided to separate the decision about the design of the new carrier from the choice of name; combining the two tended to muddle the discussion because people inevitably liked one name but another design.

I gave this presentation over and over again to various teams at the company. This was one of the few presentations I've ever prepared that worked every time. It helped that we had a great solution.

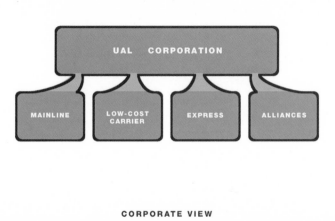

CORPORATE VIEW

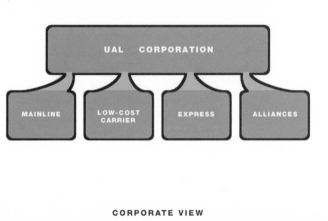

CUSTOMER VIEW

Two tools

The look and feel of the LCO identity
The LCO name

MAINLINE — EXPRESS
ALLIANCES — LOW-COST OPERATION

EXPRESS
ALLIANCES — LOW-COST OPERATION

ALLIANCES — LOW-COST OPERATION

STAR ALLIANCE — LOW-COST OPERATION

STAR ALLIANCE — ?

LCO brand profile

Brand advantages

Competitive pricing
Mileage Plus benefits
Options and frequency
Connected network
A United brand

Brand attributes

Trustworthy
Reliable
Good service
Customer first
Understanding
Open
Energized

Brand experience

Retail
Friendly
Active
Engaging
Entertaining
Attractive
Simple
Changing
Social

Above
We used two
diagrams
to show that
the internal
view of the
organization
(operational
divisions)
was different
from the
customers'
view (an
interconnected
network).

Right
Each existing
operational
division
had an
established
design
appearance.
How would
the new
carrier fit in?

Above
I usually prefer
images to lists
of words in
presentations,
but with this
audience the
words would
resonate.

Close-in vs. further out

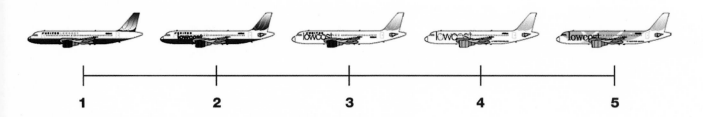

| 1 | 2 | 3 | 4 | 5 |

Approach

No invented words (Allegis, Avolar)
Be energetic and inspiring
A clear relationship with United
Avoid "me too" options
Manage expectations

Expected vs. Unexpected

1	2	3	4	5

ATA Freedom Air jetBlue Tango
America West AirTran Spirit Virgin Blue
West Jet Frontier Easy Jet Song
Southwest Ryanair

DEFINITION:
One who flies
PROS:
Passenger-focused
Simple and familiar, but hip
Participatory, energetic
Comfortable fit with current culture
FlyerFares, I'm a Flyer, Be a Flyer
CONS:
Vaguely retro

DEFINITION:
A variable color averaging a dark, silvery blue
PROS:
Indi (as in independent) + go
A shade of (United) blue
Sounds modern
Direct spanish translation
CONS:
Unfamiliar word to most

UNITEDRED

DEFINITION:
The color at the long-wave extreme
of the visible spectrum
PROS:
The energetic "other half" of United
Clear implications for visual rollout
Takes on Virgin Blue and jetBlue
Easy to say, remember, pronounce
Means "network" in spanish
CONS:
In the red, seeing red

UNITEDRED

DEFINITION:
A curved line forming a closed or
partly open curve; a circuit
PROS:
Describes the flight network
Sounds fun
Additional meaning in Chicago area
Easy to say, remember, pronounce
CONS:
Whimsical, "loopy"

Above
Presentations
happen in
windowless
rooms, so it's
important to
keep letting the
outside world
in. Here we lay
out the universe
of existing
low-cost carrier
names in which
United's new
entry would
compete.

Above
We considered
five names in
all, showing
pros and cons
for each. All
were viable, but
we saved our
favorite for last.

UNITED

TED

DEFINITION:
Short for Theodore (Greek, "Divine Gift")
A literal "part of United"

PROS:
Friendly, "first name basis"
Unique to the industry
Easy to say, remember, pronounce
Trus**ted**, exci**ted**, libera**ted**, res**ted**
"Ted E-fares", I'm with Ted

CONS:
Unorthodox, riskier

Above
Revealing our recommended name was my favorite part of the presentation. "How much have you invested in promoting this name over the past 75 years?" I would ask. "A billion dollars? What if I told you we could give you a name that already had $500 million behind it?"

The audience would always laugh at the answer (and the specious math behind it) but the point was made: the new name had been hiding in plain sight all along.

Right
People immediately understood the advantages of having a human name (and a nickname at that) to signal a more personal style of service; it made the other choices seem contrived. The treatment of the logo we presented borrowed the capital T from the United logotype.

We later changed the tagline to "Part of United," which was direct, simple, and true in more ways than one.

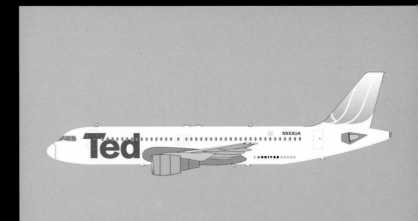

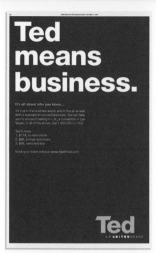

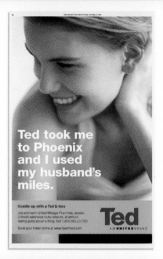

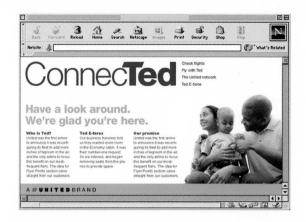

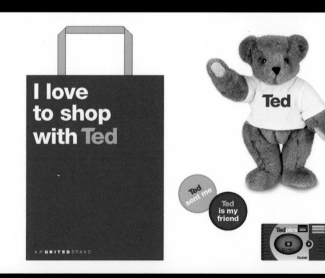

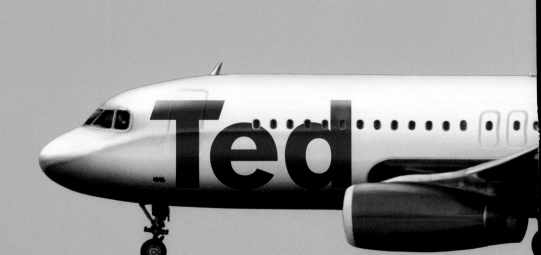

Be on a first-n

Meet Ted. A new, low-fare service that flies to fun dest

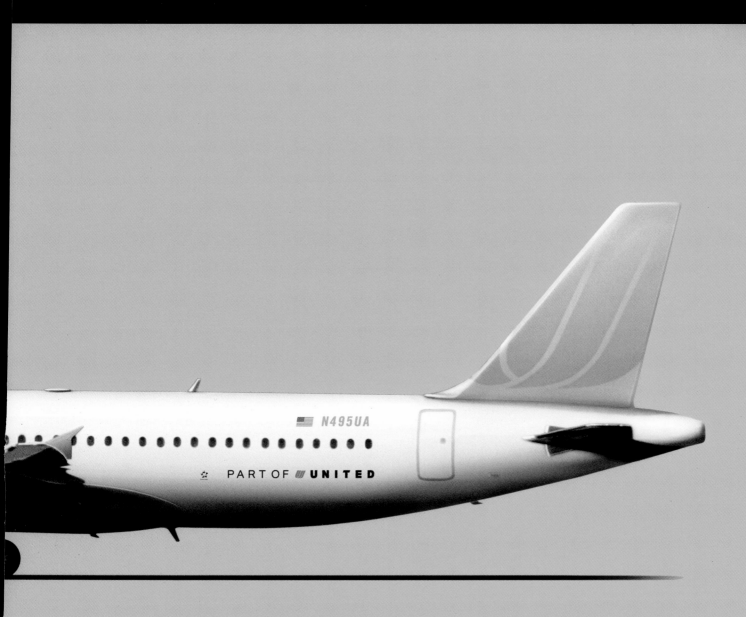

ame basis with an airline.

ations. You can book now for flights that start February 12. Ted. Part of United.

www.FlyTed.com

Times Square

Theaters

W 42 Street

Theaters

5 Times
Square
Ernst and
Young

Nederlander
Theater

Graduate School
of Journalism,
City University
of New York

Parsons the
New School
for Design

W 41 Street

W 40 Street

Fashion Walk
of Fame

**Fashion Center
Information Kiosk**

ℹ

W 39 Street

Fashion District

🚶 6 minutes

W 38 Street

W 37 Street

The Haier
Building

W 36 Street

W 35 Street

Herald Square

ℹ 🚻 ♿ ♿ 🍴 📶

Macy's

You

W 34 Street

34 St-Penn Stn
A C E 1 2 3

W 33 Street

New York
Hotel Pennsylvania

Manhattan
Mall

**Penn Station
Amtrak, LIRR,
NJT, PATH**

7 Avenue

Broadway

Conde Nast
Building

Bank of America
Tower

Bush
Tower

Metlife

Times Sq 42 St
1 2 3 7 N Q R S

♿

6 Avenue

42 St Bryant Park
B D F M

5 Av
7

🚻 ♿

♿

Bryant
Park

Fountain
Terrace
⛲ ♿ 🚻 📶

Upper
Terrace

5 Avenue
Terrace

Fortitude:
Library lion

**New York
Public Library**

Patience:
Library lion

The New
Community
College at
City University
of New York

American
Standard
Building

W 39 Street

🚶 5 minutes

Lord & Taylor ←

5 Avenue

W 38 Street

Midtown

W 37 Street

W 36 Street

Avenue of the Americas

Broadway

W 35 Street

Empire State
Building

34 St-Herald Sq
B D F M N Q R

W 34 Street

Greeley
Square Park
🚻 ♿ 🍴 ♿ 📶

**33 Street
PATH**
🚇

W.P. Grace
Building

State University
of New York
College of Optometry

E 42 Street

Grand Central 42 St
4 5 6 7 S

E 41 Street

E 40 Street

Mid-Manhattan
Library

E 39 Street

E 38 Street

E 37 Street

E 36 Street

5 Avenue

E 35 Street

**Graduate Center,
City University
of New York**

Science, Industry and
Business Library

🚶 5 minutes

E 34 Street

E 33 Street

♿

E 32 Street

Koreatown

How to get where you want to be
New York City Department of Transportation

New York City is a complicated place. Manhattan is dominated by an orderly grid, its numbered streets and avenues dictated by the Commissioners' Plan of 1811. But downtown, before the grid takes hold, you'll find West 4th Street intersecting West 11th Street. Meanwhile, in Queens, another 11th Street crosses, in order, 44th Drive, 44th Road, and 44th Avenue. New York's layout is logical except when it's not. As for Brooklyn, like they say: forget about it.

For years individual neighborhoods sought to guide confused pedestrians by creating their own signs and maps. In the 1990s, we created one such system for the crowded and confusing Financial District, inventing a unique graphic style that worked within the district but had nothing to do with the dozens of other such systems around town. Finally, in 2011, the New York City Department of Transportation decided to create a citywide system called WalkNYC that would unify wayfinding in all five boroughs. We joined a multidisciplinary team that would create maps and signs for five pilot neighborhoods.

We quickly found ourselves in a new world where people's navigating habits had been turned upside down—literally. For years, urban wayfinding often started with a single piece of artwork: a big static map, everything fixed in place, north at the top. But GPS-savvy travelers today expect a map to orient itself in the position of travel and have the ability to zoom in for more detail. Could our system's printed maps, deployed throughout the city, satisfy these expectations? Using a nimble, infinitely modifiable database capable of multiple orientations and dense detail, our team created analog maps that provide a remarkably digital experience.

Handsome, urbane wayfinding fixtures introduced the new system throughout the city in 2013. The maps now appear at bike-share locations, in subway stations, and on express-bus kiosks. Despite the ubiquity of handheld devices, the sidewalks around our wayfinding kiosks are always crowded with people figuring out how to get where they want to be in this beautifully confusing city.

Urban wayfinding is an extraordinarily complicated enterprise that requires the collaboration of a wide range of experts. How do people actually find their way in a complex city? What information do they need? How and where should it be provided? Answering these questions meant conducting dozens of workshops and interviews, stopping pedestrians on the sidewalk to find out where they were going and how they were getting there.

The NYC Department of Transportation told us that WalkNYC would affect not just wayfinding, but everything from public health (by encouraging people to walk) to economic development (more sidewalk activity means more shopping). Simplicity was the key, but achieving it was anything but simple. Our task was to translate the cartographic data into maps that we hoped would not only work well, but would become as distinctive a part of New York's graphic language as Massimo Vignelli's subway signage or Milton Glaser's "I Love NY" logo.

Right top
Consultants City ID led our team in a series of neighborhood tours with local residents and business owners to help determine the location and content of our wayfinding kiosks.

Right middle
Understanding how people find their way is complicated enough in someplace like an airport, where everyone comes through the same front door and has the same goal. In a city, where people may be starting anywhere and going anywhere, new in town or lifelong residents, in a hurry or ready to get lost, addressing the complexity means making deliberate choices.

Right bottom
Would we refer to north as uptown? How would we determine walking distances? Which landmarks qualified to appear on the maps? What colors were the most legible at day and at night? The details were seemingly endless.

Opposite
We considered many different typefaces for the system, but none conveyed the same authority as Helvetica. No surprise there: users of the New York Subway system have been trusting it since the 1970s, so why not continue the same graphic language above ground? We made one modification I've secretly wanted for years: all the square dots are round, a not-so-subtle customization for our client DOT.

New York City Department of Transportation

Midtown
Tribeca
Chinatown
Flatiron
You are here
ij!?:;.

Left
Because we were managing a dense jungle of information, we knew every graphic element needed to be perfectly engineered. For instance, the symbol system developed for the US Department of Transportation by Roger Cook and Don Shanosky at the American Institute of Graphic Arts in 1974 provided some, but not all, of the icons we'd need. We customized some (changing the bike symbol to match the designs used in the city's new bike share program) and invented others (a shopping bag bearing New York's familiar slogan).

Below
We wanted the information icons to seem like an extension of the typography. This meant hundreds of small modifications, masterminded by designer Jesse Reed.

Opposite
Designer Hamish Smyth led our work for the WalkNYC program, including the design of the architectural icons that punctuate each map. Despite technology, some things can't be automated. It took an army of interns to draw over 100 of them by hand. Each one is a gem.

New York City Department of Transportation

"Heads-up mapping" is the cartographic convention where the orientation of the map depends on the direction the viewer is facing. With traditional maps, north is always up. With heads-up maps, if the viewer is facing south, the map is turned so that south is at the top. Many were dubious—including me—that such a system would work in a city where, so it's said, "the Bronx is up and the Battery's down."

But I was persuaded by early tests that showed the new method was favored by an astounding 84 percent of users. Clearly, digital maps and global positioning systems have changed the way we navigate. Later, the *New York Times*, reporting on the system, conducted a more informal poll and discovered six out of ten New Yorkers on the street couldn't point north. Heads-up mapping is here to stay.

New York City Department of Transportation

Above left
We believe that signs should be digital only when they have to be. The kiosks that support New York's Select Bus Service feature real-time schedule information.

Above right
The signs have been engineered to withstand collision, vandalism, and tough New York winters.

Left
The wayfinding maps, with their color scheme adjusted for 24-hour artificial light, have been installed in all of New York's subway stations.

Opposite
The structures that house the maps were designed to echo New York's modernist architecture.

New York City Department of Transportation

How to investigate a murder
A Wilderness of Error

Filmmaker Errol Morris is obsessed with truth. All of his films have at their centers people who know the truth, don't want to know the truth, want to stop other people from learning the truth, or want to uncover the truth. As a former private investigator, Morris knows well how physical evidence can support or challenge conflicting testimony. So often the inanimate objects in his movies acquire an outsized significance: documents, photographs, an umbrella, a teacup. Morris's breakthrough in 1988, *The Thin Blue Line*, used interviews and reenactments to investigate the colliding stories behind an obscure shooting of a police officer in Dallas. The mesmerizing film exonerated a man on death row who had been unjustly convicted of the crime.

Brilliant and inexhaustible, Errol Morris also writes books. In 2012, he decided to examine another decades-old crime, this one anything but obscure. On February 17, 1970, army physician Jeffrey MacDonald's wife and children were brutally murdered in their home in Fort Bragg, North Carolina. Although MacDonald maintained that they were killed by intruders, he was convicted of the crime. He has been in prison since 1982, consistently maintaining his innocence. Since then, the case has been the subject of several previous books as well as two television movies. Morris was convinced there was more to be discovered.

The book he wrote about the case, *A Wilderness of Error*, is a study in black and white of a case that is anything but. For the book's design, we decided to avoid the clichés of true-crime books. Instead, we focused on the eerie collection of physical evidence that survived from that evening: a coffee table, a flower pot, a child's doll, a rocking horse, a pajama top. Mute witnesses to a crime that has defied resolution, they have been examined and reexamined so many times they have acquired an iconic status to people who know the case. We reduced each of them to a simple black-and-white line drawing. Morris realized that their stark, deadpan quality could provide the book's central visual motif; we ended up doing nearly fifty of them. The cover, the floor plan of the tiny MacDonald apartment, represents the claustrophobic "wilderness" where this mystery unfolded, and where, somewhere, the truth resides.

*Academ
privat
nature
Jeffrey*

Early
Bragg.
Beret
officer
and ba
wife a
writte
bedro
the am
hippies

So beg
murde
MacDo
remai
bestse
*Vision
Murde*
have t
and w

Errol
case f
of Err
shock
every
deeply
case a
a mas
book
these
that c
and c

By thi
there
create
and t
impri
his w

(contin

A Wilderness of Error

THE IMPOSSIBLE COFFEE TABLE

*You'd better think less about us and what's going to happen
to you, and think a bit more about yourself. And stop making
all this fuss about your sense of innocence; you don't make
such a bad impression, but with all this fuss you're damaging it.*
—Franz Kafka, *The Trial*

When Jeffrey MacDonald was brought in for questioning on April 6, 1970, less than two months after the murders, he was read his rights, declined to have an attorney present, and a tape recorder was turned on. The interview was conducted by CID chief investigator Franz Grebner, Agent William Ivory, and Agent Robert Shaw. Grebner first asked for MacDonald's account of the events of February 17.

> And I went to bed about—somewheres around two o'clock. I really don't know; I was reading on the couch, and my little girl Kristy had gone into bed with my wife.
>
> And I went in to go to bed, and the bed was wet. She had wet the bed on my side, so I brought her in her own room. And I don't remember if I changed her or not, gave her a bottle and went out to the couch 'cause my bed was wet. And I went to sleep on the couch.
>
> And then the next thing I know I heard some screaming, at least my wife; but I thought I heard Kimmie, my older daughter, screaming also. And I sat up. The kitchen light was on, and I saw some people at the foot of the bed.

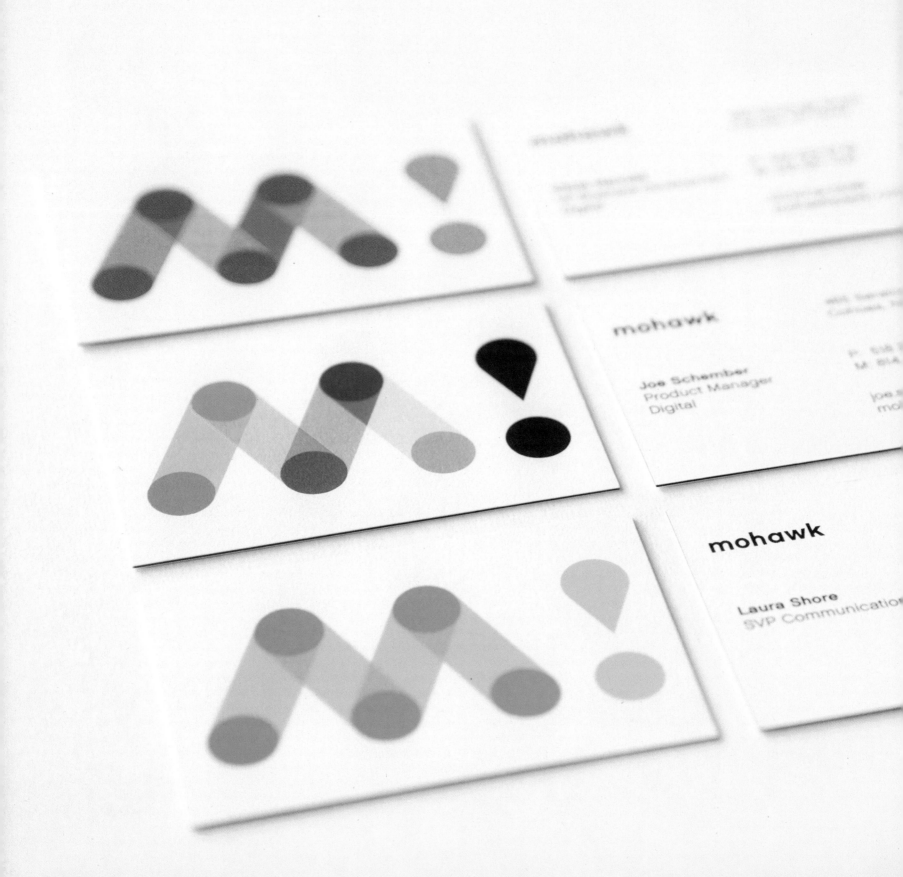

How to be who you are
Mohawk Fine Papers

Once, a logo was meant to last forever. Some still do, and should. But at a time when organizations must change rapidly to meet new challenges or risk oblivion, what worked yesterday may not work tomorrow. A company's identity must be authentic and consistent, but never frozen in time.

Founded in 1931 in upstate New York at the confluence of the Mohawk and Hudson Rivers, Mohawk Fine Papers has been owned by the O'Connor family for three generations. In a digital world, papermaking remains a frankly industrial process: anyone who has toured a paper mill and seen a giant vat of swirling pulp transformed into smooth stacks of paper is unlikely to forget it. Among practitioners of this ancient art, few paper companies have been as innovative as Mohawk. From dominating the world of print with textured and colored papers in the 1940s and 1950s, to inventing processes to ensure good offset (and later digital) reproduction in the 1980s and 1990s, to becoming the first paper company in America to offset carbon emissions with wind-farm credits, this little company has met each challenge with imagination and aplomb.

Marketing paper is complicated. For years, companies like Mohawk sold it to distributors, who in turn sold it to printers, who placed orders based on the specifications of designers and art directors. The 21st century added more complexity. Large-scale orders for corporate literature like annual reports evaporated as companies went online. In the meantime, small-batch and do-it-yourself operations opened markets directly to consumers.

In response, we've redesigned the brand identity of Mohawk three times, or once every ten years. The newest identity—centered on a stylized letter M that can take many different forms—positions the company at the center of the digital world, while confirming its commitment to craft and connectivity.

The best graphic identity will fail if it doesn't connect with the authentic core of the organization it represents. Dolly Parton's advice to young singers is also the best branding philosophy I've ever heard: "Find out who you are, and do it on purpose." How lucky to have a client who knows who they are.

Right
The symbol can be reproduced as a line drawing as well as in a wide variety of monochromatic and multicolor combinations.

Above
The drawing of the M is meant to simultaneously evoke four things: rolls of uncut paper on the mill floor, the mechanics of offset printing, digital circuitry, and the idea of connection.

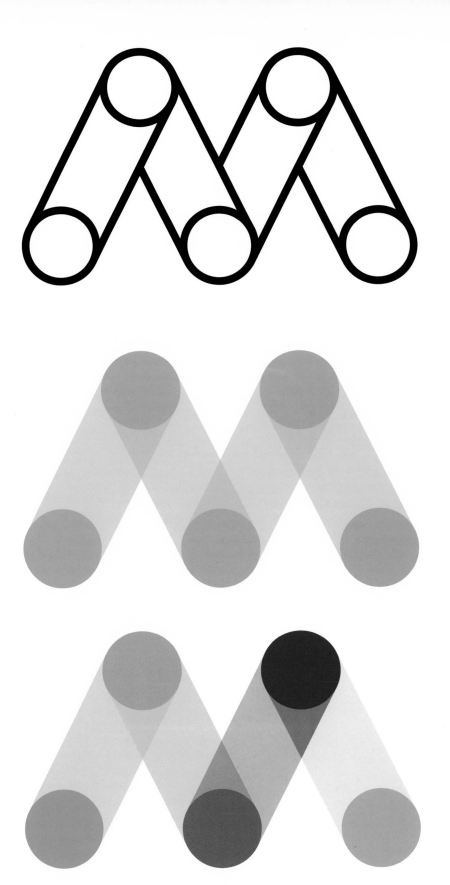

Mohawk Fine Papers

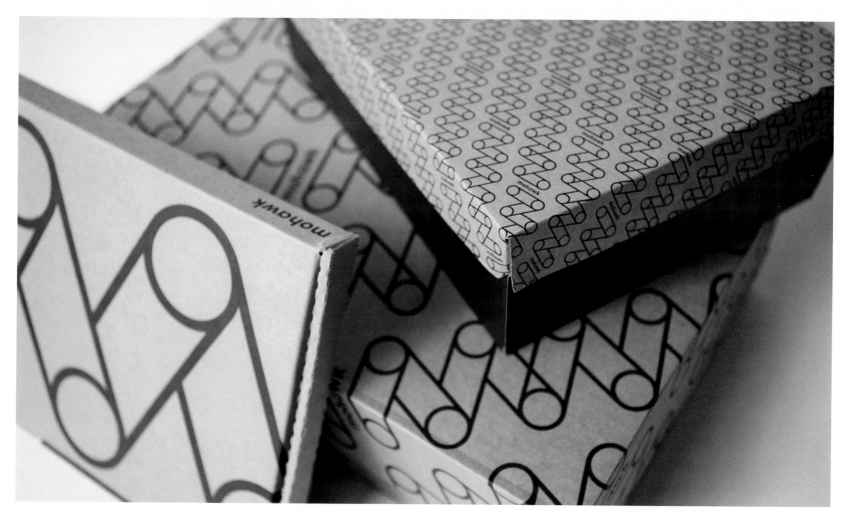

Left
The forms
of the M
symbol can
be rearranged
to form a
wide variety of
symbols, from
exclamation
marks to
arithmetic
notation.

Above
A simple
black-on-craft-
paper pattern
identifies
Mohawk's
rugged
shipping
boxes.

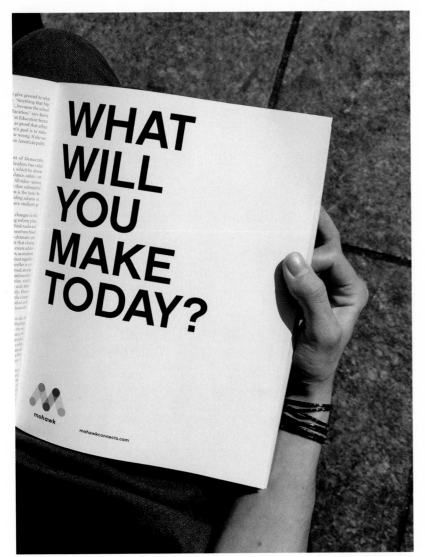

Mohawk Fine Papers

AIA

A[]A

A[WE]A

How to get the passion back
American Institute of Architects

Founded in 1857, with more than 80,000 members today, the American Institute of Architects is the oldest and largest design organization in the United States. The 13 original members, bearded white men all, would not recognize the profession as it approaches its 160th birthday. In recent years the AIA has faced unprecedented challenges: the global economic downturn, the revolutionary effect of technology, an ever-more-diverse potential membership base. In response, the organization, led by the deliberate and determined Robert Ivy, undertook a sweeping repositioning process. We were asked to help imagine what this new AIA might look like.

Reinventing an organization this old and this big is a difficult and potentially traumatic process. As is often the case, part of the challenge was figuring out exactly what the challenge was. The AIA hoped to improve the general public's opinion of architects. But that wasn't really the problem: as we learned from an analysis conducted by my colleague Arthur Cohen, people like architects. The problem was that architects didn't like architects. Frequently demoralized by the multiple stresses on their profession, many could only dimly recall the passion that led them into architecture in the first place. They looked to the AIA for education, affirmation, and support. We wanted to restore the passion as well.

Our work, then, had multiple audiences, but at the center sat the architects, who inevitably were the best advocates for their own value. We began to unify the communications issued by AIA and its network of chapters and components, creating a new tone of voice suited to their new initiatives. We invented a proprietary typeface based on the simple Doric column-like character of the capital I that sits at the center of their acronym. And I got personal with a heartfelt 193-word manifesto that addressed what motivates individual designers, and why we're all stronger together. The first time it was presented at an AIA board meeting, a few members confessed they were moved to tears. The passion was back.

Below
An ad conceived by our colleagues at LaPlaca Cohen focuses not on architecture but on the people that architecture serves.

Opposite
A new typeface, AIArchitype, unifies the organization's communications. Drawn by Jeremy Mickel, it is based loosely on a post-and-lintel system, with strong verticals supporting narrower horizontals.

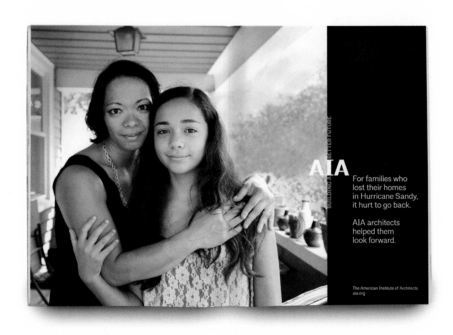

AIA

BUILDING A BETTER FUTURE

For families who lost their homes in Hurricane Sandy, it hurt to go back.

AIA architects helped them look forward.

The American Institute of Architects
aia.org

TECTONIC STRENGTH

God is in the Details

BUILDING COMMUNITIES

Cantilevered Support Structure

2419 Design Iterations

One Corbusier Lamp

Mister Wright

PRESERVING LANDMARKS

Computer Aided Design

Right and opposite
The AIA's annual convention in 2014 was held in Chicago, America's greatest architectural city. It was a perfect place to launch the organization's new voice. Pentagram's Hamish Smyth worked with the AIA's in-house marketing team on a coordinated program, all anchored by an energetic wordmark that literally embedded the AIA into the destination. Ads and merchandise paraphrase a famous quote by Chicago's master planner Daniel Burnham: "Make no little plans. They have no magic to stir men's souls."

Next spread
We conducted months of research on what motivated architects and what they wanted from their professional organization, and reduced it to a simple 200-word manifesto.

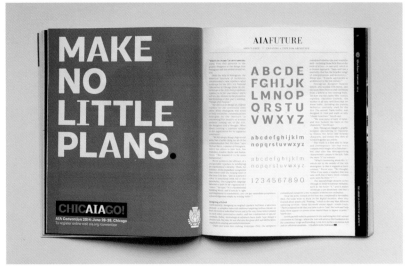

American Institute of Architects

CHIC
AIA
GO!

CHICAIAGO!
AIA Convention 2014
June 26–28, Chicago

It's more than three letters after your name.
Or a taste in exotic eyewear.
Or the color of clothes in your closet.

It's more than the sleepless nights, the brutal critiques,
the hundreds of hours spent alone in front of a computer,
the tight budgets, and the overdue invoices.

It's looking at an empty space and seeing a world of possibilities.
It's transforming a complex problem into a brilliantly simple solution.
It's knowing that today's investment in our built environment
will be repaid one hundred times over tomorrow.
It's believing that the way our surroundings are designed can
change the way we live.

This is what drives us.
This is what it is to be an architect.

But this thing we do cannot be done alone.

We need clients who can believe in the power of a reality
that doesn't yet exist.
We need to listen to the people who will live, work and play in
the places we create.
We need leadership in our communities, and in our profession.
We need each other.

We are America's architects.
We are committed to building a better world.
And we can only do it together.

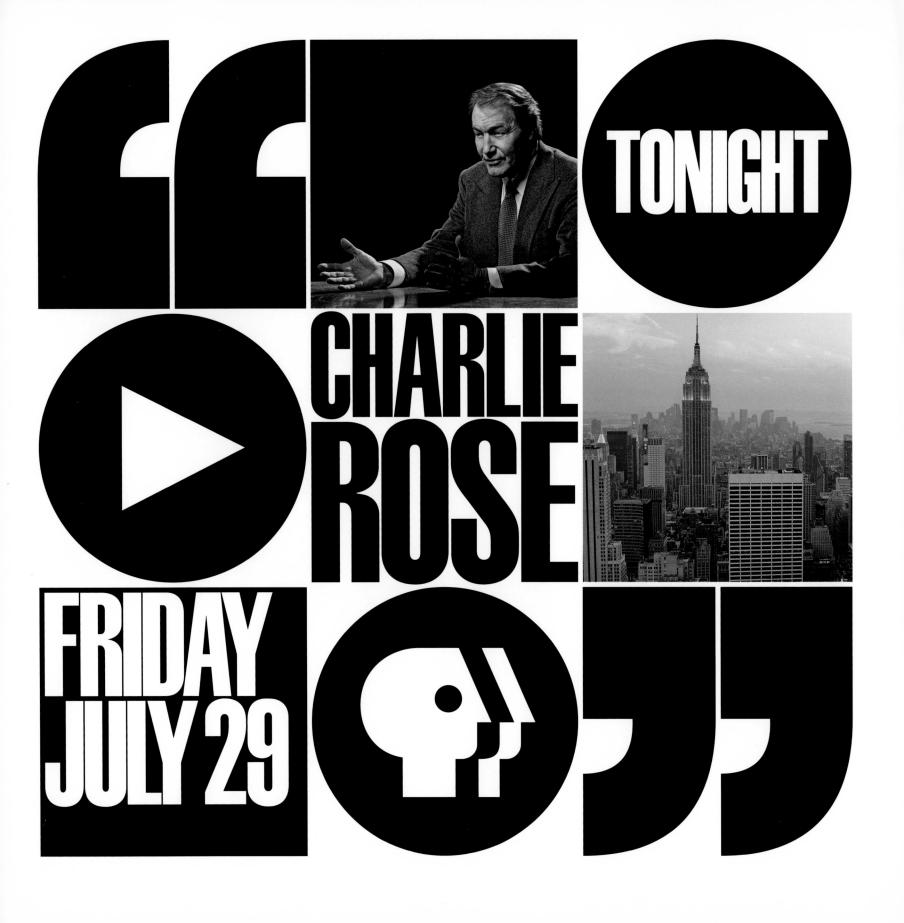

How to make news
Charlie Rose

With its cheesy effects, kitschy animation, and rotten typography, much of the design you see on television looks like nothing more than animated junk mail. And is anything worse than news shows? The inescapable din of 24-hour cable has provoked its own visual corollary, a relentless tsunami of on-screen graphics that seem calculated to obfuscate rather than inform.

Against this hopelessly cluttered environment, the public television show hosted by journalist Charlie Rose is an oasis of confident, understated clarity. Since 1991, Rose has conducted interviews in a setting of striking asceticism: a round wooden table in a featureless black void. The guests at that table have ranged from presidents and prime ministers to actors and authors. Rose's courtly manner, tinged with a laconic accent from his North Carolina upbringing, belies his ability to ask probing questions that provoke surprising responses. His hundreds of recorded interviews, spanning three decades, provide an unmatched record of eyewitness accounts of the events that have changed our world.

There was one weak spot: the graphics, which had barely evolved beyond their 1990s roots. As a faithful viewer, I have seldom been as happy to get a call asking if we could help. I knew immediately we could state the challenge in a single question: what is the graphic corollary to the round wooden table?

Our solution was just as direct. Using a condensed typeface that suggested the urgency of classic newspaper headlines, we set the host's name on two lines. They formed a perfect square, an ideal counterpart to the tabletop's circle. The combination of squares and circles generated a modular system that allowed us to organize everything from advertising layouts to web pages. No 3-D effects, no shiny metallic finishes. A custom set of quotation marks, again built from the geometry of circles and squares, completed the graphic package. It emphasized what *Charlie Rose* is all about: conversation, spontaneous and unvarnished, the essence of journalism and the key to understanding an increasingly complex world.

ABCDEFGHIJ
KLMNOPQRS
TUVWXYZ
1234567890

THE FOOTNOTES GET

"VERY VERY VERY ADDICTIVE "

Opposite
To create a signature typographic voice for *Charlie Rose*, Pentagram designer Jessica Svendsen adapted an underused font from the mid-1950s, Schmalfette Grotesk. It evokes the straightforward headlines of print journalism, and eschews typical television tricks like 3-D shadows and shiny highlights.

Left
Almost every *Charlie Rose* show generates memorable quotes, a testimony to his skill as an interviewer. The quotes are transformed into miniature posters that can be used to encourage viewers to tune in.

IT'S A VERY

"PERSONAL CHOICE "

"HIP-HOP IS WHAT YOU LIVE "

RAP IS WHAT YOU DO.

269

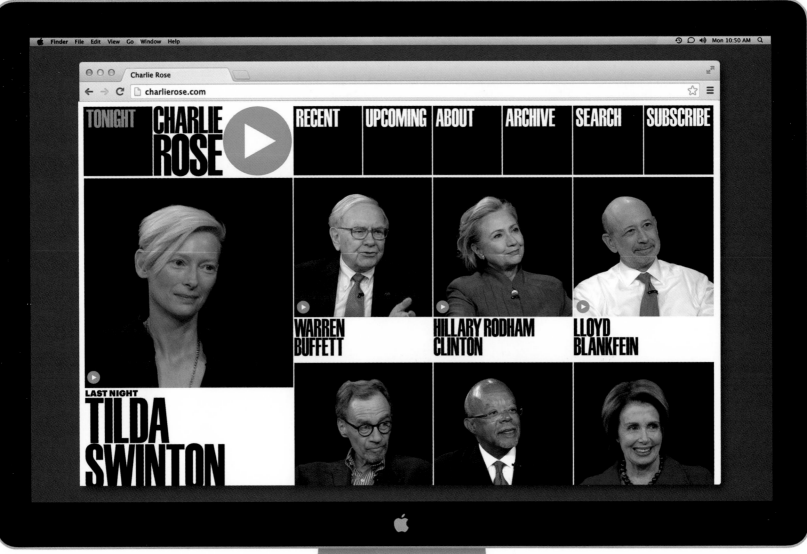

Above and opposite
The redesigned *Charlie Rose* website offers a searchable archive of the show's vast repository of interviews.

These conceptual designs demonstrate how the modular system could be adapted for digital interactivity.

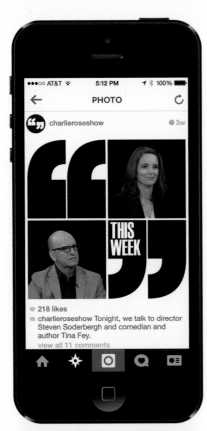

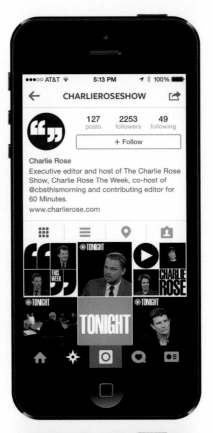

Charlie Rose

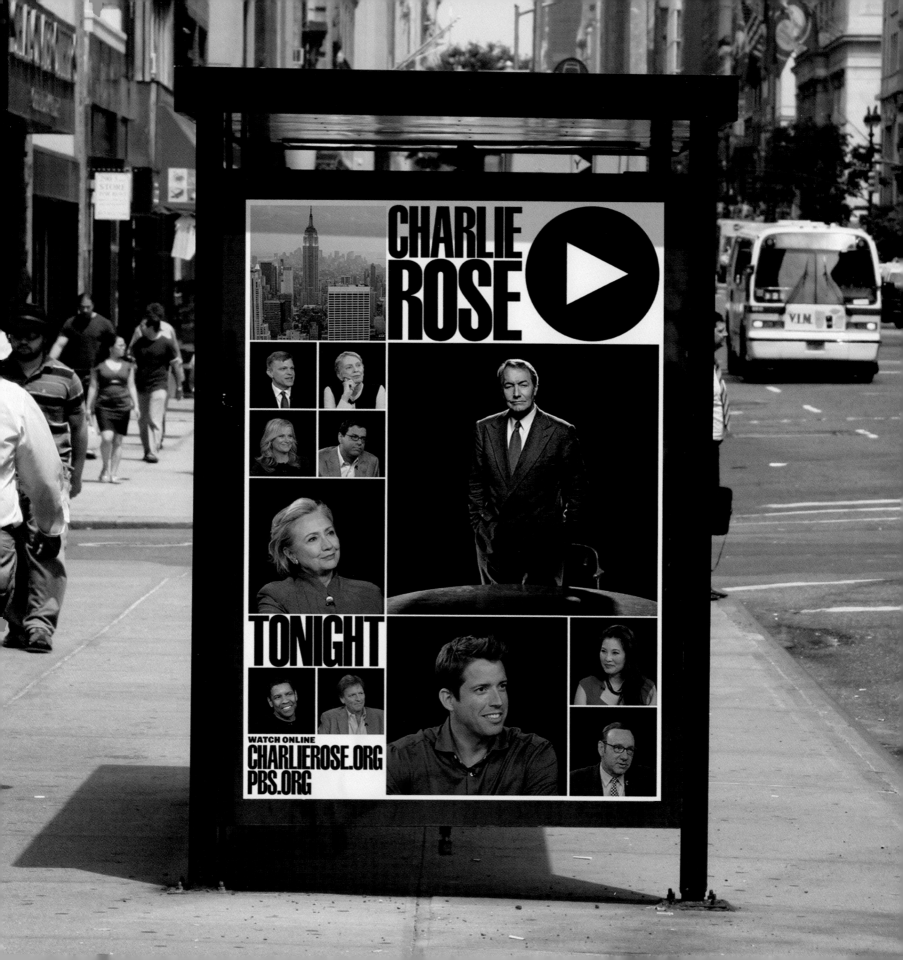

How to set a table
The restaurants of Bobby Flay

A few years back, "experience design" was all the rage. Designers, advertisers, and marketers suddenly seemed to realize that consumers didn't form their impressions of brands based solely on logos and advertisements. Instead, their opinion of a product or company emerges from a broad range of "touchpoints" based on a "360-degree view" of human experience. Or, as normal people might call it, real life. This was evidently a surprise to self-obsessed communications professionals. But it wouldn't have been a surprise to anyone who's ever run a restaurant.

Great restaurateurs understand that a restaurant experience must engage all five senses; that the way you're greeted at the door is just as important (maybe more) as the way the food tastes; and that the dining experience is fundamentally theatrical, with guests who are both audience and performer.

Bobby Flay is one of the best-known chefs in the world. A culinary wunderkind born and bred in New York, he mastered the art of southwestern cuisine at Mesa Grill, and reinvented the midtown dining experience at Bar Americain. He and his partner Laurence Kretchmer know exactly what it takes to run a deliriously successful restaurant.

We discovered the key is communicating with absolute precision to the target audience. What should they expect and how can you exceed those expectations? Bobby's Burger Palace is a "fast casual" experience: great burgers, fries, and shakes delivered to your seat with efficient finesse. Everything about the design of the space supports this idea: the counters that snake around the room, the horizontal lines that reinforce the idea of speed. Our logo borrows those forms to make a hamburger out of the name itself: bun, burger, and lettuce in perfect equipoise.

Bobby's upscale restaurant, Gato, in Manhattan's Noho district, is the opposite: inventive, customized dishes, each created to order, with every detail implying the attention of the passionate chef behind the scenes. The graphics are tailored and understated. Two restaurants, two graphic languages, two experiences: working on Gato and Bobby's Burger Palace reminded us that what ends up on the plate is only the beginning.

Bobby's Burger Palace is Flay's tribute to the hamburger joints of his youth. Painstakingly researched on trips back and forth across the United States, the menu features everything from the Philadelphia Burger (provolone cheese, griddled onions, hot peppers) to the Dallas Burger (spice-crusted patty, coleslaw, Monterey Jack cheese, BBQ sauce, pickles) to the LA Burger (avocado relish, watercress, cheddar cheese, tomato). Starting with a single location in suburban New Jersey in 2008, there are now 18 BBPs around the United States.

Right and opposite
Everything about the graphic program for BBP is bright and lively. We based our graphic motifs and color scheme on Rockwell Group's energetic interior design, which can be reconfigured for spaces of all sizes and shapes. Bobby offers to "crunchify" each burger (by adding a layer of potato chips); designer Joe Marianek and I tried to keep the graphic program just as brazen.

Above
The typography for the Bobby's Burger Palace logo is stacked like the joint's signature product. It can also reduce to a vertical initials-only acronymic "slider."

The restaurants of Bobby Flay

Gato opened on Lafayette Street in lower Manhattan in 2014, Bobby Flay's first new restaurant in nearly ten years. Located in a renovated 1897 warehouse, it celebrates the flavors of the Mediterranean, with dishes and ingredients from Spain, Italy, France, and Greece. The space's renovation, again by Rockwell Group, balances cosmopolitan luxury with downtown grit. Our goal with the graphic program was to do the same.

Right and opposite
The balance of tough and luxe is maintained in every detail. The secondary typeface Pitch, a refinement of monospaced typewriter fonts, is paired with deep blues from the hand-set tile work on Gato's floors. Pentagram's Jesse Reed supervised details from the gold leaf logos on the windows to the hand-painted "Employees must wash hands" notice in the WC.

Next spread
The exterior of Gato on Lafayette Street. The chef is visible through the window on the right.

GATO

Above
Gato's logo is based on Anthony Burrill's stylish-but-tough typeface Lisbon, itself inspired by the street addresses of its namesake city and other Mediterranean locales.

The restaurants of Bobby Flay

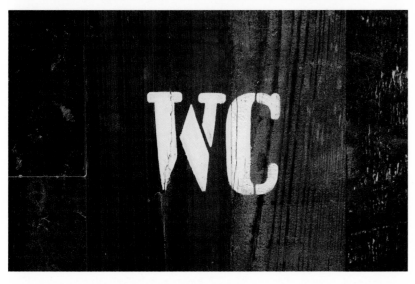

How to survive on an island
Governors Island

Opposite and above
For most of its history, Governors Island had very few visitors. It was a secret destination hiding in plain sight less than half a mile from the coast of lower Manhattan. Today, it is open to the public all summer and accessible only by ferry. The island has astounding views that serve to orient visitors as they move about its periphery.

Next spread
The enormous gantries at the island's docks serve as gateways upon arrival and as frames upon departure. Their structure provided the key to our approach to the island's signs.

Governors Island sits 800 yards off the shore of lower Manhattan, reachable only by ferry, a ride that takes a little more than seven minutes. But the contrast with the city is positively surreal. There are no cars. There are no crowds. Instead, to the north, just an abandoned military base, elegant and eerie, built over a century ago. And to the south, stretches of featureless landfill, overlooking astonishing views of Manhattan, Brooklyn, New York Harbor, and the Statue of Liberty.

Our client Leslie Koch, appointed by the mayor to shape Governors Island's 172 acres of undeveloped landfill, devised a competition to create the city's newest public park. Dutch landscape architects West 8, led by the brilliant Adriaan Geuze, won. Our job was to create the signs that would help the island's visitors find their way around.

The island has just two "front doors," the docks for ferries from Manhattan and Brooklyn. It wasn't really so big you could get lost. And the glorious views provided constant orientation. It seemed easy.

Yet we were struggling. I had become fixated on a single approach: bulky, cylindrical signs that worked in 360 degrees, just like the island itself. I presented ever-more-developed versions in meeting after meeting. The more I developed them, the less I liked them. Neither, I sensed, did anyone else. Finally I admitted defeat.

"Can I show you something?" I asked my partner Paula Scher. I laid out months of work, alongside pictures from our many visits to Governors Island. Paula had never been there. She pointed at a picture we had taken of a gantry, one of the giant, skeletal superstructures at the island's docks. "This is what the signs should look like. It's all about the views, right? So why not make signs you can see through?"

That took three minutes. I visited our colleagues at West 8 and asked for permission to throw everything out and start over. I thought they would be alarmed. Instead they were relieved. The new approach worked perfectly, and from the first moment we showed it to Leslie Koch, I could tell we had the answer. Today she calls them "the most beautiful signs in New York."

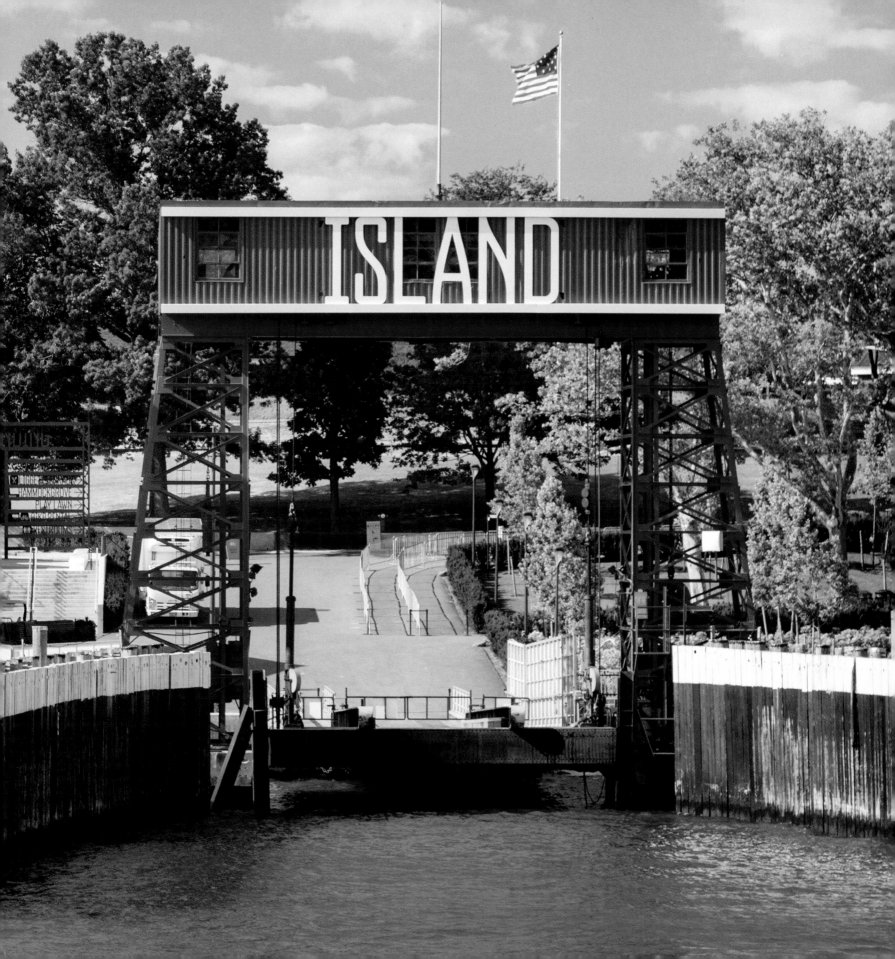

Above
The signs had to look robust but playful, big enough to stand out in the environment but capable of fading into the background. Adriaan Geuze, Jamie Maslyn Larson, and their team at West 8 helped create the signs' structures, including supports that incorporate the curvy, organic patterns that can be found throughout their designs for public spaces.

Above
We designed a custom typeface for Governors Island called Guppy Sans, a cross between a rugged sans serif (to reflect the island's utilitarian past) and an ornamental display font (to suggest the lush parkland to come). Pentagram's Britt Cobb and Hamish Smyth masterminded the design's deployment and spent many hours walking and biking the island's paths.

Above
A key challenge for the island's signage program was anticipating change. The signs had to look permanent, but needed to be updated weekly to accommodate temporary events, and seasonally to incorporate new destinations. As a result, the signs are built from modular elements that can be easily updated.

Above
No matter how complicated the signage system, one sign is inevitably the most important.

Governors Island

Left top, middle, and bottom
By using the same custom typeface on every sign, including street signs, informational signs, and interpretive signs, we hoped to create a distinct sense of place that would set the island apart from other New York destinations.

Above
Leslie Koch believes strongly that memorable place names are key to wayfinding. On the island, some are historic (Colonels Row) and others are brand-new (Hammock Grove); they build anticipation even as words on a map.

Next spread
The structure of the signs, and their location in the lush landscape of the island's park and open spaces, suggest they might be excellent trellises. My private fantasy is to see them smothered in vines, achieving the perfect synthesis of design and nature.

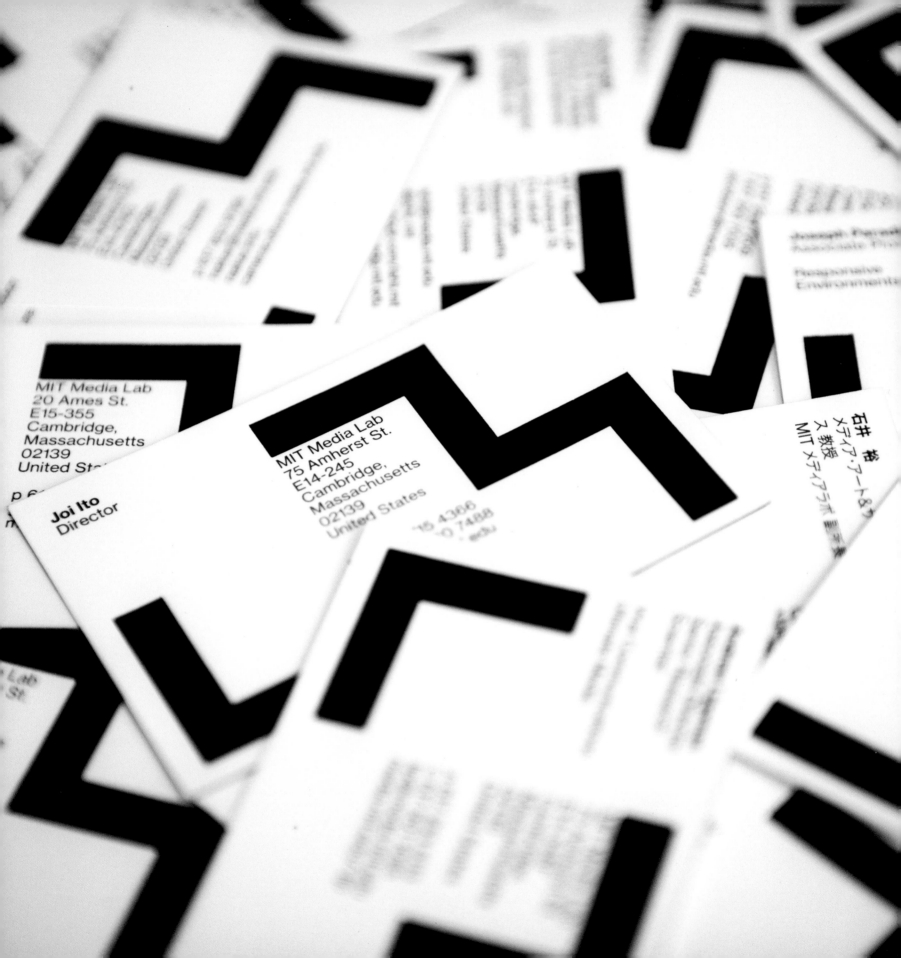

How to design two dozen logos at once
MIT Media Lab

Digital technology forever transformed the way we communicate. It also overturned the way we decide what makes a good logo. Then came the rise of digital media. The old tests (can you fax it?) were replaced by new ones (can you animate it?). Complexity and dynamism were not only made possible by new technology, but inescapably came to symbolize it.

Since 1985, the global epicenter of digital innovation has been the research groups at the Massachusetts Institute of Technology's Media Lab. The Lab's first identity, by Jacqueline Casey, was a malleable motif of colored bars inspired by an installation that artist Kenneth Noland had created for the original Media Lab building. It lasted two dozen years. For the Lab's 25th anniversary, designer Richard The created a dazzling algorithmic system capable of generating over 40,000 permutations. Both programs were models of dynamic identity, capable of infinite change. But looming large at MIT was another model: the classic logo designed by Media Lab legend Muriel Cooper for MIT Press. A minimalistic configuration of seven vertical lines, it has remained unchanged since 1962. The team at MIT Media Lab came to us with a question: could a single logo combine these two traditions of timelessness and flexibility?

I was already thinking about this question. Having designed more than my share of dynamic identities and non-logo logos, I had begun to doubt their power. All that variability had come to seem entropic, projecting difference without meaning. The symbols designed by Cooper and her peers during the golden age of American corporate identity, by comparison, were striking in their clarity and confidence.

Our solution came after many false starts. Using a seven-by-seven grid, we generated a simple ML monogram. This would serve as the logo for the Media Lab. Then, using the same grid, we extended the same graphic language to each of the 23 research groups that lie at the heart of the Lab's activities. The result is an interrelated family of logos that at once establishes a fixed identity for the Media Lab, and celebrates the diverse activities that make the Lab great.

Right
Our logo for
MIT Media Lab
was created by
constructing
a simple ML
monogram
on a seven-
by-seven
square grid.

Opposite
The symbol
for the Media
Lab does not
vary, but the
relationship
between type
and symbol
does.

Next spread
The same
seven-by-seven
grid was used
to create
logos for the
Lab's research
groups, from
Affective
Computing
to Viral
Communica-
tions. Each
logo uses
the group's
initial letters
to generate
a unique
configuration.

**Following
spread**
Because all
the logos in the
system share
the same
underlying
geometry, they
are perceived
as a family, a
whole that
exceeds
the sum of
its parts.

**mit
media
lab**

MIT Media Lab

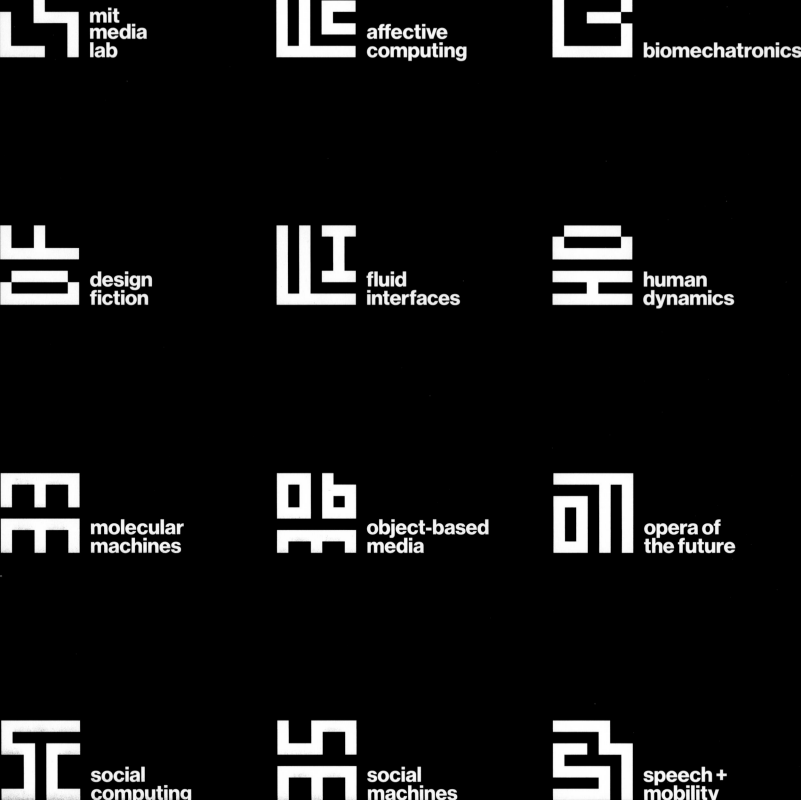

mit
media
lab

affective
computing

biomechatronics

design
fiction

fluid
interfaces

human
dynamics

molecular
machines

object-based
media

opera of
the future

social
computing

social
machines

speech +
mobility

 camera
culture

 changing
places

 civic
media

 lifelong
kindergarten

 macro
connections

 mediated
matter

 personal
robots

 playful
systems

 responsive
environments

 synthetic
neurobiology

 tangible
media

 viral
communications

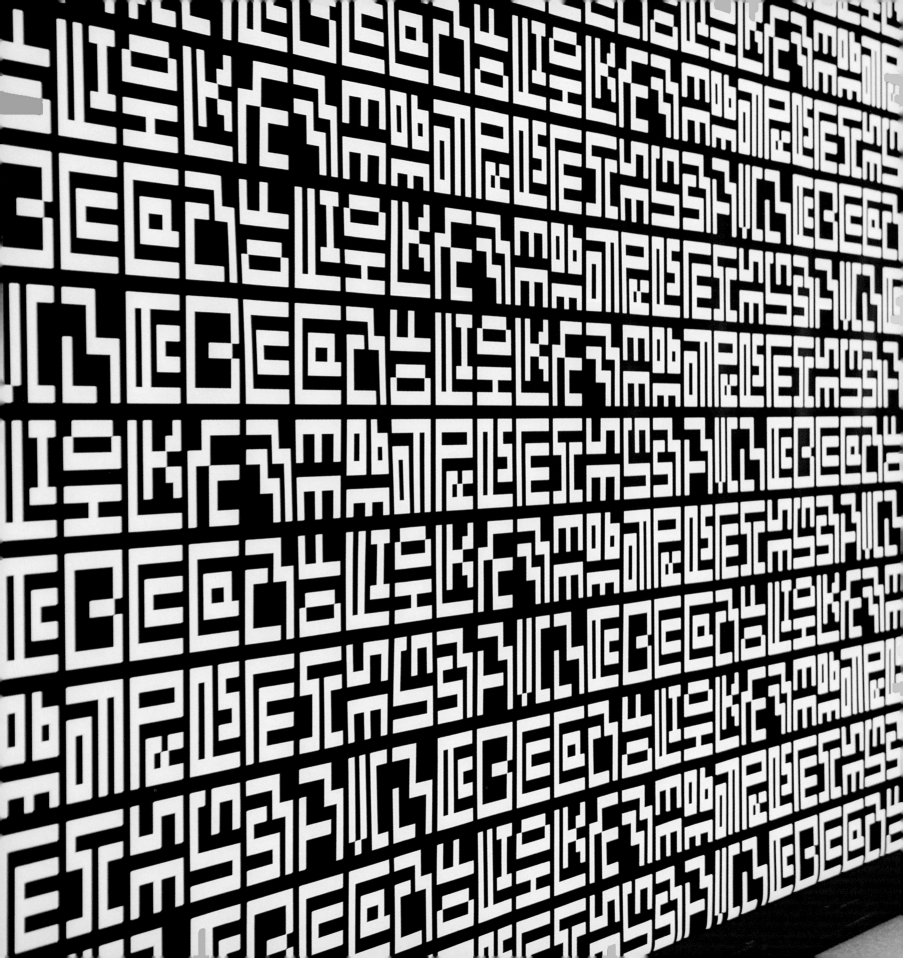

Right top

The typeface Helvetica has been associated with MIT's graphics since the 1960s, when designers like Jacqueline Casey, Muriel Cooper, Ralph Coburn, and Dietmar Winkler were among the first to introduce the Swiss-based "international style" of design to the United States. We used it throughout the identity program, and extended it to the Lab's wayfinding.

Right bottom

The logo, rearranged, becomes a playful arrow pointing to the Media Lab's upper floors.

Right top and bottom
Interactive touchscreens help visitors find their way throughout the Lab complex and announce current programs and coming events.

Next spread
The new identity was launched at the Media Lab's Fall 2014 Member Event, which appropriately had the theme "Deploy."

Following spread
Designer Aron Fay masterminded the implementation of this intricate program, including the application of the same graphic language to posters celebrating the Deploy Member Event.

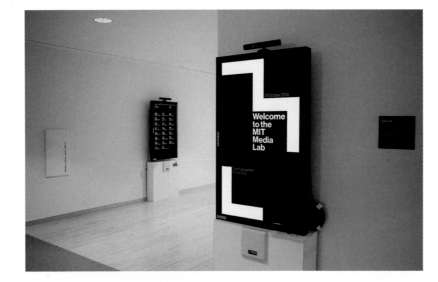

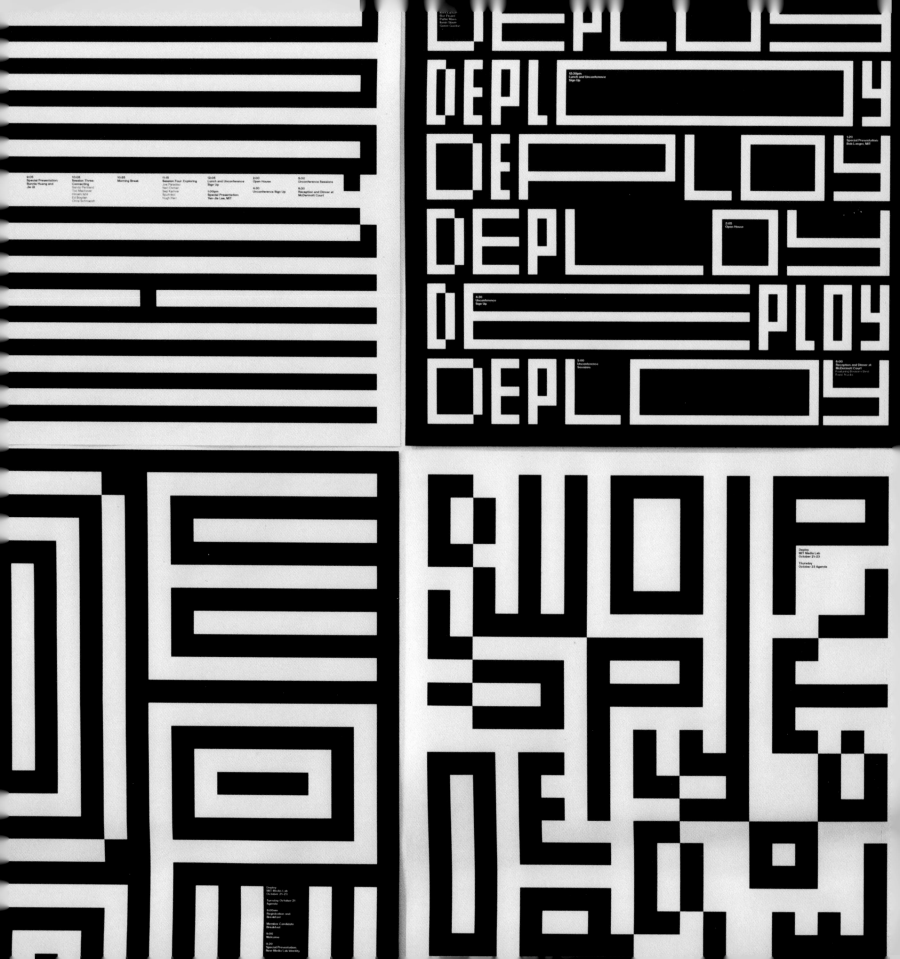

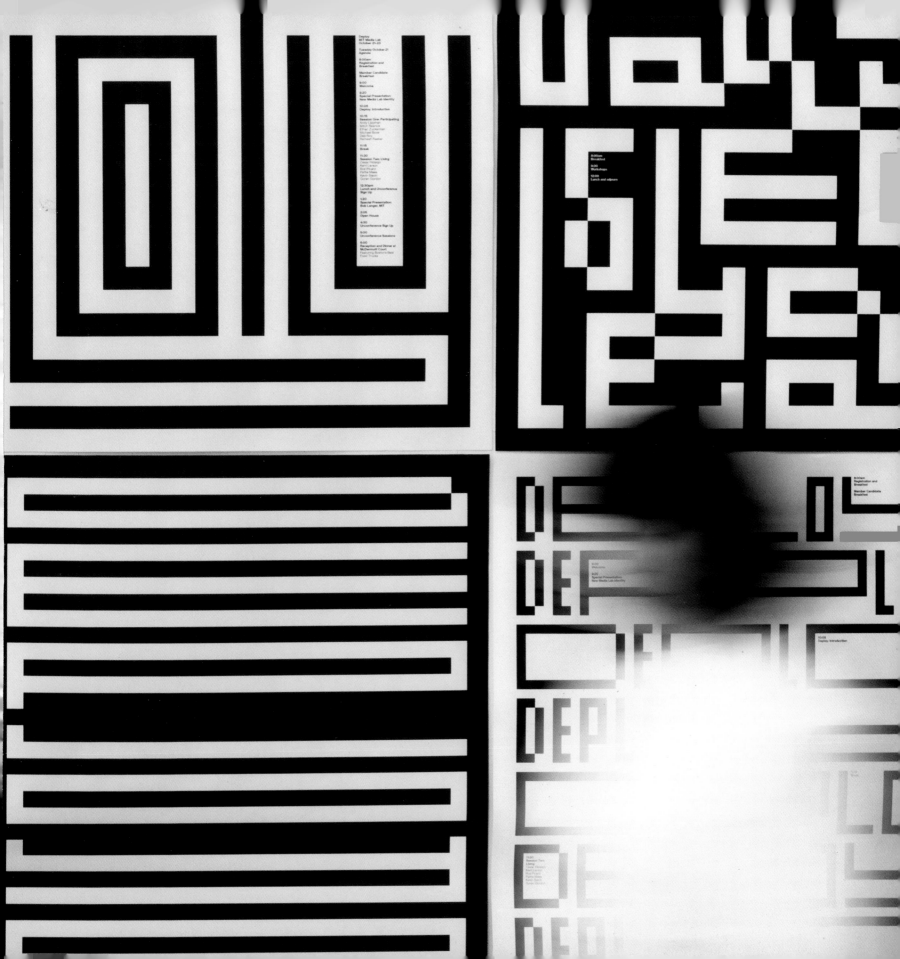

Deploy
MIT Media Lab
October 21–23
Agenda

Tuesday October 21

8:00am
Registration and
Breakfast

Member Candidate
Breakfast

9:00
Welcome

9:20
Special Presentation
New Media Lab Identity

10:05
Deploy: Introduction

10:15
Session One: Participating
Andy Lippman
Mitch Resnick
Ethan Zuckerman
Michael Bove
Deb Roy
Ramesh Raskar

11:15
Break

11:30
Session Two: Living
Cesar Hidalgo
Kent Larson
Rosalind Picard
Pattie Maes
Kevin Slavin
Goran Gordon

12:30pm
Lunch and Unconference
Sign Up

1:20
Special Presentation
Bob Langer, MIT

2:05
Open House

4:50
Unconference Sign Up

5:00
Unconference Sessions

6:00
Reception and Dinner at
McDermott Court
Featuring Boston's Best
Food Trucks

8:00am
Breakfast

9:00
Workshops

12:00
Lunch and adjourn

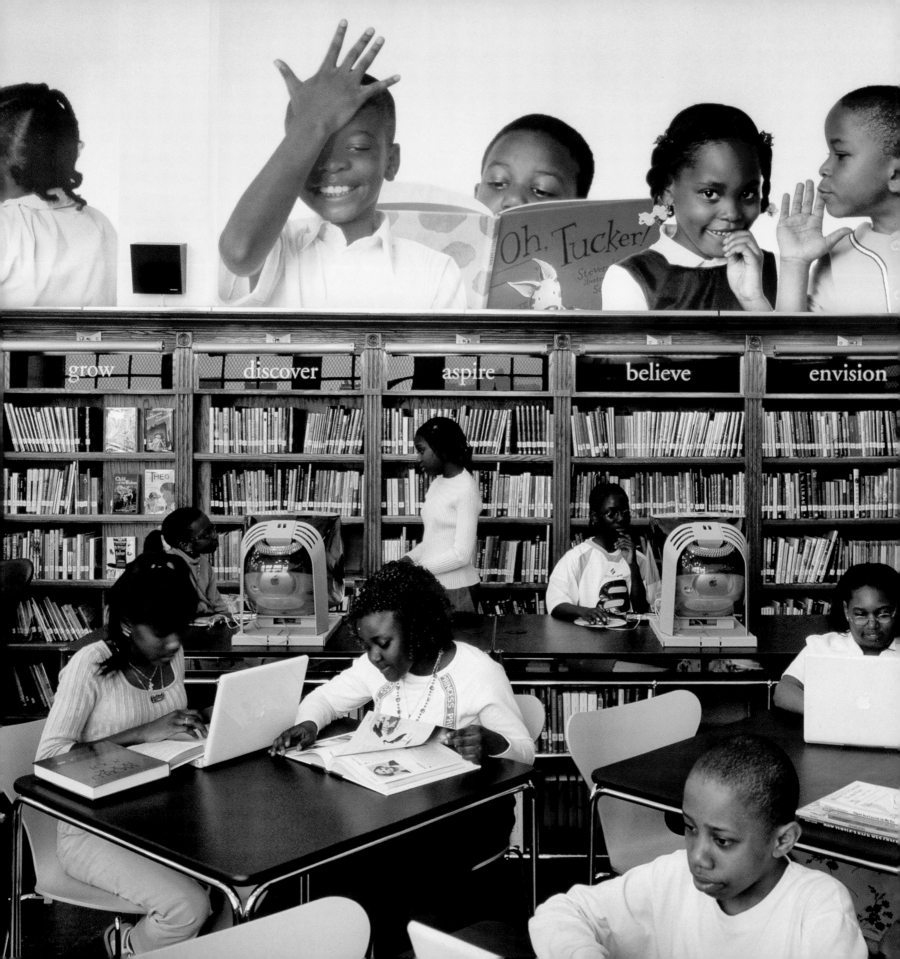

How to save the world with graphic design
The Robin Hood Foundation's Library Initiative

Opposite
One of my favorite projects began with a technical problem. Designing graphics for libraries in schools throughout New York City, we learned that the buildings were old and the ceilings were high. But the kids were little, so the highest shelf they could reach was only halfway up the wall. What could fill the rest of that space? At P.S. 184 in Brooklyn, the answer was oversized portraits by my wife, Dorothy Kresz.

The Robin Hood Foundation had taken on a big challenge: transforming the quality of education at public schools in some of New York's toughest neighborhoods by focusing their attention on a single room, the school library. A group of architects was asked to design the libraries, and we volunteered to be the project's graphic designers.

Our assignment seemed clear: give the program a logo, and create signs to identify the participating schools. We were almost done when one of the architects asked us to help fill the space between the kid-size shelves and the high ceiling. I pictured a modern version of a classical frieze along the top of the walls, celebrating not ancient gods but the kids themselves. My wife, Dorothy, took their portraits. It became a favorite in the system. Every school wanted a mural.

The new libraries were opening in places like Harlem, East Brooklyn, and the South Bronx, serving hundreds of children and, after school, their communities. We decided to make each mural different. We asked illustrators Lynn Pauley and Peter Arkle to do portraits. Designers like Christoph Niemann, Charles Wilkin, Rafael Esquer, Stefan Sagmeister, and Maira Kalman agreed to contribute.

One day, we took a tour of the completed libraries. It was thrilling to see them filled with kids that might discover their futures there, as I had so many years ago in my own school library. Our last stop was at the end of the school day. It was getting late. As the librarian was closing up, she asked, "Would you like to see how I turn out the lights?" Slightly baffled, I said, sure. "I always turn this light out last," she explained. It was the one that lit the mural of the faces of the school's students. "I like to remind myself why we do all this."

I understood only then the real purpose of our project: to help this librarian and the dozens like her to do their jobs better. In a way, this is the only purpose my work has ever had. For design can't save the world. Only people can do that. But design can give us the inspiration, the tools, and the means to try. We left determined to keep trying.

The Robin Hood Foundation is New York's most remarkable charity. True to its name, it takes money donated by the city's wealthiest citizens and uses 100 percent of those funds to help the city's poorest. Robin Hood's genius is finding ways to magnify the impact of those dollars, often using design as a tool. The Library Initiative, which rallied dozens of publishers, builders, and architects, is a perfect example. As the project's graphic design directors, we asked the best illustrators and designers in New York to join us in transforming the one room in a public school where students are most likely to learn in a group environment: the library.

Below
Reasoning that a new idea needed a new name, I wasted a lot of time coming up with puns like "The Red Zone" and acronyms like "OWL" (which I recall stood for Our World Library or something). The project's guiding light, Robin Hood's Lonni Tanner, hated them. I protested that kids think that libraries are boring. "Michael," she told me, "most of our kids have never seen a real library." Set straight, we did a straightforward logo, hinting that these particular libraries were something special just by tinkering with one letter.

Opposite
Because we weren't designing a franchise operation, we decided to come up with a different approach to each library's graphics. This impractical choice complicated our efforts substantially, but a customized solution made each space much more memorable, such as this grand entrance at C.S. 50 in the Bronx, designed by architect Henry Myerberg.

Next spread
We asked the best artists in New York to contribute to the library project. Illustrator Peter Arkle interviewed students and included their words in his black-and-white portraits at P.S. 287 in Brooklyn, designed by architect Richard Lewis.

L!BRARY

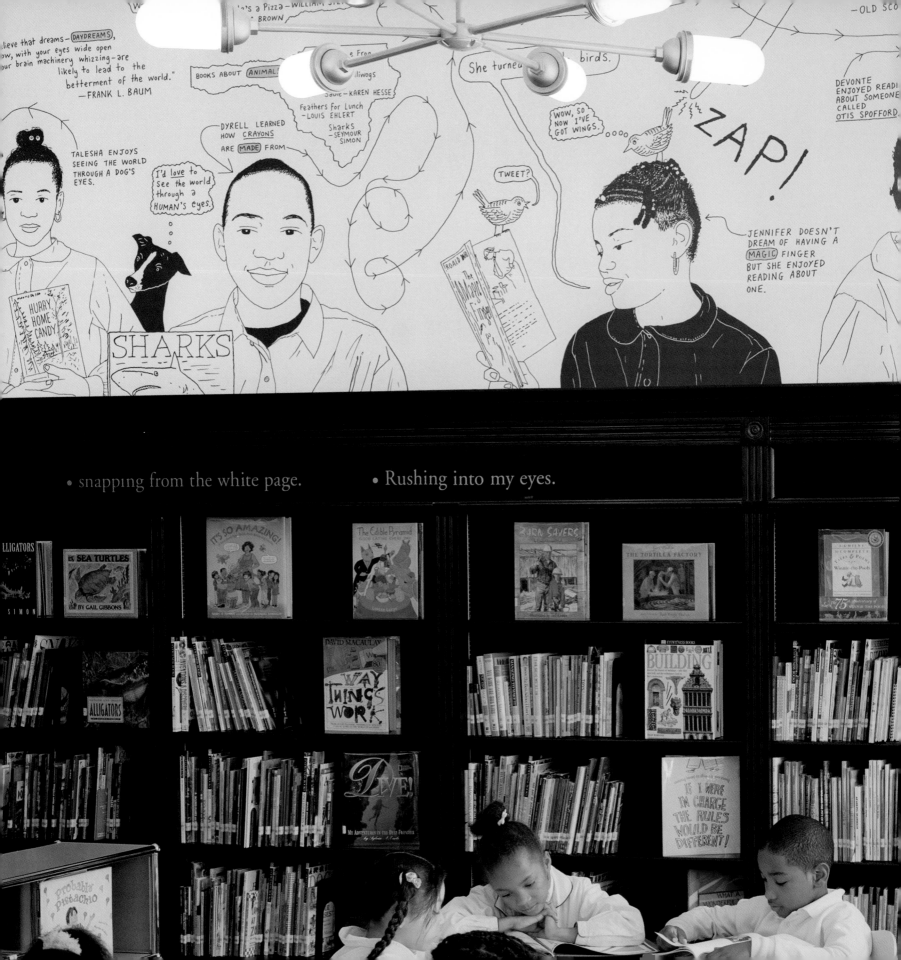

Sliding into my brain which gobbles them.

Opposite
Designer Stefan Sagmeister and illustrator Yuko Shimizu bring the phrase "Everybody who is honest is interesting" to life on the walls of P.S. 96 in the Bronx.

Right top
Illustrator Lynn Pauley traveled from school to school painting portraits of students in a variety of styles for several libraries, including P.S. 36 in the Bronx.

Right bottom
At P.S. 196 in Brooklyn, designer Rafael Esquer created murals that illustrated the words of students in thousands of tiny silhouettes.

Next spread
Christoph Niemann's mural at P.S. 69 in the Bronx playfully integrated books into various images: Ahab's whale, an eagle's wings, and the American flag.

Following spread
Writer and illustrator Maira Kalman invented a three-dimensional installation that included images, objects, and her own idiosyncratic handwriting.

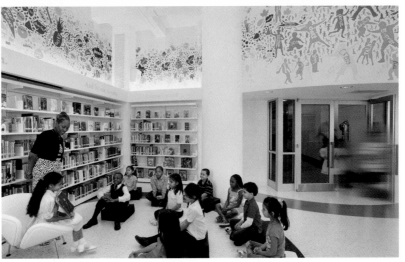

313

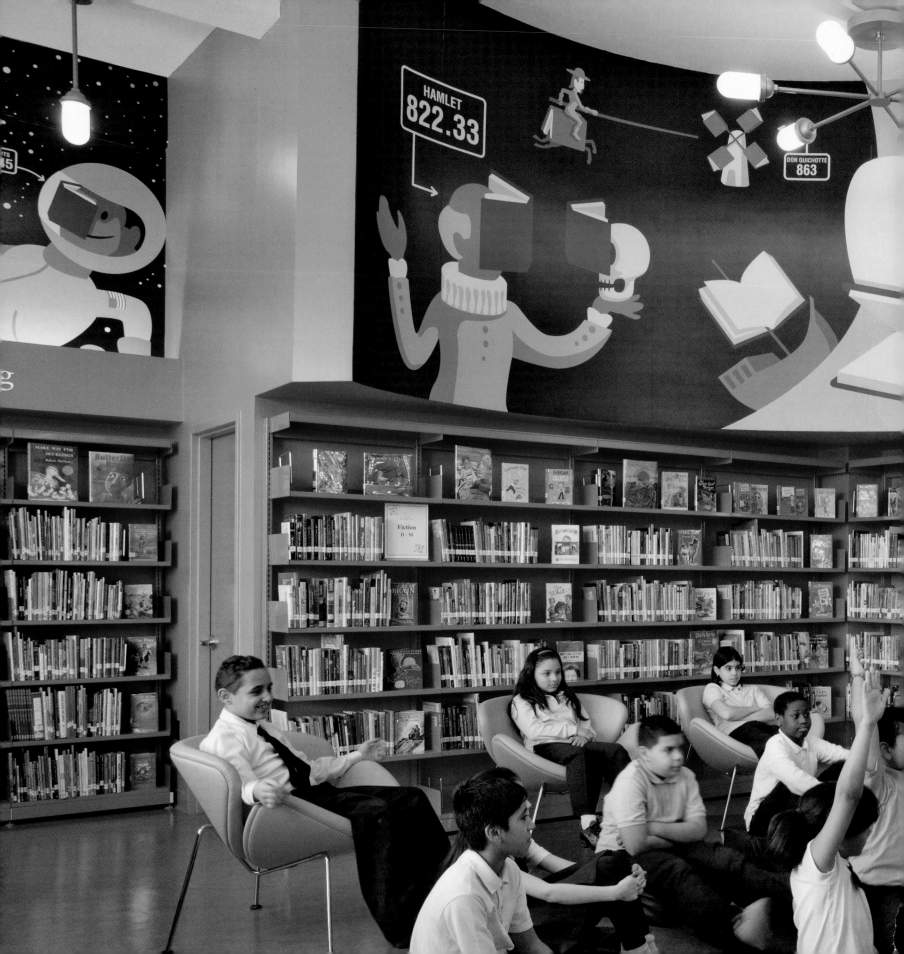

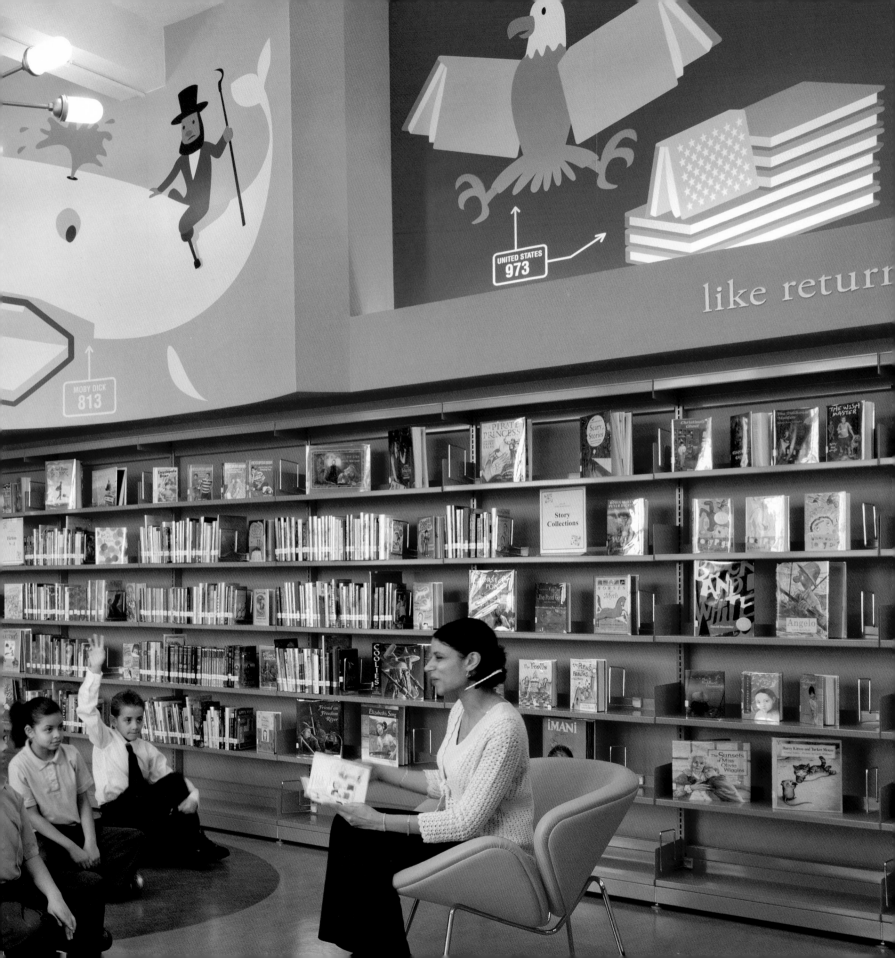

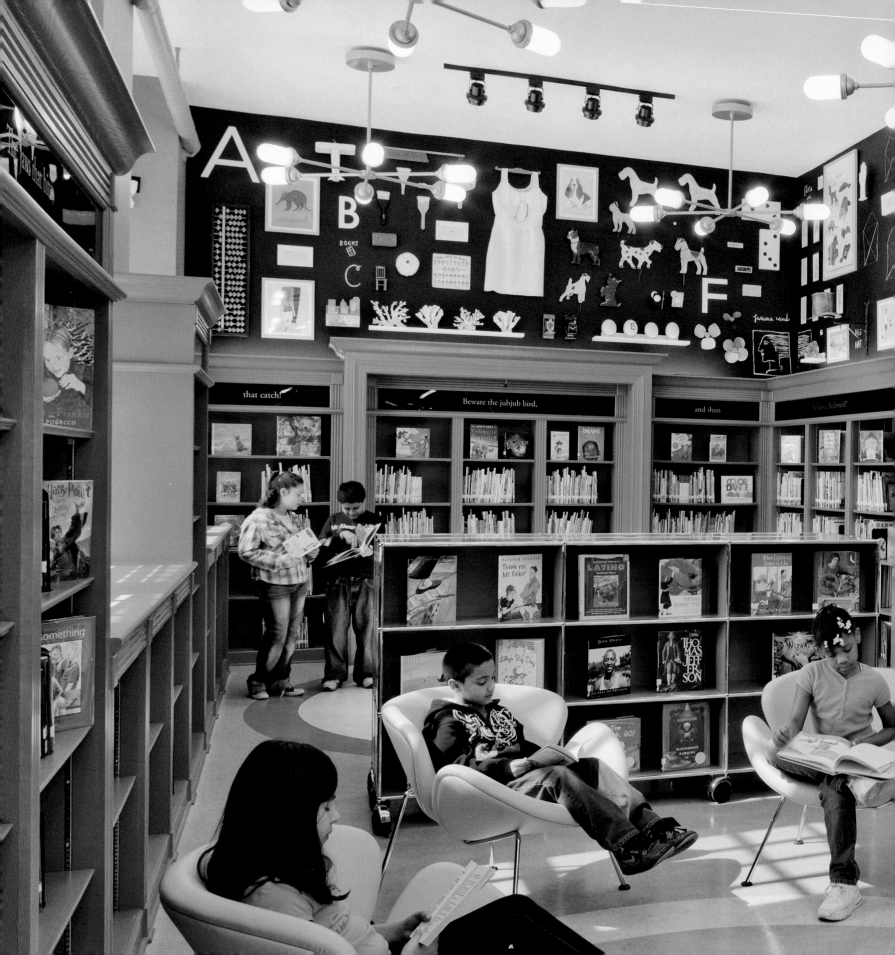

Acknowledgments

This book is dedicated to the memory of two extraordinary men: Massimo Vignelli and William Drenttel. From Massimo, I learned how to be a designer. From Bill, I learned that there were no limits to what a designer could contribute to the world. I strive to reach the standards they set.

Long before I knew what a graphic designer was, my parents, Leonard and Anne Marie Bierut, encouraged me to be an artist. My parents and my wonderful brothers, Ronald and Donald, must have found me baffling, but they usually managed to conceal it. They were the best thing about growing up in suburban Cleveland.

In junior high school, in high school, and in college, I had remarkable, dedicated teachers like Sue Ann Neroni, John Kocsis, Gordon Salchow, Joe Bottoni, Anne Ghory-Goodman, Stan Brod, Heinz Schenker, and Robert Probst. When I entered the workplace as a lowly intern, Chris Pullman and Dan Bittman were my first bosses and my earliest mentors.

My life as a designer has been shaped by the quarter century I've spent as a partner at Pentagram. I am grateful to Colin Forbes, Woody Pirtle, and Peter Harrison, who put their faith in me at the very start. I am so proud to be part of an organization that includes amazing designers like Lorenzo Apicella, Angus Hyland, Domenic Lippa, Justus Oehler, Harry Pearce, John Rushworth, William Russell, DJ Stout, Marina Willer, and my favorite traveling companion Daniel Weil.

Most important are my partners in New York, past and present, who inspire me every day: James Biber, Michael Gericke, Luke Hayman, Natasha Jen, Abbott Miller, Emily Oberman, Eddie Opara, and Lisa Strausfeld. Paula Scher and I joined Pentagram together, and she is still the person I am desperately trying to impress.